BIGGER
AND BETTER
ENLARGING

by
Don Nibbelink, F.R.P.S., F.P.S.A
and
Rex Anderson

AMPHOTO
American Photographic Book Publishing
Company, Inc. Garden City, New York

Contents

A straight print? No! It is, however, the naturalistic kind of result that can be obtained through using the techniques described in this book. The outdoor portrait was taken with fill-in flash held off to the right of the camera. The flash provided the wonderful facial highlights but it also overlighted the white shirt. The shirt received considerable additional exposure during printing.

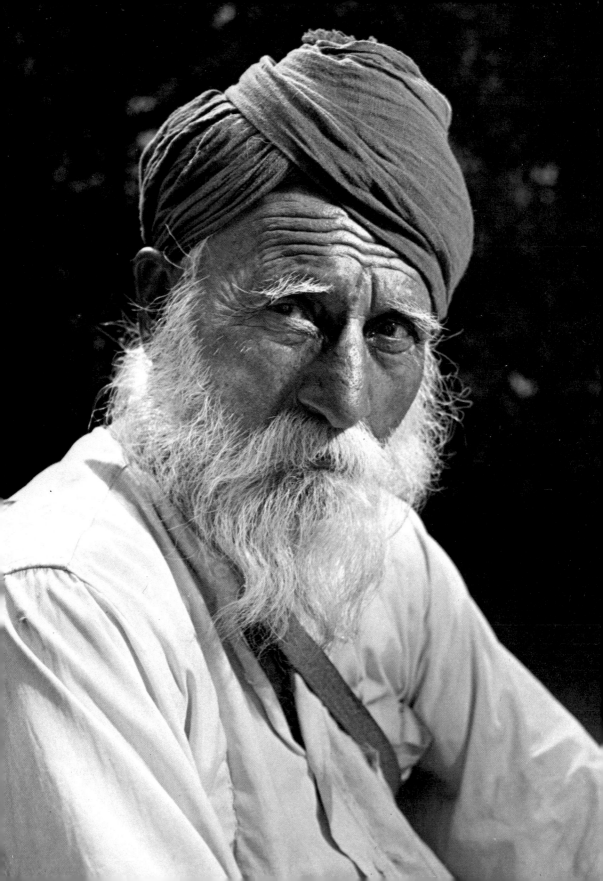

Introduction

A capable photographer—note the word capable—is not merely a person who can take a technically excellent photograph, any more than a good writer is a person who can operate a typewriter and spell correctly, or an effective speaker is someone who stands before an audience and talks. A photographer worthy of the title is really a *communicator,* one who can transmit ideas or emotions through his medium, an agile-minded thinker with a message for his print viewers.

Good photographs can be powerful transmitters. Even beyond its ability to transmit excitement or tranquility or beauty, even more than its capacity to stretch the mind or teach or train, the photographic medium can motivate.

It works like a chain of command: the creator of the idea—if you took the picture this is probably you—transforms the idea into a photographic image; the viewer looks and receives the message and, it is hoped, reacts or is motivated as you intended. However, the whole thing works well only if the message is unimpaired and crystal clear. A writer must not misspell, a speaker must not stutter, a print maker—you again—must not print the message too dark, too green, too contrasty, too anything that would distract from the clarity of the communication.

The purpose of this book is to help you make enlargements that communicate. In fact, we'd like to have you read this book straight through, like a novel, at least until you reach the final reference section. We put this "tools section"—with information on chemicals, enlarger selection, and so on—last, where it will not interfere but where you can refer to it if need be. In other words, this is not a reference book, one to be held in one hand while you make a print with the other. Rather, we hope you'll find it inspirational, a book that will send you back into the darkroom with the understanding and enthusiasm to make a better print.

We'll discuss black-and-white enlarging and color printing jointly, topic by topic, since the principles involved are usually interrelated. However, for the sake of clarity, pages dealing exclusively with monochrome printing are indicated by a black triangle in the upper corner; color pages are indicated by a red triangle. This coding is maintained in both the table of contents and index.

Happy printing!

Don Nibbelink
Rex Anderson

Chapter 1

Why Enlargements?

The pioneer photographer, William Henry Jackson, once carried a mule load of 20″ × 24″ glass plates for his camera to Mesa Verde. He wanted to be sure that his prints, which were to be made by contact, would be large enough to convince audiences of the significance of the ancient cliff dwellings he had explored. Today, the same job could, of course, be accomplished more easily with a miniature camera taking pictures scarcely larger than a postage stamp. A major reason for this great advance is the development of modern fine-grained emulsions and the photographic enlarger.

The small print is by no means either dead or dying. It has a definite place in modern photography, such as in the fixed-ratio small enlargements of photofinishing, for proofing in commercial work, for documentary reproduction, and in industrial fields. However, for producing the great majority of pictorial and commercial prints, the enlargement reigns supreme. Studio portraits, photomurals, prints for newspaper and magazine reproductions, and many other types of photographs are made with an enlarger. Because details in small prints may become "lost" and fail to stand out, modern exhibition prints are also enlargements. Furthermore, from a perspective standpoint (and this is most interesting) enlargements usually appear more natural than contact prints because they place the viewer's eye closer to the center of perspective than is possible with a tiny print. Commercially, an enlarger is used to obtain a print of a given size, whether enlarged or reduced.

But we're sure you're convinced about the value of good enlargements. The point is you can probably make *better* ones than you have before. Let's see how to do it.

Chapter 2

Preprinting Considerations

If you wanted to build a new house, would you order a load of miscellaneous building materials to be delivered to your lot *before* you decided what kind of house you wanted or before you had completed a set of plans? Obviously not. But so many photographers do just that sort of thing when it comes to making an enlargement: they throw the negative into the enlarger and proceed with abandon to use up a package of paper to get "just the right effect." And even then, they are not sure if it is printed the way it ought to be. There is no question that amateur photographers are more guilty of this than their more cost-conscious professional cousins.

It's sensible, of course, to avoid this waste of time and materials. Photography is a wonderful way to express one's artistic thoughts; and when you make a print, it represents everything you have put into the entire conception and execution of the picture up to this point. If prints are worth making, they're worth making well. The procedure is very simple. *Make a proof print; study it carefully; then make the final enlargements.*

Just for fun, let's assume you have either a black-and-white or color negative from which you want to make an excellent enlargement—it can be a pictorial landscape with salon possibilities, a portrait of your best friend, or a commercial shot taken for a customer. Let's make a proof print from this negative and see what we can learn from analyzing it carefully. The actual method of proofing, naturally, varies with your preference. Some people can get along with a contact print of a 35mm negative and a magnifying glass; others use an 8″ × 10″ enlargement. Of course, the customary procedure with regard to color would be to examine the small fixed-ratio enlargements made by the commercial color printing lab and regard these as proof prints. Obviously, you can do the same thing with any black-and-white print made by a photofinishing plant. However,

speaking ideally, the size of the proof print should be the same size as the final enlargement you plan to make. It will then be of most help in deciding about the distribution of tones, contrast, color balance, compositional emphasis, and the like. But regardless of which size you prefer or are already using, the primary point is not to exclude this important "step of deliberation" from your plan of attack.

An old pro may glance with a practiced eye over a small proof and immediately proceed to make superb enlargements, but if you are relatively new at the game, the first step is to take the negative you've selected and make a "straight" enlargement as normal as possible in all respects.

The term "straight" is used to designate a print that has not been dodged, diffused, or altered in any manner; furthermore, the print should include the entire negative area. The paper used in making a black-and-white proof print is relatively unimportant so long as it is not glossy. We suggest you use Kodak Medalist J or Kodabromide paper N for black-and-white proofing. These particular surfaces are perhaps unexcelled for their ability to accept all types of retouching media, and they are physically hard enough to withstand erasures or alterations with pencil markings. If black-and-white glossy paper is all you have on hand at the moment, be sure not to ferrotype it, because you may want to mark it up with pencil lines, smudges, or chalk. With color we suggest you use an N surface paper.

After the proof print has been processed according to the manufacturer's recommendations for that particular paper, you are ready for the next step in the production of your masterpiece—the analysis. There are five questions you should consider after studying this proof print. These apply in general to both black-and-white and color printing; the special considerations for color printing will be discussed later. These questions are:

1. How should the picture be cropped?
2. Should the image be reversed?
3. Should any local areas be lighter or darker?
4. How large should the final print be?
5. What paper (a black-and-white consideration only) should be used for the final print?

Let's discuss these one at a time.

HOW SHOULD THE PICTURE BE CROPPED?

"Painting is dead from today on!" Paul Delaroche cried out when he saw his first "sun picture" more than 100 years ago. But, artists took hope again when they discovered that the trouble with the camera was that it saw too much. The composition of a picture is largely determined at the moment the film is exposed, and the camera is not at all selective. Ideally, the photographer should compose his picture so that the entire negative can always be included in the print area, but it never seems to work that way, does it? Consequently, in making the final print, you can frequently improve a picture by using only the most interesting portion of the negative. Through careful selection, you can eliminate an extra bit of foreground, for instance, or other superfluous areas or distracting features surrounding the center of interest. Look for a "picture within a picture." This elimination of unwanted parts from the total negative area is known as "cropping."

Probably the best way to determine how you should crop to advantage is to cut two L-shaped masks from lightweight cardboard or a discarded print. The size of the pieces should be adequate to mask the longest dimension of the proof print. If the proof measures 8″ × 10″, each L should be about ten inches long. An inch or two in width is sufficient but wider masks would be even better. Place the two masks on the prints so that they conform to the square or rectangular outside dimensions of the proof.

Print-making is, of course, both an art and a science. The science part is largely taken care of by the manufacturer. But, now, here is your chance to show artistic judgment. Fortunately, there is something of the artist in everyone, so let's be at it!

First, ask yourself, should the picture be horizontal or vertical? Could the composition be improved if a portion were eliminated from any of the four sides? Is there too much foreground? Does a towering expanse of sky overbalance the picture? Does the center of interest need to be moved to the right or left, or does it assume its proper place with relation to the entire picture area?

As you consider each of these factors, slide the mask about on the print to see if you can improve the composition. *Try every reasonable possibility.* Then try the unreasonable possibilities!

16

For instance, the sides of the mask don't always have to be kept parallel with the proof borders. Rotate the masks together, first one way then the other, until you find the most artistic position possible. Of course, you cannot tilt a strong horizontal line out of its exact horizontal plane, and trees and buildings cannot lean over and still appear normal, but often you can improve a head-and-shoulders portrait by tipping the subject forward or backward.

The purpose of this procedure is to determine the shape and size of the area of the negative to be used in making the final print. When you've done this, hold the mask firmly in place on the print and outline the selected area with a soft-lead pencil. Do not trim the print; you may change your mind tomorrow or next week about which area makes the best composition. Also, it is a good idea to retain this print in your files. If you wish to print that particular negative in the future, it will greatly facilitate matters if the proof is available as a guide for cropping.

Explore the full test print for "pictures within the picture."

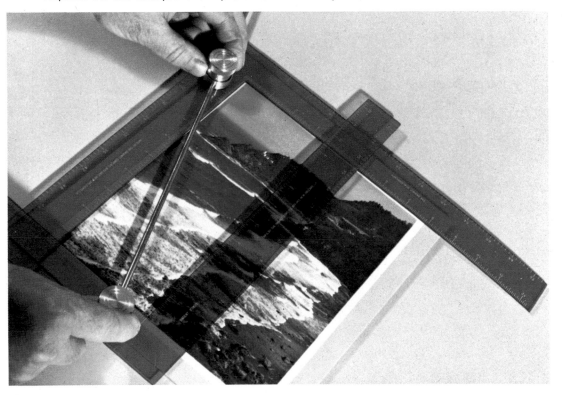

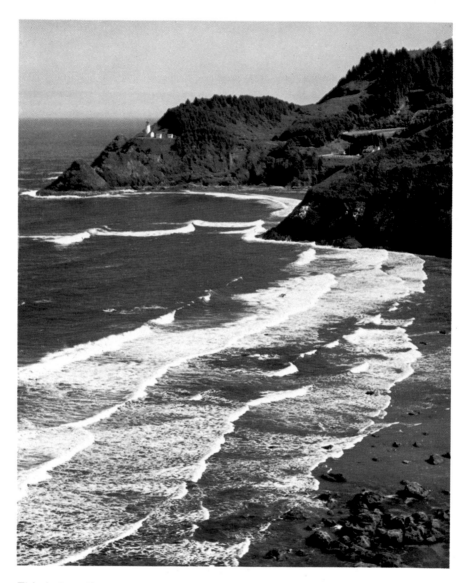

This is how the camera saw it. Did it see too much?

One version is shown opposite. Think of your intended use for the print when making your cropping decisions.

18

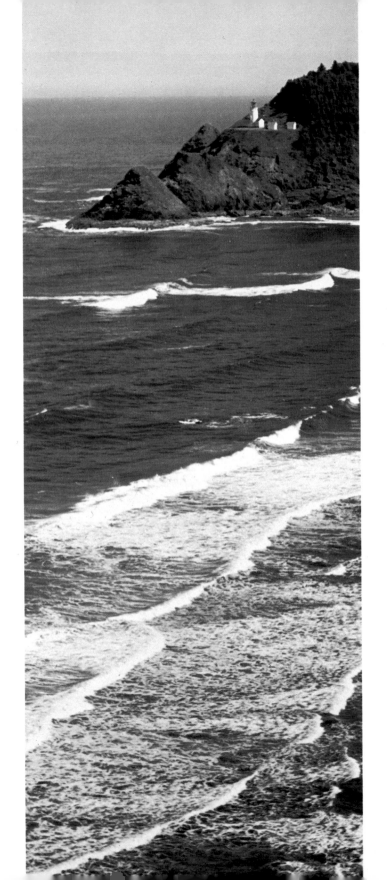

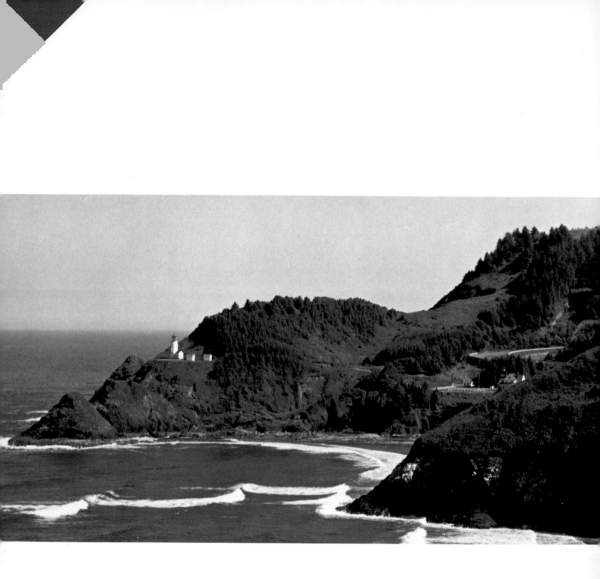

Here's another version. Who says all prints have to have an 8 × 10 format?

SHOULD THE IMAGE BE REVERSED?

When you made the proof print, the emulsion side of the negative was toward the enlarging paper. This means that everything in the print is oriented in the same manner as it was in the original scene. The snow-covered mountain peak that you saw at the left side of your direct camera viewfinder is still at the left side of the print; the little group of pine trees in the lower right-hand portion of the foreground is also found in the same relative position in the print. But would the composition be improved if you reversed things so that the trees were at the *left* and the mountains at the *right?* That is another matter for you to decide. Here, of course, truth of representation is discarded.

To see if reversal would improve the picture, simply hold the proof print with the image side toward a strong light source (an ordinary electric light bulb will serve) and examine it from the reverse side. You will see the image in reverse. Is the arrangement of the subject matter now more pleasing to you than before? If so, print it that way later. This procedure is rarely if ever applied in portraiture! The subject may object to having his hair parted on the "wrong" side or seeing his right ear where his left ought to be. Also, don't reverse your picture of the downtown business district. To say the least, signs would be backward and give the whole thing away!

Which way do the Presidents face? Obviously, you can't get away with reversing scenes including signs or even well-known subjects such as the Mount Rushmore memorial. However, you may want to consider reversing certain landscapes or still lifes to effect a compositional improvement.

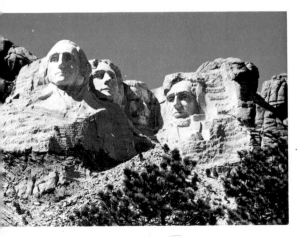 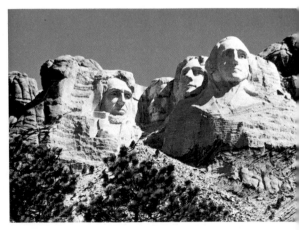

SHOULD THE PRINT BE DODGED?

Dodging the print, as the term indicates, is the method of *locally* lightening or darkening the tones in a picture. At this point in the analysis, ask yourself if any local area of the picture would be improved if it were slightly darker than it is in the proof. Suppose a cloud is nothing more than a white blob on the proof print, with no suggestion of contours or fleeciness. But you suspect that if just the cloud were allowed to print a little longer, with the rest of the picture remaining as is, the print would be greatly improved. To help you decide on this aesthetic effect, place the proof print on a flat surface and lightly shade in the cloud with a soft-lead pencil. Smear the graphite with your finger or a small tuft of cotton so that the deposit will be more even. Does that help the pictorial effect? Try it a bit darker. If you put on too much graphite, remove some with an Artgum eraser, and reblend the pencil lead for just the right effect.

Try the same technique on that three-quarter-length portrait you took recently—the one in which the hands compete with the face for interest because they are approximately the same tone. Pencil in those hands a bit darker and see if that doesn't subdue them to their proper degree.

You can improve many prints by darkening slightly the borders or peripheral areas. With a razor blade, scrape off enough lead from the end of a pencil to make a little pile of graphite dust. Pick up a small quantity on a tuft of cotton and gradually work it around with a circular motion on the corners and edges of the print. Is the unity of the composition improved? Does the eye have less tendency to wander out of the picture? Remember all these things when making the final print and try to give each portion of the paper the right amount of exposure to approximate the effects in the proof.

It is slightly more difficult to ascertain beforehand if you should print some shadow areas lighter and, if so, how much. Some workers find that white chalk, used in a manner similar to

An evenly illuminated subject? It would appear so from print opposite. But it took considerable holding back of the upper portion of the print so that it wouldn't be too dark. Also, the statue at the lower left received about three times the normal print exposure so that it wouldn't be excessively light.

that used with the graphite, is helpful. Others, however, simply make a mental note of those areas to be printed lighter and "hold back" some of the exposing light in making the final prints. Both techniques of dodging—that is, "printing in" and "holding back"—will be fully explained in a subsequent chapter.

Note that you can easily apply these same techniques to color print-making.

HOW LARGE SHOULD THE PRINT BE?

If you are making this print for a friend, for a Christmas greeting, or for your living-room wall, you doubtless have the size requirements well in mind. If you are concerned with salon or competition exhibitions, the matter may be a little more complicated.

Salon print sizes have followed a typical American trend—they've gotten bigger as well as better. Time was when 5″ × 7″ prints, for example, were frequently accepted by salons. But now even an 11″ × 14″ print is considered small for this purpose. In most salons, accepted prints are about equally divided between the 14″ × 17″ and the 16″ × 20″ sizes. Most salons require prints to be mounted on 16″ × 20″ boards.

Before going on, let's explain one point. In the language of the salon exhibitor, any print larger than 14″ × 17″, even though it measures somewhat less than an actual 16″ × 20″ in size, is called a 16″ × 20″ print. This is because the print was probably made on 16″ × 20″ paper to begin with. In the finishing process, the print borders or easel marks or any frilled edges may have been trimmed off. Perhaps the print was cropped somewhat on the trimmer so that the shape of the print would better fit a particular composition. Actually, you will find that very few full 16″ × 20″ prints are mounted flush with the edges of the conventional 16″ × 20″ mount board. In their travels about the country from one salon to another, full size 16″ × 20″ prints are likely to collect more than their share of bent corners through careless handling, compared with slightly smaller prints where the mount board alone takes the bruises. Since the large prints cannot be conveniently remounted, this also helps to shorten their exhibition life.

Suppose you were trying to decide what size to make your exhibition or competition prints. Here are some additional points you should consider:

1. The paper cost.

2. Salon prints are often accepted or rejected by the jury after only a few moments' consideration. After all, there may be hundreds upon hundreds of prints to consider and time is of the essence. Accordingly, *visual impact* is an important factor. And, in general, the larger the print size, the greater the impact.

3. Of all the prints submitted to a salon, a greater percent-

24

age of the 16″ × 20″ are accepted than of any other print size.

4. The more experienced and consistently successful exhibitors generally make their prints on 16″ × 20″ paper. It is the newcomer to an exhibition or competition who makes his prints on 11″ × 14″ or smaller paper. As soon as he learns the ropes, he graduates to the larger sizes.

Obviously, prolific salon exhibiting isn't easy on the pocketbook; and the trend toward larger prints doesn't help in that respect. The most dyed-in-the-wool exhibitors, however, would rather make fewer 16″ × 20″ prints with that extra edge of acceptability than a larger quantity of smaller prints that might not fare so well. You've probably heard these photographers say that enlarging is the acid test for a negative—that enlarging makes a good picture better and a poor picture worse. With 16″ × 20″ prints as the top limit, they may have a point at that!

There is another matter that may help you determine what size to make the finished print—perspective. This, the dictionary says, is the science of representing on a flat surface natural objects as they appear to the eye. So, for a moment, let's think of a photograph as a *perspective view;* furthermore, let's call the camera lens the *center of perspective.* Now, follow this reasoning:

1. If a photograph is to look most natural, its perspective should be correct.

2. The perspective is correct only if you look at the print the same way the camera lens viewed the original scene.

3. Thus, you should view a print at the center of perspective. *This is a distance from the print equal to the focal length of the camera lens times the degree of enlargement.* For example, for an 8″ × 10″ enlargement made from a 4″ × 5″ negative (2× enlargement) taken with a camera that had a 5″ lens, the best viewing distance would be ten inches. You can obtain the most natural perspective by viewing the contact print from the same negative at a distance of five inches; however, since the normal eye does not focus clearly at five inches, the small print is held farther away at a more comfortable viewing distance. Here, then, is the reason why enlargements generally appear more natural or realistic than contact prints; it is easier to view enlargements from their center of perspective.

How does this work from a practical standpoint in determining print size? Well, you've already seen from the preceding

paragraph why it would be better to show somebody an 8″ × 10″ print than a contact print or a small fixed-ratio enlargement if you knew the 4″ × 5″ print was going to be held at the normal reading distance of about 10 to 12 inches. Suppose you knew that a group of salon judges were going to sit six feet away from your print entry, or that prospective portrait customers were going to look at a print display case from a distance of about six feet. How large should the prints be for the most natural impression? If the camera lens had a 6″ focal length, then a 12× enlargement would place the center of perspective at 72 inches (six feet) where it should be. Of course, many other factors, such as available space to hang the picture or the intended purpose of the print, will also determine the actual print dimensions. However, this matter of viewing the print from the center of perspective is often overlooked when making the best possible print from any particular negative.

Just a minute. You're not convinced that the scene will look much more natural viewed from the center of perspective as compared from any old place, are you? Then make this test: first, look at a small print with both eyes at a comfortable viewing distance. Then look at the same print with a magnifying glass and notice how much more realistic the scene becomes—it almost seems to take on a three-dimensional quality. The reason is that the reading lens places your eye closer to the center of perspective and forces you to look at the print with only one eye, as the camera did.

The above statement probably causes you to wonder if pictures will appear more realistic if you view them with only one eye. Well, the answer is definitely yes! But, since no one is going to do this, we won't discuss the subject further. Let's take a look at the characteristics of printing paper.

SELECTING THE PAPER

Whatever the intended purpose of the final print, the paper used plays an important part in producing a picture of quality, beauty, and character. In your selection of the paper, you give the picture another creative touch and help to express your own artistic interpretations of the subject.

Many considerations enter into the selection of the printing paper. The intended use of the print will determine its size, the character of the negative will influence the printing grade of the black-and-white paper used, and personal preference will govern the tint of the paper stock and the texture and gloss of the paper surface. (In selecting color paper you do not have to be concerned about printing grades, only the selection of a surface. This is discussed elsewhere.) Let's look briefly at these characteristics.

Achieving *consistently* good print quality does not result from a will-o'-the-wisp chase from one paper to another—either from surface to surface or from manufacturer to manufacturer—but more from learning thoroughly the characteristics of one or, at most, a few papers. This advice may have whiskers on it, but it's nonetheless true.

The characteristics of a black-and-white paper include speed, contrast, image color, exposure latitude, development latitude, how it reacts to various toning baths, how much the surface "dries down," and other factors which may be less obvious but which also have an important bearing on print quality. As an example of the less obvious characteristics, when an exposed sheet of paper is placed in the developer, its image may either "come up" fast and then "level out," gradually building up density until the normal development time is completed, or its image may build up density in a more gradual fashion. Here is another item: Some papers, such as Kodak Medalist paper, increase contrast with increased development. This can be useful if your negative requires a different paper grade from the one you have. On the other hand, the contrast of a print made on Kodabromide paper does not change with development time. This latter characteristic meets the requirement of those photographers who like to have on hand a selection of papers of various printing grades and who wish uniform contrast regardless of development time.

27

Incidentally, some photographers prefer a particular grade of paper over another grade; it gives "better tones," they say. True, a particular grade may fit most of their negatives better than some other grade. But such photographers are doubtless prejudiced, since, *with negatives appropriate to the paper grade being used,* there is no difference in quality between prints made on No. 2, No. 3, or even high-contrast No. 4 grade paper. Of course, it is best to aim your negative contrast so that you usually print on a No. 2 or No. 3 grade paper. That way you will have some contrast latitude on either side of normal. When we say "to aim your negative contrast" we assume you would be doing your own negative processing; if, however, proofing is done at a commercial photofinishing establishment, normal-contrast results are usually received.

Needless to say, if you use No. 4 grade paper as an emergency procedure to salvage an underexposed negative, then small highlights may tend to "break out" of the first gray tone into blank paper. If, however, the negative is not underexposed and suffers only from low contrast, then No. 4 grade paper can give you a beautiful print.

Frankly speaking, stock tint, that is, the actual color or tint of the paper base, has so little influence on the image tone that it is scarcely worthy of mention. Furthermore, modern papers seem to be available only in white, warm-white, or cream-white. The "old-ivory" or "buff" tones of yesteryear that the oldtimers seemed to prefer for their heavily atmospheric landscapes or diffuse portraits have disappeared from the market.

Quite naturally, the term "image tone" refers to the color of the silver image. This varies from brownish through warm black to a fairly neutral black. It is controlled in large part by the manufacturer and is mainly a question of grain size, the smaller-grained images being the warmer-toned ones. To a certain extent, you can vary the image tone in smaller-grained materials by varying development times, shorter development resulting in warmer-toned images. However, the warmth of tone is essentially a matter of paper selection. Typical possibilities are Kodabromide paper, which has a neutral black tone, Kodak Medalist paper, which has a warm black tone, and Kodak Ektalure paper, which has a brownish-black tone. To a very small extent, also, you can vary the warmth of tone of the warm-black and brown-black papers by using a cold-tone developer (such as

Kodak Dektol developer) or a warm-tone developer (such as Kodak Selectol developer).

Paper stock, generally speaking, varies in thickness. The two most common types are designated as single weight (SW) and double weight (DW). For the most part, single-weight papers are used for small-sized prints—8″ × 10″ or smaller—whereas double-weight papers are preferred for greater enlargements for ease in processing and in print finishing. An exception would be Kodak mural paper, which has a tough, single-weight base to withstand the handling and folding necessary in making wall-sized enlargements. The thin base facilitates making splices as nearly invisible as possible when photo murals are made in several sections.

Special paper bases to note in passing: Papers such as Kodak Resisto, Resisto rapid, Polycontrast rapid RC, and Resisto rapid pan are made with a water-resistant base to provide good dimensional stability. This also shortens processing time since the base does not absorb water and chemical solutions to the same degree as ordinary paper.

Because it is worthwhile advice, we repeat it: choose one kind of paper and then stick with it until you are completely familiar with it, until it's as "comfortable as an old shoe."

Texture

Although each paper manufacturer's designations differ somewhat, surface textures can be grouped into the following general categories:

Smooth paper has no discernible surface texture to interfere with the reproduction of fine detail. This would include the glossy papers. Consequently, it is well suited for small prints and for the retention of negative detail.

Fine-grained paper has a slightly pebbled surface that adds distinctiveness but no appreciable loss of definition. It is useful for close-ups of young people and for architectural subjects. It is also a popular surface for exhibition and competition prints.

Rough paper has a definite surface texture that has a slight tendency to subdue fine detail and thus focus attention on the larger planes or areas of the picture. It is for this reason that rough-texture papers are used widely for making portrait proof prints (where the negative has yet to be retouched) and for photo murals (to help conceal the tendency toward graininess).

Tweed paper has a coarser-surfaced texture than "rough" paper and therefore gives more opportunity to emphasize the masses in the picture; landscapes and character studies, such as large portrait heads of older people, are typical applications.

Tapestry paper offers an extremely rough surface with a maximum subordination of detail. Its most effective use is in large prints.

Silk paper has a shiny, cloth-like surface that adds sparkle and distinction to high-key portraits, snow-covered landscapes, water scenes, and black-and-white wedding pictures.

Suede paper has a napped texture similar to suede leather. Its deep blacks are particularly suited to low-key pictures. The surface is extremely matte and useful for eliminating annoying light reflections from the print surface.

Paper Speed

The speed of photographic papers is normally less than that of films. It is determined primarily on the basis of the amount of exposure required to produce satisfactory shadow details. Enlarging papers are relatively higher in speed than contact-printing papers, but some moderately fast papers such as Kodak Ektalure paper can be used for both purposes. There is an American National Standards Institute (ANSI) paper-speed number system that indicates the relative speed of different papers. You can use these speed numbers, which are found in data sheets of papers supplied by photographic manufacturers, as a guide for estimating approximate exposures when you change from one kind of paper to another or from one contrast grade of paper to another. This subject is discussed for both black-and-white and color papers in the Reference Section, and examples are given. However, all the arithmetic—provided you are so inclined—may be more time-consuming than helpful. It may be more beneficial to make an actual "wet test" based upon your estimate; this will provide you with more accurate practical information on using a new material, and on its proper exposure relative to a previous material.

Surface Gloss

The sheen or gloss of the surface is somewhat related to its texture, of course, but the two should be differentiated in your mind. For example, a given fine-grained paper may have a matte

finish, while a fine-grained paper from another manufacturer may have a sheen to it that would alter its total surface characteristics. Surface sheen is a very important factor in the selection of a paper and for this reason it is worthy of a little extra discussion. In general, surfaces can be classified as glossy, lustre, and matte.

Glossy paper is favored for prints that are to be reproduced and for small prints in which fine detail is important. To increase the degree of gloss, this paper is usually dried on ferrotype plates that are either flat plates to which the prints are applied by hand with a roller, or continuous ferrotyping drums such as used in photofinishing establishments.

Lustre paper has a subdued gloss and is the all-purpose choice for general exhibition and portrait work.

Matte paper has a very dull surface and is frequently the choice for high-key pictures and atmospheric shots.

Surface gloss affects prints in two ways. First, you can control the range of tones in the prints. The higher the gloss, the higher the density a particular paper can produce. Zero density—that of white paper—is practically the same for all papers, and the range of tone from light to dark is therefore dependent on the maximum density or, to put it simply, on the "blackest black." A long range of available tones is highly desirable because most negatives, being transparencies, have a greater range of tones than can be reproduced in the paper print, which is viewed by reflected light. The more accurately a paper can reproduce the range or density scale of the negative, the more realistic the result will be. To put this all another way: A normal, sunlit, outdoor scene has a tremendous range of tones from highlight to deepest shadow; the negative can capture this tonal range with a fair degree of accuracy because it is a transparency. However, when transmitted to a paper print, which is viewed only by reflected light, this tonal range has to be compressed considerably and it is usually the shadow details that suffer.

From a practical standpoint, therefore, it is most desirable to use a glossy or high-lustre paper for subjects that have a long tonal range and include important shadow details. These subjects are typified by low-key portraits, night scenes, or any scenes which contain fairly dark shadows having relatively significant subject detail. High-key subjects or fog scenes generally have most of their important details encompassed by a

relatively short tonal scale, which can be satisfactorily reproduced by a short-scale, matte paper.

The other way surface gloss affects prints is this: When removed from the wash water, matte papers tend to "dry down" and lose more of their apparent (wet) tonal range than do glossy papers. However, you can select a matte-textured paper best suited to a particular subject, and then give the print a high gloss later by means of a print lacquer, a subject we'll take up later.

Printing Grades

Many papers, such as Kodabromide paper, are supplied in several printing grades to fit negatives that vary in density scale due to differences in subject lighting, exposure, or degree of development. Other papers, such as Kodak Ektalure paper, are intended for use with negatives of uniform quality made under carefully controlled conditions, such as the day-to-day output of a portrait studio; for this reason, they are supplied in only one printing grade. Choosing the right grade for a particular negative is somewhat of a trial-and-error procedure, although the selection is usually not difficult. If you are in doubt, start by making a print on paper grade No. 2, which is intended to yield a print of normal contrast from a normal negative. If you have a

Printed on normal-contrast paper. When viewed in comparison with the "soft" and "hard" prints, it's easy to see that this normal print is the best one. However, if you cover up any two, the remaining print appears to be satisfactory. This contrast latitude is due to the non-critical nature of the subject itself.

"soot-and-whitewash" effect, with few middle tones, try grade No. 1. If the result is "flat" or "muddy" try grade No. 3.

As hinted at previously, the contrast of a particular paper can be changed only slightly—Kodabromide paper scarcely at all. A warm-toned paper such as Kodak Ektalure can be changed somewhat more, especially through the use of a soft-contrast developer and, also, by varying the length of the print development time. However, you should become thoroughly familiar with variable-contrast papers, which are designed so that contrast can be varied by using suitable filters. These may be placed over the enlarger lens or above the condenser system, the latter placement being the preferred one.

The contrast range available with variable-contrast papers is equal to about four contrast grades of ordinary paper; that is, from grade No. 1 to grade No. 4. An additional advantage with these papers is that you can "split" the degree of contrast halfway between the normal contrast spacings. In other words, seven degrees of contrast in half-grade steps are available when the appropriate filters are used with a paper such as Kodak Polycontrast or Polycontrast rapid paper.

While we're on the subject, note that the contrast-control filters are available in two forms—gelatin, which are for use in

Printed on low-contrast paper. Printed on high-contrast paper.

Left: Printed on low-contrast paper.
Below: Printed on high-contrast paper.

Printed on normal-contrast paper. Because this is a critical, or sensitive, subject, it has a very limited contrast latitude and only the normal-contrast print is acceptable.

front of the enlarger lens, and acetate (which are sold in larger sheets up to 11" × 14"), for use over the enlarger condensers. (Of course, the enlarger must have a filter slot in the proper position.) The acetate filters should not be used in front of the enlarger lens because they might possibly distort the projected image. Also worthy of note is that some papers, such as Kodak Portralure paper, though not classified as a true variable-contrast paper, can achieve limited contrast variability through the use of Kodak Polycontrast filters.

SELECTING COLOR PAPER

Kodak Ektacolor 37 RC paper is available in only one grade of normal contrast, and it will accommodate the great majority of your color negatives. Why is this so, you might ask, when black-and-white papers are available in such a wide range of contrasts? It's because:

1. Color negatives, by and large, are carefully processed by machines governed by automatic replenishing systems for very accurate sensitometric control. Consequently, the development contrast is uniformly normal and most negatives can be printed on a normal grade of paper. Conversely, black-and-white negatives are more apt to be influenced by varying processing conditions.

2. The type of enlarger illumination (diffuse vs. condenser) has virtually no influence on the print contrast in color printing; in black-and-white printing the contrast difference can be as much as one full paper grade.

3. In addition, a psychological factor seems to be involved, in that an observer is simply more tolerant of high or low print contrast in a color print than he is of a comparable degree of abnormal contrast in a black-and-white print.

There is, however, a way of controlling color-print contrast; it is discussed in Chapter 14, Color-Print Contrast Control.

Color Print Surfaces

Kodak Ektacolor 37 RC paper is available in the following surfaces:

F surface, smooth glossy, is usually selected for prints that are intended for photomechanical reproduction because of max-

imum retention of subject detail. Incidentally, there is no need to ferrotype this paper, since it is already very glossy. If the F surface of black-and-white papers benefits by ferrotyping, why not the F surface of color paper? The reason is that the emulsion coating of a black-and-white paper follows the minute surface irregularities of the paper base; this emulsion surface is flattened out by the ferrotyping process. On the other hand, the Kodak Ektacolor 37 RC paper emulsion is coated on a resin-coated paper base. This subcoating is already very smooth, and since the emulsion assumes the characteristics of its support, the paper needs no ferrotyping. If you try it, the paper will stick!

N surface is slightly pebbled; it is a general-purpose surface for portraits, landscapes, album prints, exhibition prints, and so on. This is by far the most popular color-print surface.

Y Surface is silk-textured for a slightly unusual surface effect. This surface is often used for wedding and school pictures. It is somewhat helpful in minimizing grain patterns in extreme enlargements.

Note that the surface appearance of color prints can be somewhat altered by a post-finishing procedure—spraying the prints with one of a number of lacquers made expressly for this purpose. In fact, a variety of surface effects, from matte to glossy, can be achieved by varying the type of lacquer and its dilution.

Chapter 3

Further Preprinting Considerations

Let's face it: good enlargements are the result of carefully following simple, straightforward directions, plus a liberal portion of photographic horse sense. So here is a section dealing with elementary instructions for enlarging in both black-and-white and color. Yet, you should not pass it by as "elementary stuff." Perhaps you've already made good enlargements. Then why not consider this chapter as a helpful review? Even a concert pianist has scales and exercises to play, and a professor occasionally has to review the fundamentals of his field to retain full command of his subject. It's the same with photography.

CLEANING THE NEGATIVE

Before you make any print, you should clean the negative. This means removing any dust, dirt, greasy fingerprints, and so on, since these deposits will print as though they were part of the negative image and will show up as spots on the print. The smaller the negative, obviously, the greater the degree of magnification, and the more important it is to keep the negative dust-free. Also, remember that condenser-type enlargers—the type that you probably will be using—show negative defects more readily than do diffusion enlargers.

If your negatives have been treated with care ever since they were made, and stored in a suitable negative file, it may be sufficient to merely dust them off with a soft brush. For quantity professional work an anti-static brush is a good investment. Other "less fortunate" negatives may have surface streaks or dirt that seem to be embedded in the emulsion. It is quite important to remove these particles, if possible, since they may scratch the emulsion if the negative is used in a "glass-sandwich" type of

negative carrier. In this instance—and let's hope it's a rare one—it may be best to rewash the negative for about 15 minutes and then carefully swab its surfaces with a piece of dry cotton. Immersing the negative in Kodak Photo-Flo solution prior to drying will help prevent the formation of water spots.

You can best remove fingerprints and other surface deposits with a grease solvent, such as Kodak film cleaner. Carbon tetrachloride was often recommended as a cleaner in the past. Although it is an excellent grease and oil solvent, it is considered dangerous to use since the vapors are toxic. Film cleaners are usually volatile solvents that produce harmful vapors and should only be used with adequate ventilation. Avoid breathing the vapor and prolonged or repeated contact with the skin. Don't use too much cleaner, avoid "scrubbing" the film, and use the cleaner quickly so that pools of liquid do not form or stand on the film surface.

One more suggestion: The use of solvent-type cleaners often creates enough static electricity to attract dust particles to the film. This is not serious, particularly if you use a lintless applicator or one of the static-repelling brushes, but it does mean you should check the negative for dust particles just before placing it in the enlarger.

Scratches in the negative are serious, however. Although there is no remedy that is completely satisfactory, you can fill the scratch with a light application of Vaseline or glycerin or one of the commercial scratch-repair preparations available in camera stores. These are helpful in lessening the "printing effective-ness" of the scratch. Professional photographers note: There is available for some professional enlargers a "wet-cell" type of negative carrier that can be filled with a silicone, or other liquid solution, which has approximately the same index of refraction as the emulsion of the negative. The negative is printed while immersed in this solution and this technique does a remarkable job of eliminating the printing effect of serious scratches or digs in a negative.

MASKING THE NEGATIVE

After you have cleaned the negative of grease marks and brushed it free of dust particles, place it with its emulsion side down in the enlarger negative carrier. The emulsion side of black-and-white negatives is the duller surface. The emulsion side of any sheet film is toward you when the code notches are in the upper edge of the top right-hand corner of the film. The emulsion side of color roll films is toward you when the arrows are on the top edge of the film and pointing to the right.

The next step is important and you should not omit it. Cut a mask from a piece of black paper so that only that part of the negative that you intend to include in the print will be projected. Some enlargers have built-in adjustable masks, but if yours does not, keep the individual masks you make and it won't be long until you have a collection that will accommodate most masking requirements.

The purpose of this mask is to prevent any "stray" light from being projected down to the easel area, where it could possibly degrade the quality of the print by bouncing around and being reflected by various surfaces onto the sensitive paper. "I never bothered with making a mask, and my prints aren't degraded," a well-meaning friend may tell you. Well, perhaps he doesn't realize that masking will make a subtle improvement in overall print quality. It is most important to use a mask where the negative is smaller than the minimum size the enlarger was designed for—say, printing a $2^{1}/_{4}'' \times 3^{1}/_{4}''$ negative in a $4'' \times 5''$ enlarger. The white light that escapes past the edges of the negatives can create a flare light condition in the enlarger lens. Also, in passing the edges of the negative, some of the light is bent or refracted directly into the printing area. You can test this yourself by cutting a sheet of black paper the size of your negative, placing it in the "oversize" carrier, and turning on the enlarger light. You can easily see that the printing area is receiving some of this unwanted, "bent-and-splashed" fogging light.

It is also important to mask down the negative to the desired area if (a) the negative is abnormally dense or (b) the exposure time is abnormally long because of slow-speed enlarging paper and a relatively large degree of magnification. The scattering light exposure has a cumulative effect with print exposure times

40

of more than a minute, and when added to the normal print exposure this can have a degrading influence, particularly on the print highlights.

Are you now convinced that masking is worthwhile?

Remember, give the negative carrier a final check just before placing it in the enlarger to be sure that no dust particles have settled on either the negative or the glass of the carrier, if you are using this type of negative holder.

COMPOSING ON THE EASEL

After adjusting the easel to the desired print size, insert a blank piece of white paper—the reverse side of an old print will do just fine—on which the projected image can be focused and composed. Switch from normal room light to safelight illumination, and turn on the enlarger. Next, raise or lower the enlarger lamphouse to make the image area on the easel correspond exactly with your cropping of the proof print. Tighten the vertical lamphouse adjustment if necessary; make sure the lens diaphragm is set at its *widest* opening, and bring the image into focus. If necessary, you can make focusing easier by turning off the safelight.

This is a very critical time in the making of your print; let's think for a moment about composing the image within the size format you have selected. Now is the time to review the thoughts you had in cropping the proof print. Or, if you skipped the proof-print step entirely, it is even more important to know how you want your print to look before you proceed further.

Contrary to popular opinion, the composition or arrangement of objects within a print is not completely and irrevocably fixed when the film is exposed in the camera. Far from it; many things can change a picture's "face" in the darkroom. Probably most important is the elimination of distracting, irrelevant, or unnecessary details; in other words, using only the best "story-telling" portion of the negative to make the print. To do this, perhaps you should rotate the easel clockwise or counter-clockwise to improve subject emphasis. Maybe the final print would make a better horizontal composition than the vertical picture you had planned originally. All of these things and many more discussed in the following chapters can alter the composi-

tion of the picture. Of course, photographers, unlike other artists, aren't expected to be able to move trees at will; nevertheless, questions of the type that follow should be seriously considered before each different print is made.

Assume for the moment that your picture is a landscape. Just how much prominence should be given to a figure in a landscape? How large should it be in relation to the size of the print? Where should it be placed in relation to the print borders? Where should the horizon line be positioned? If these problems trouble you, you may find the following idea helpful.

On the back of the discarded print that you are using to view the projected image, draw in the rectangular outline of the print area. (See Chapter 8 for determining rectangular print shapes of pleasing proportions.) The easiest way to do this is to run a pencil around the inside edge of the easel masking arms. Next, using a ruler to aid you, draw in diagonal lines across the rectangle from each of the opposite corners.

Using these diagonals as base lines, construct a perpendicular line to each of the opposite corners.

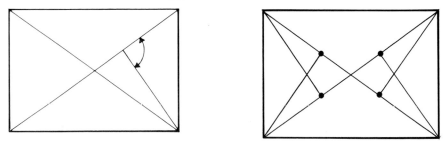

At the intersection of the diagonals and the perpendicular lines, you have now located focus points in the picture area that may be used as "interest points"—that is, places where the center of interest may be located. Since these interest points are important, darken them heavily or circle them.

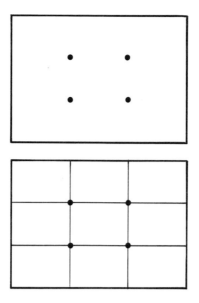

To complete the compositional guide, draw parallel lines from opposite borders through the four points. Each line will be about ¹/₃ the distance to the nearest edge of the rectangle and will serve as "horizon location lines."

Now let's put this guide to work. Place it in the easel and turn on the enlarger. The general rules to follow are these: Move the easel about on the baseboard, and raise or lower the enlarger head until:

1. The primary and secondary centers of interest are located as near as possible to any of the appropriate "interest center points of the scene."

2. No print detail of *major* importance to the composition is positioned outside of an imaginary boundary line formed by the four interest points.

3. The horizon is located at or near one of the lines drawn through the interest points. This obviously gives you the choice of placing the sky either in the vertical or horizontal picture.

4. Strong vertical or horizontal lines of importance to the composition are located at or near one of the four "horizon" lines.

This system works equally well with portraits, landscapes, or other subjects. For example, if your print is to be a ³/₄-length portrait in the vertical format, you will probably want to

position the face at one of the top interest points. A subordinate center of interest, such as the hands, will then be as near as possible to either one of the two lower points. In a landscape, a lone tree on the horizon may be located on one of the vertical "horizon placement lines," while a figure in the foreground could probably be aesthetically located at one of the lower points. Horizon lines are generally in a pleasing position if located by this guide system. All in all, this is simply a time-proven system for avoiding basic compositional errors, such as placing the horizon exactly through the center of the picture or having the primary center of interest located exactly in the middle of the print.

No one, however, wants to walk with a crutch. A guide such as this should be used at first to avoid stumbling awkwardly, from a compositional standpoint. A feeling for tasteful arrangement is something that can be cultivated and developed. So, don't limit your picture-making to the narrow confines of rules; break them now and then. Dare to make a different picture—dare to be yourself.

When composing the projected image on the enlarger easel, consider the suggested arrangement of the subject elements according to this time-tested compositional guide.

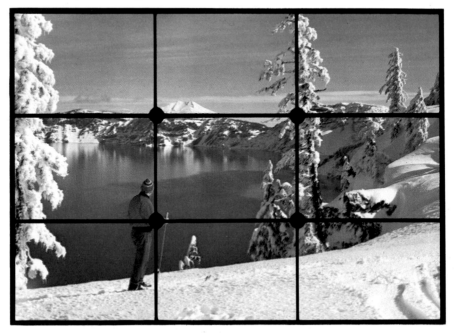

TILTING THE EASEL

Did you ever take a picture of a building in which the building appears to be leaning over backward? This distortion, most commonly seen in architectural pictures, is caused by a convergence of lines that are parallel in the original subject. Such results are inevitable when the film in the camera is not parallel with the front surface of the building. To counteract this, professional view cameras are equipped with rising and falling fronts and swinging and tilting backs, which permit the necessary parallelism. But, you can correct pictures taken with the less-flexible reflex or miniature cameras by tilting the easel when you make the enlargement. Thus, if you aimed your camera upward a few degrees from horizontal to include the spire on the steeple of a picturesque New England church, you must tilt the easel the same amount in the *opposite* direction to compensate for the convergence in your negative.

Actually, it is incorrect to say that the distortion was induced by tilting the camera or that the distortion is eliminated by tilting the easel. More properly, these are matters of altering perspective. Tilting the easel really introduces a new form of distortion by elongating the image. However, the elongation is usually the lesser of the two evils and the results generally warrant the slight "stretching" of the subject.

This stretching of the print subject has an interesting practical application that many photographers often overlook. For example, in portraiture, it is easy to widen a too-narrow face by tilting the easel up from one side. Similarly, you can make a round face narrower by tilting the easel from the top or the bottom. True, in many cases the portrait subject himself may object to having his features distorted. However, a *little* distortion may be flattering and the subject may not even notice. Certainly, few short people would object to appearing slightly taller, or stout people slightly thinner.

For an even more practical example, suppose that you are printing a ³/₄-length portrait from a negative in which the hands in the subject's lap are unduly prominent because they were located closer to the camera than was his face. This undesirable prominence is emphasized more with shorter focal-length lenses than with longer ones. (Note that the change in perspective is not due to the focal length of the lens but to the closer viewpoint

45

required by the shorter focal-length lenses. As an interesting aside, the ideal portrait lens should, as a rule of thumb, be approximately twice the diagonal of the negative rather than equal to it, to help prevent this problem.) In printing this negative, tilt the easel so that the bottom part of the picture is brought closer to the enlarger lens. Because the hands at the bottom part of the picture are now *nearer* the lens than the subject's head and shoulders—that is, the image of the hands will be projected over a lesser distance—the hands will be made somewhat *smaller* in proportion to the rest of the subject. Thus, your problem may be alleviated.

When you tip the easel from its normal horizontal position, naturally you must refocus the enlarger. The added difficulty here is that because the easel is off the level position, the enlarger lens must focus on more than one plane—it must focus on both the near and far edges of the paper. Some enlargers have a built-in control, such as a tilting negative carrier or a tilting lens board, which greatly facilitates this problem of trying to cover a great depth of field. For enlargers without this convenience, it is best to focus on a spot in the projected image approximately ⅓ the distance from the top of the easel, as shown in the accompanying diagram. Focus the image with the enlarger lens wide open, and then stop it down until all parts of the image are critically sharp. Usually this means that the lens will have to be stopped down as far as possible.

There are, of course, practical limits to tilting the easel. They must be determined by the particular picture and your good judgment. Do not expect this technique to perform the miracle of changing a fat person into a thin one. Rather, it is a technique for producing *subtle* improvements and you should consider using it before you make any prints.

Fixed easel but tilted enlarger. The lens is tilted to make the image plane uniformly sharp even with a large lens aperture.

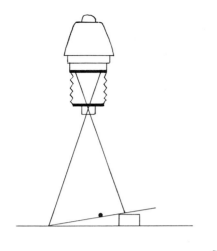

Fixed negative and lens but tilted easel. In this case the depth of field is quite shallow and the lens must be well stopped down.

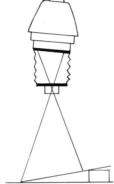

Tilted negative and tilted easel. Sharpness over the image area is provided by tilting the negative in the indicated direction.

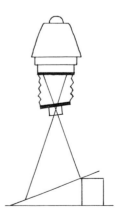

Fixed negative but tilted lens and easel. Notice that this condition is similar to that shown opposite except that the enlarger is upright.

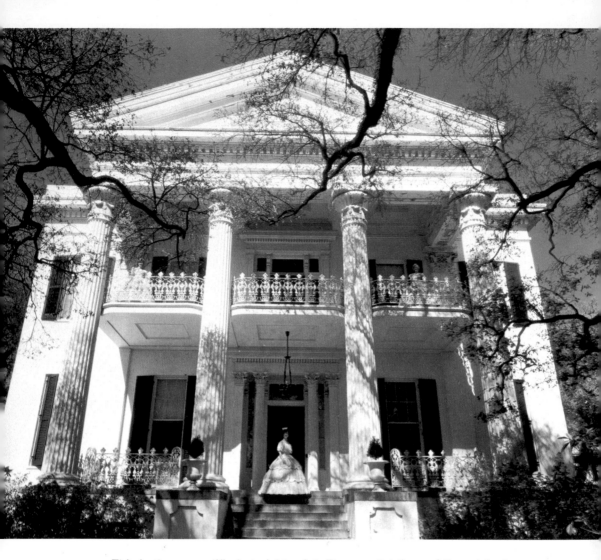

This is the unmodified straight print. The parallel lines of the original scene tend to converge because the camera was tilted upward. This perspective distortion is often noticeable when you use a wide-angle lens.

In the print on the opposite page, the convergence has been partially corrected by tipping the enlarger easel so that the foreground portion of the image was closer to the enlarger lens than the top of the picture. However, note that the house has been elongated vertically.

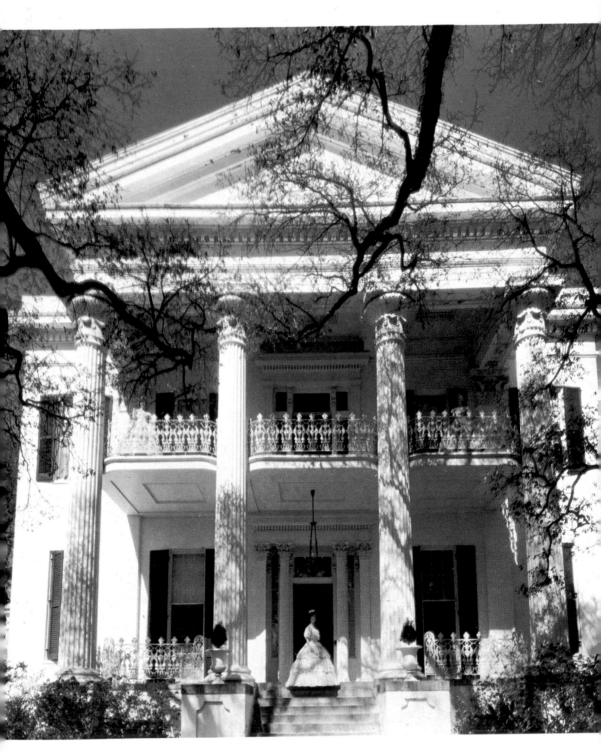

If this is your house, we've gone too far. If it isn't your house, you may like the completely corrected convergence. The important thing is to realize this degree of control is available in every enlargement you make.

FOCUSING THE IMAGE

As a final preparation before exposing the print, check to be sure that the projected image is as sharp as it possibly can be. For best visibility, focus with the lens at its maximum aperture, then stop down it down approximately two stops (this should put you at about $f/8$) for a normal enlarging time.

Is there any difference in image sharpness when using the enlarger lens wide open or stopped down? Sharper enlarge-

50

ments generally result with the lens stopped down. Of course, it depends on the lens in question. Some, such as the Kodak enlarging Ektar lens, have a flat field since they were designed for this purpose and are sharp even at their maximum aperture. Other lenses have a curved field—a camera lens used as an enlarger lens is an example of this type—and are best used stopped down.

If you're trying to print a dense negative on a slow paper at a high magnification and find it necessary to use the enlarger lens at its widest aperture, try to focus on a point about ¼ the distance from the center of the projected image to the corners. The exception to this would be in the case of portraiture, where you should be focusing on the catch-light of the eyes as the most important spot. In general, however, focusing off center this way will make for better overall image sharpness than by focusing in the exact center of the image (in which the corners may be slightly out of focus) or at the corners of the easel (in which the center may be slightly out of focus). But to eliminate as much lens aberration as possible, regardless of the lens used, remember to stop down if circumstances permit.

The bluish fluorescent light in a cold-light enlarger is visually weak, and you may have some difficulty in focusing fairly dense* negatives, such as heavily exposed high-key pictures, at a relatively large degree of magnification. In this case, you have two alternatives. The first, and most convenient, is to use one of the optical focusing accessories that has a magnifier. These are usually available at camera stores and are useful accessories for a cold-light enlarger. The second method might well be called "focusing by substitution." With the enlarger lamphouse firmly in place, remove the dense negative and replace it with a discarded negative that you have intentionally scratched. It will be an easy matter to focus on these marks and then reposition the negative you wish to print.

*Of course, you will make enlarging much easier and your prints much better if you avoid overexposure of your negatives, color or black-and-white. Besides increasing the printing time, overexposure adversely affects negative quality. It also increases grain size and thus decreases print sharpness.

Chapter 4

Exposing and Processing

The exposure latitude of photographic papers is really quite small—regard it as being comparable to the exposure latitude of a color transparency. In fact, it might be best in the interest of superb print quality to regard the exposure latitude as having zero tolerance and proceed accordingly! Consequently, determining the print exposure is of particular importance because it is one of the primary factors influencing the technical quality of the print. If the paper is appreciably overexposed or underexposed, you will have to discard it and make a new print. To be sure, you can compensate for minor errors more or less by development. This can, however, depend on the type of print paper you use: Kodak Medalist paper, for example, has a fairly wide development latitude that is often useful when exposures vary from the norm. Nonetheless, it is clearly better to expose the paper as accurately as possible.

TEST STRIPS

Guessing at the exposure when printing a new negative is hardly ever correct, even for experienced workers, so try to avoid that understandable impulse to put a full-sized sheet of paper in the easel the first time. It can soon become an expensive habit. One easy and economical method of determining the correct exposure time is with test strips.

With a pair of scissors or a trimmer, cut a full sheet of paper into four equal strips. Replace three of them in the paper box and put the remaining one emulsion-side up on the easel where an important part of the image will be projected. If the picture is a portrait, this will be the face; if it is a landscape, try to include a portion of both the sky and the foreground. Now cover up 4/5 of this strip with an opaque black paper and switch on the enlarger light. Keep close check on the time with a watch that has a sweep

Exposure controls print density with very little latitude for most print subjects. This test-strip method of exposure determination can be used in either black-and-white or color.

Processing must be very consistent from batch to batch or your test-strip exposure determination may not be valid.

second hand, or with an audible timer. After 32 seconds, quickly move the black paper so that it covers $3/5$ of the test strip. Be careful not to change the position of the strip. In this position, expose the test strip for the next 16 seconds. Now, cover $2/5$ of the strip and expose for 8 seconds, then cover $1/5$ of the strip and expose for 4 seconds. Finally, remove the black covering paper entirely and expose the whole strip for another 4 seconds. Switch off the enlarger light.

Now let's take a breath and see what you have: You gave the small test print a staggered series of five exposures for 32, 16, 8, 4, and 4 seconds. Reversing the order, then, these five sections received 4, 8, 16, 32, and 64 seconds of exposure. In other words, each section received twice as much light as the one exposed immediately after it. Develop this test strip exactly according to the instructions packaged with the paper. You now have—if the negative was anywhere near normal—a suitable range of print densities from which to choose the correct exposure for a full-size sheet of paper. Which of the five sections seems neither too dark nor too light? If you think that the one that received the 8-second exposure is normal, the next obvious step is to try exposing a full-size sheet of paper for 8 seconds. If the exact exposure seems to be between 8 and 16 seconds, for example, try exposing a full sheet for 12 seconds; there is no real need for a second test strip with a 12-second exposure since there is some development latitude which you can use to adjust print density in case of *small* exposure errors. It is often helpful in selecting the print exposure time to compare the processed test strip with one or two full-size prints, even if they were made from different negatives.

In addition to determining exposure, the test strip should also give you a clue as to the correctness of print contrast. Here again, comparing the test strip with finished prints of similar subjects of normal contrast and density will be helpful.

A streamlined method of making a test strip to determine the correct exposure time for any enlargement utilizes a Kodak projection print scale. The procedure is quick and simple:

1. Place the negative in the enlarger and focus sharply.
2. Turn off the printing light.
3. Place a small piece of enlarging paper on the easel.
4. Lay the scale (shiny side up) on the paper and locate it over the place where the center of interest will be projected. This

With the Kodak Projection Print scale placed on top of the paper, an exposure of 60 seconds was given.

The final print was then exposed at the number of seconds indicated in the sector with the best exposure.

would be the center of a face if it were a portrait.

5. Expose the paper for 60 seconds and develop it as recommended by the manufacturer.

6. Inspect the image and select the best appearing sector. The correct printing time *in seconds* will be found in the rim of that sector.

7. Without disturbing the enlarger, expose a full-size sheet of the same kind of paper for the indicated time and develop it in the same manner as the test print.

Another print-exposure-determination technique is to use a densitometer to measure negative densities or an easel photometer to measure the projected image brightness. You can also use these devices as a general guide for predicting the desirable grade of paper contrast.

PHOTOMETERS

Easel photometers are easy-to-use, time-saving, and not-too-expensive devices to measure the intensity of the projected image at the easel. They can be used to select both the proper print exposure and paper contrast. Here is how they work.

First, through trial and error, establish the correct printing time for any typical negative. Next, use the photometer probe to measure the intensity of that projected negative image. The forehead of a portrait would be an ideal place to measure. Now, replace the old negative with a new one you wish to print. Turn on the enlarger and adjust the lens aperture until the probe shows that the light intensity for the new negative is the same as that for the negative that was printed previously. The new negative will now print correctly at the same exposure time as the old one. It is just that simple and without any calculations! The system works well because the measurements are made under conditions that are directly related to actual printing conditions.

To use a photometer to determine the proper black-and-white paper contrast, you must measure the density range of the projected image. This means measuring the image in two areas, the lightest or "thinnest" portion of the negative in which you desire to retain shadow detail, and the darkest or heaviest

portion of the negative in which you desire to preserve highlight detail. The difference between these two measured values is known as the density range. Select the grade of paper according to the following table:

Measured Density Range	Paper Grade
0.60 or less	5
0.60 to 0.80	4
0.80 to 1.00	3
1.00 to 1.20	2
1.20 to 1.40	1
1.40 or greater	0

One moderately priced on-easel photometer is the Spiratone Enlarging Meter Computer. This unit employs a solid-state photocell with adequate sensitivity for all usual printing purposes. It is an excellent aid in predicting exposures so that gross errors are minimized; you can make a spot reading or an overall integrated reading, the latter with a supplied diffusion disc attached to the enlarger lens. This instrument can also be used to calculate the desired dodging time, for either holding back or printing in.

Some photometers are made specifically for use as aids in color printing. These photometers can be "programmed" so that red, green, and blue readings made from a correctly printed color negative are "remembered" by the instrument. Then, corresponding three-color readings are made of the new negative. These readings are translated into filter-pack adjustments so that the new negative will print as well as the old one. In addition to programming color-balance information on such easel photometers, it is also possible to program the exposure information as well.

DENSITOMETERS

These devices, as the name indicates, directly measure negative densities and also can be used to determine exposure, contrast, and, for color printing, color-balance information. As with photometers, all this information becomes useful only when correlated with data obtained from previously successful trial-and-error printing.

Let's suppose you have a series of differently exposed portrait negatives to print, and the object is to print them all correctly without wasting a single sheet of paper. Here is what to do. Measure the density of the highest diffuse forehead highlights for all the negatives and make a note of these values. By trial and error, make a excellent print from any one of these negatives. Then find the density difference between the printed and the unprinted negatives. An easy way to convert the density differences to actual exposure time differences is to use the circular "Color Printing Computer" (found in the Kodak Color Dataguide, Kodak Publication R-19). This computer has rotating dials that allow you to determine a new exposure from a density difference in terms of either a new printing time or a new lens aperture, or a combination of both.

You'll find that the instructions refer to the red density readings of color negatives, but the method works as well for black-and-white density readings. In addition, the time dial of the computer includes an expanded scale for correcting reciprocity effects of color-printing materials. This correction factor has no practical effect when the customary black-and-white enlarging papers are used.

Densitometers have become less popular for color printing since the advent of easy-to-use photometers. Although it is possible to obtain accurate printing information with densitometers, the procedure is time-consuming. You must read the red, green, and blue densities of the negative to be printed and mathematically utilize the corresponding values from a previously printed negative to convert this information into a new filter pack. A further discussion of this procedure is found in the Kodak data book No. E-66, *Printing Color Negatives.*

These measurement systems have their most practical application in large portrait studios where the photographer turns out negatives of consistently high quality and is willing to exercise close control over his equipment and processing conditions. For example, when the photographer works with portrait negatives exclusively, he uses diffuse highlight or flesh-tone readings with a high degree of exposure predictability. As with all other measurement systems, new control tests must be made for each type of paper used and, preferably, for each different emulsion number of a particular kind of paper. This would even include "reprogramming" sophisticated electronic negative-measuring

equipment like the Kodak video color negative analyzer.

But here is an important consideration. *The most precise way of "predicting" the proper exposure and contrast grade is, nonetheless, to make a number of prints, varying the exposure, and, if necessary, the contrast grade and then selecting the best print by careful comparison under proper illumination.* Be sure to view the prints in sufficiently bright light when making your selection. And, it is better to make this appraisal if the prints are dry. If you don't want to wait until the prints are "bone dry," at least wipe off the surface water before the evaluation.

For enlargements, the ideal exposure time should fall between 8 and 25 seconds. (In a production setup, an operator would argue in favor of a shorter time, no doubt.) Exposures shorter than 8 seconds make dodging difficult, and repeatability of the exposure time for subsequent duplicate prints becomes almost impossible, unless print exposure is controlled by an electric timer. Exposures longer than 25 seconds make exposing a tedious chore, particularly if considerable dodging is required. To keep the average exposures at a convenient working level, you may find that you should increase or decrease the aperture of the enlarging lens, depending on the negative density, the speed of the printing paper, and the wattage of the enlarger lamp. However, if your print exposure time tends to be too long, you could use a fast enlarging paper to increase your print-per-hour output.

PROCESSING

The trays are customarily arranged in this order, left to right: (1) developer; (2) stop bath; (3) fixing bath; and (4) wash. Space them far enough apart so that you will not splash one solution into another. The trays for the developer and the stop bath should be slightly larger than the largest print you plan to make. Because the trays for fixing and washing will probably contain several prints at a time, they should be about twice as large as the other trays. Be sure to use enough solution in each tray to cover the prints by at least $1/2''$. Incidentally, when you have finished printing, do not leave the trays scattered about. Clean them well, inside and out, and stand them up on edge to dry. Always use the same tray for the same purpose to help prevent

the solutions from becoming contaminated.

Handling the test strips may have left traces of the processing solution on your fingers, so be sure that you rinse your hands thoroughly and dry them on a clean, dry towel. In fact, consider using the "three-towel" technique: with three towels set up from left to right, wipe your hands first on the left one, wipe them thoroughly on the center one, and polish them on the last one! Beware of fingerprints caused by solutions you haven't washed away! To help prevent fingerprints from appearing in the picture area, you should take this rinsing and drying precaution before handling each new sheet of photographic paper. If your fingers are naturally oily, use print tongs to solve the fingerprint problem. You'll need two: one for the developer and the other for the stop bath and the hypo. Do not mix up these tongs—use each one only in the proper solution. Also, use them gently; tongs can scratch the tender print emulsion. They can also cause black pressure-sensitized marks in black-and-white as well as color prints if you wield them with vigor.

Developing

Hold the exposed paper by an edge (with dry fingers!) *emulsion-side up.* With a glance at the timer or clock, slide the paper smoothly and quickly into the developer. Be sure the print remains completely submerged, particularly during the first few seconds of development. Paper that has been stored in a dry place may have a tendency to curl. Watch out for this, because if a part of the paper protrudes unnoticed above the surface of the solution it will receive less development, and a line of demarcation may show in the finished print. Keep your fingers off the picture area at all times.

Incidentally, do you know why we strongly suggest you insert the paper into the developer *emulsion-side up?* It's for this reason: A rough-textured paper may have a tendency to trap small air bubbles on its surface as the paper is being immersed into the developer. If the paper is inserted emulsion-side up and then agitated quite vigorously during the first few seconds of development, any air bubbles present will be freed and will rise to the surface. But if the paper is immersed emulsion-side down (as some photographers are apt to do under the theory that this will help prevent undue safelight exposure), these bubbles would be trapped and could prevent the print from being

60

developed wherever the air bubbles might be. (Color prints are not subject to the same air-bell problem.) Then, too, another reason for developing the paper emulsion-side up is that the emulsion, which rapidly becomes soft and susceptible to abrasion while wet, is not likely to be scratched against a rough tray bottom.

For the remainder of the developing time, you should keep the print under the surface of the solution as much as possible and agitate it constantly by gently tipping the tray back and forth to help promote uniform development. You can see at this point why it is inadvisable to fill the tray brimful with solution. Try to control a rather universal urge to pick up the print every few seconds to examine its progress. If you do so, you will only increase the possibility of fogging it by holding it nearer than the recommended distance to the safelight, and of staining it if the developer is not fresh.

For most papers, the longer you leave the print in the developer, the darker it becomes until all of the exposed silver halide has been developed. But do not infer that, because the paper becomes darker and darker for the first portion of the development, the time of development should determine the proper print density. *This should be controlled almost entirely by print exposure.* The duration of development varies with different paper–developer combinations. But this information is always found on the instruction sheet packaged with the paper. Note that there is a recommended development time in minutes, and this is in the center of the small useful range of development times.

The sacrifice in print quality begins when either limit of this range is appreciably exceeded. There is a natural tendency to "pull" a print out of the developer if it is sufficiently dark even before you have reached the lower limit of the range of recommended times. However, an underdeveloped print is usually flat and "muddy" with blocked-up shadows. The image tone may be warmer than normal, but, worst of all, the print may be grainy or even mottled. In addition, this print may not tone evenly.

On the other hand, "forced" development (development beyond the maximum time recommended) may cause fog or yellow stains, both of which will be most noticeable in the highlight portions of the print. The maximum development time

that can be used decreases with old or partially exhausted developers and at higher-than-normal temperatures.

If you have no alternative to working at high temperatures, you may want to keep in mind that, for most developers, the safe maximum development time decreases about 30 seconds for each 5° F (3° C) rise in temperature above 68° F (20° C). This, however, is only a general rule.

With the majority of papers, the developing tray is *not* the place to control print contrast. The paper contrast is largely inherent in the emulsion and the type of surface. Some papers, such as Kodak Ektalure paper, can be contrast-controlled only within very narrow limits by varying the time of development. Another example is Kodabromide paper, whose contrast varies scarcely at all with different development times. With Kodak Medalist paper, however, you have somewhat greater control. The general principle is that overexposure and underdevelopment reduce contrast, while underexposure and overdevelopment increase contrast. Remember that, in any case, the degree of control is very small—smaller, actually, than that effected by changing the paper contrast by about ½ grade.

The Stop Bath

Immediately after development, rinse the prints in fresh stop bath (such as Kodak stop bath SB-1 that you've mixed yourself from stock acetic acid, or Kodak indicator stop bath). The purpose of this solution is to halt the development. However, since the developer is a basic solution and the fixer is an acidic solution, the stop bath protects the life of the subsequent fixer and also prevents scum and stains from forming on the surface of the print in the fixer. This scum might be minute and nearly undetectable but it is one of the enemies of good ferrotyping. Now don't just throw the print in the stop bath and leave it there—agitate it! Then move it right along to the fixing bath. The reason is that watersoak or mottle in the paper base may be caused by lack of agitation and prolonged soaking in the stop bath. Also, you may encounter a subsequent problem in toning these prints in a brown sulfide toner because the base will show brown spots due to lack of agitation in the stop bath.

Incidentally, drain the prints for one or two seconds before immersing them in the stop bath. If you do this, you can process approximately twenty 8" × 10" prints per quart.

Fixing

After rinsing the prints carefully in the stop bath for about 15 seconds, fix them for 5 minutes at 65 to 70° F (18 to 21° C) in a solution prepared from Kodak rapid fixer or for 10 minutes in Kodafix solution. *Agitate the prints frequently when they are first immersed in the fixing bath and continue to agitate them throughout the whole process.* The purpose of fixing bath solution is to dissolve out all the remaining silver halide in the emulsion that was not used to form the print image and thus render the picture permanent. The usual advice to agitate is worthy of emphasis, especially if you intend to process several prints or even batches simultaneously.

If recommended fixing times are exceeded, the fixer may have a tendency to bleach the prints, especially the fine-grained or warm-toned "portrait" emulsions. This will occur wherever the fixer has ready access to the emulsion—such as the edge of a print protruding from a stack of prints that may have accumulated in this bath. "Warm-tone" is another way of saying "fine-grained," and fine silver grains are more readily dissolved than coarse ones. Thus, overfixing can lead to loss of image warmth, and if continued further, to severely bleached and ruined prints. Be especially careful of overfixing during warm summer months. At 68° F (20° C) a very noticeable loss of density and change in image tone may occur in about twice the normal fixing time; the same density loss can occur at 80 to 85° F (27 to 30° C) even at normal fixing times. The effect is, of course, most pronounced with fresh fixing baths, and decreases gradually as the bath becomes exhausted.

Overfixing, especially in nearly exhausted fixing baths, can also cause toning problems, as the paper base becomes mordanted with the silver salts. The fixing baths mentioned above will fix about a hundred 8″ × 10″ prints, or the equivalent area of other sizes, if a stop bath is used between development and fixing. (But don't even consider not using a stop bath!)

For complete fixation and image-tone consistency, especially with non-resin-coated papers, you should use two fixing baths, the second one freshly made. This is particularly true when permanence is necessary, or when the prints are to be sepia-toned later. Fix the prints for 5 minutes in each bath, with a 5-second drain between baths. Be sure to consult the instruction sheet for a given paper for exact times; for instance, fixing

time is only *two* minutes for Kodak Polycontrast rapid RC paper.

You may find the reason for using two baths quite interesting. Used fixing baths are "loaded" with silver salts from previously fixed prints. Thus, it is difficult to remove all the unused silver salt from any print subsequently fixed in this old solution. The silver salts cannot be removed completely from the emulsion even by extending the washing times up to two hours or more. Eventually, the silver salts are gradually converted during the life of the print to brownish-silver sulfide and show up in the form of highlight stain. Residual silver salts show up immediately if the print is toned brown, because the toner does not distinguish between the metallic silver image and the unwanted silver salts. However, immersion in a second, relatively silver-free hypo bath removes most of the silver salts and thus lessens the highlight stain possibility when prints are toned in the brown toner.

For the two-bath method, discard bath A after fixing twenty-five 8″ × 10″ prints, or the equivalent. Bath B now becomes bath A, and a fresh bath B is mixed.

Follow processing instructions carefully for resin-coated papers. Overfixing causes a penetration of the chemicals at the edges of the paper up to ½″ deep for prolonged immersions. The fixer would then be extremely difficult to remove and possibly cause an eventual border mottle or discoloration.

Hypo Clearing Agent

While it is not essential, at this point we would like to have you seriously consider using a prewash rinse of Kodak hypo clearing agent for all non-resin-coated papers. This solution helps to eliminate fixer and silver salts and makes possible faster and more thorough washing which, in turn, means greater stability. This washing aid reduces both the washing time and water consumption by at least two-thirds. Moreover, you can use much colder water.

Use the hypo clearing agent at 65 to 70° F. Treat double-weight papers for approximately 3 minutes, single-weight papers for about 2 minutes, both with agitation. Try not to let the time exceed 10 minutes, or else the trouble known as watersoak (slight mottle on the paper side of the print) may occur.

Hypo clearing agent is not essential or even needed with RC papers. The intended purpose of hypo clearing agent is, as its

name suggests, to aid in the removal of hypo from the fibers in the conventional photographic paper. This is desirable to help prevent any residual hypo from migrating and subsequently degrading the silver image over a period of time. However, with RC papers, there is no hypo penetration of the paper fibers because the resin coatings on the front and the back act as an efficient barrier. Accordingly, only a 4-minute washing time is required to remove the hypo from the gelatin layer.

Washing

You should wash double-weight prints treated with hypo clearing agent for 20 minutes in running water that flows fast enough to provide an active agitation. The rate of water flow should be sufficient to change the water once every 5 minutes. If you can give the prints the attention they deserve, separate them and turn them over frequently. You should wash prints not given the hypo clearing agent treatment in the same way for about one hour. Be careful not to contaminate prints that have nearly finished washing by adding other prints directly from the fixing bath. Otherwise, you must wash *all* of the prints for the time required by the new prints.

During the winter months, if the water temperature cannot be brought up to the recommended minimum of 65° F, you should double the washing time. In addition to the troubles arising from the possibility of inadequate washing, cold wash water can cause overhardening of the emulsion with consequent curl and ferrotyping problems.

Drying Matte Prints

When washing is completed, remove as much excess water from the prints as possible with a squeegee—an old automobile windshield wiper blade still in good condition is a good substitute for a professional squeegee. Then place the prints on cheesecloth stretchers, on stretched plastic screening, between clean, white, photo blotters, or dry them on a professional belt-type drum dryer. Be sure to put the prints image-side up if you lay them out to dry on cheesecloth or plastic screening, so the emulsion doesn't have a chance to stick.

Did you ever hear the word "plum" applied to photographic prints? Some papers have a tendency to change image color when dried at excessively high temperatures, shifting slightly

65

toward a purplish "plum-like" hue. This trouble occurs mostly with warm-toned portrait papers dried on electrically heated drum dryers; it is really nothing to be concerned about if the drying temperature does not exceed 180° F. It occasionally occurs in dry-mounting if the press is too hot.

Forced drying has still another effect on most matte papers. In general, the hotter and faster you dry a print, the higher its surface sheen becomes. This difference in sheen between cold-dried prints and hot-dried prints is not great but it is apparent.

Drying Glossy Prints

If you made your print on glossy paper (this is an F surface), you should dry it on ferrotype tins or drums. (The exception is resin-coated paper, which should not be ferrotyped in view of the high probability of its sticking tenaciously to the ferrotyping surface. These prints can be simply air dried.) The principle of ferrotyping is the compression of the surface gelatin when a wet print is dried in close contact with a very smooth surface. This compression causes an increase in the reflectivity of the print. The ferrotyping surfaces of yesteryear were sheets of iron coated with black, baked enamel, but today they are customarily sheets of stainless steel that are chromium plated.

Never allow the surface of ferrotyping tins to become scratched from being in contact with each other. Preferably, when they are not in use, you should store them apart in an upright position in a grooved cabinet. Stainless steel or chromium tins do not require waxing as did the old enameled ferrotyping tins. You should wash them occasionally with soap and water, dry them, and then polish them with *cake* Bon Ami (do not use the powdered form).

If you own and use the old black enamel ferrotype plates, you can repolish them after you have used them five or six times with the following solution:

Paraffin	0.7 gram	10 grains
Kodak Film Cleaner	32 cc	1 oz.

Be sure the paraffin is dissolved completely before use. Apply the solution sparingly to the plate with a tuft of cotton and polish it *well* with a soft cloth such as flannel. The plate should show no visible trace of the polish, since an excess of wax is picked up by the prints as an objectionable surface pattern.

66

Each time you are ready to use the ferrotyping tins, regardless of material used in their construction, you should rinse them in clean warm water to remove dust and lint. Put the wet, glossy print emulsion-side down on the plate and squeegee firmly in place with a hand roller or print wringer. No air bubbles should remain under the print because perfect contact over the entire print surface is necessary to produce the uniform gloss. Admittedly, consistently good ferrotyping is a knack, but there is nothing really difficult about it.

You should carefully blot away any excess water on the back of the print after it has been applied to the ferrotyping tin and put the plate aside to dry in a current of warm air. Do not use excessively high temperatures on individual plates to hasten the drying. This may cause drying marks, often called "oyster-shell markings," particularly on double-weight papers. The problem can be avoided if the prints are covered with a blotter or a cloth while they are drying.

When completely dry, the prints should fall off the ferrotype plates of their own accord. If they do not, slide an old piece of film under the edge of each print and gently pry it loose.

One of the most frequent problems encountered by photographers making glossy enlargements is the sticking of the paper to the ferrotyping tin. Usually the sticking is due either to insufficient hardening of the paper in the fixing bath or to a film of dirt on the ferrotyping tin. You can clean chromium-plated tins or drums by using a Carborundum product known as Aloxite grade A No. 1 Fine Buffing Powder. Here are the steps:

1. Make a thin watery paste of the Aloxite powder.

2. Apply this paste to the drum or tin with a soft cloth over a small portion at a time. Continue to rub until there is no break in the water film. *Do this at room temperature, not while the tin is heated.*

3. Allow the powder to dry and then wipe it off.

4. Polish the drum with cake Bon Ami until you obtain a broken film of water, indicating a high degree of water repellency over the entire surface. This is very important; otherwise, the prints will stick to the surface and be impossible to remove.

5. Allow the Bon Ami to dry and wipe the powder off with a clean cloth.

This procedure is recommended only when you notice signs of sticking, not necessarily as a regular routine.

Chapter 5

Rapid Print Processing by Stabilization

High-quality prints processed in 15 seconds—this is the reality of the stabilization process. Here is how it works:

A specially manufactured paper, such as Kodak Ektamatic SC paper, incorporates the developing agent as an integral part of the photographic emulsion. This developing agent remains inactive, or inert, during storage and exposure. After exposure by the usual enlarging procedures, the paper is fed into a machine containing only two processing solutions. The first one, an alkaline activator, "turns on" the developer. Since very little penetration time is required for the chemicals, development is extremely rapid, requiring only a few seconds. The machine's rubber drive rollers carry the developed print into the second solution, the stabilizing bath, which halts further development and stabilizes the undeveloped silver salts. The print emerges squeegeed damp-dry, ready for use. You can turn the room lights on the instant the print emerges from the machine.

Photographic quality is not compromised, and the entire procedure is simplicity itself. In fact, a darkroom completely equipped to produce these prints would consist of only an enlarger, a light amber safelight (Kodak safelight filter OC), and a stabilization processor—no sink, no running water, no trays, no chemicals to mix, no wet hands.

Several companies manufacture the necessary machines, chemicals, and papers. In general, the equipment and materials of the different manufacturers are compatible and interchangeable. Considered from the standpoint of an amateur photographer making an occasional enlargement, the machines are relatively expensive. However, when volume print production and speed are important factors, the machines pay for themselves very quickly. You might regard a stabilization processing ma-

chine as a skilled darkroom assistant who will process your prints with precision, speed, and expertise.

Applications in which stabilized prints are useful include:
—general proof printing
—instructional or teaching aids
—deadline work, as for newspapers
—industrial and commercial applications where speed of production is essential
—medical photography
—military photography
—police photography
—any situation in which speed is vital

Of course, there are advantages and disadvantages to any procedure, and the stabilization process has its set of recommendations if fast and trouble-free results are to be obtained:

1. Accurate print exposure is essential because the developing time cannot be altered. An on-easel photometer and an enlarger timer are recommended accessories.

2. Be sure you do not contaminate the two solutions. Allowing contamination can be easier than you might suspect. For example, it is best to handle the prints coming out of the machine with print tongs reserved for this purpose only. The damp-dry prints are coated with a minute amount of stabilizer that might transfer to your fingers and, in turn, to an unprocessed sheet of paper. This would result in fingerprints on the image of the next print. Severe contamination of the activator with the stabilizer will cause yellow-stained prints.

3. Keep stabilized prints separated until they are thoroughly dry or they may stick together. The drying time is quite short—only a few minutes.

4. Do not mix stabilized prints and ordinary prints for either delivery or storage purposes. If you inadvertently allow this to happen, the stabilized prints may cause the others to stain. It's recommended that you mark stabilized prints on the reverse side to avoid any possibility of confusion.

5. Don't wash a stabilized print, since the image stability depends on the chemicals that remain in the emulsion.

6. Don't use heat to dry stabilized prints, because the combination of heat and moisture may stain the print a yellowish brown. Heat isn't necessary for drying anyway, as the prints will be completely dry, without curl, in a few minutes at room

The exposed paper is fed emulsion side down into the stabilization processor. Electrically operated drive rollers take the print first through an activator solution and then, when development is complete, through a stabilizing solution. Prints emerge damp dry.

Stabilization processing requires only a machine like this Kodak Ektamatic processor, Model 214-K; no sink, no plumbing, no wet hands.

Since prints are processed in about 15 seconds, the stabilization process is ideal for anyone who wants a print in a hurry, such as for meeting publication deadlines. Stabilization prints are of excellent quality.

High-contrast papers for graphic arts purposes are available in roll form for stabilization processing.

temperature.

7. Stabilized prints, as the term implies, are for temporary use only, and not for long-term storage. They should last without undue image change for six months or longer, depending on the storage conditions. The image will gradually darken. The rate of change is influenced primarily by the light level, and also by the storage temperature and humidity. If the prints are exposed to bright light, the darkening will occur in a relatively short time.

If you want stabilized prints to last as long as ordinary prints, simply fix and wash them as usual. These steps remove the stabilized silver salts and the residual chemicals from the emulsion. This can be done at any convenient time, a day or a month after the stabilization processing.

There is a very slight effect of lessened density when the prints are fixed and washed, and if you wish, you can compensate for this by increasing the print exposure time by 2 to 5 percent. Primarily, this is only a slight change of image color, the shift going from a warm black to a more neutral black. The density shift is comparable to the "drying-down" change of ordinary matte papers, but in the opposite direction.

Let's look further at the advantages of stabilization processing.

1. *Uniformity.* Prints are all processed alike. From any one negative, the first print will look just like the hundredth print. If you had to process a large number by the tray method, doing them in batches, processing variations and perhaps even streaks and uneven marks might occur due to nonuniform agitation or nonuniform chemical treatment.

2. *Speed.* Darkroom time is cut by at least two-thirds with stabilization processing. You can do in two hours what otherwise would take six or eight. You might take a tip from large commercial print production companies and studios, where time is money; they are making increasing use of stabilization processing, *but they are routinely fixing and washing these prints as usual.* In other words, the growing popularity of stabilization is due primarily to the extremely short development time and *not to the stabilization feature itself.*

3. *Versatility of paper types.* For example, Kodak Ektamatic SC papers are available in the following surfaces and weights in standard sheet sizes from 5″ × 7″ to 16″ × 20″:

Above: a straight, normal print made by the stabilization process. Below: the stabilization print made from the same negative but on a high-contrast paper intended primarily for photo-type setting or graphic arts purposes.

Above left: a straight, normal print made by the stabilization process. Above right: what happens if you wash a stabilized print and then redevelop it in ordinary paper developer. This is known as the Sabattier effect—often called solarization.

To enhance the tonal separation, the reversed print was copied and printed on high-contrast paper.

G—Glossy, smooth, single-weight, and double-weight.

N—Smooth, lustre, single-weight.

A—Smooth, lustre, lightweight.

These particular papers are variable-contrast papers. This means that you can obtain the equivalent of grade 1 through grade 4 in half-grade steps by using Kodak Polycontrast filters when exposing these prints. Incidentally, because the control of contrast depends on the relative exposure to blue and yellow light, you should avoid lengthy exposure of the paper to yellowish safe-light illumination.

Here is another important plus: *Stabilization papers can be processed in ordinary paper chemicals.* Thus, if you kept only this type of paper on hand and ran out of the stabilization chemicals, you could process the paper in the "old-fashioned" way. In addition, you can gain a bit more—like a half grade— of maximum contrast from the conventional tray processing. Of course, ordinary photographic papers cannot be processed with stabilization chemicals.

There are also high-contrast, orthochromatic projection-speed materials designed for graphic-arts users. For example, Kodak Ektamatic grade T paper is specially designed for photo-typesetting. This paper can be used to produce a very high-contrast, "poster-type" image from a normal negative if this is desired for a special effect.

ADDITIONAL APPLICATIONS

The stabilization process is ideally suited to making paper-negative prints. You can quickly proof-test the effectiveness of your retouching on both the positive and paper negative. Furthermore, the Kodak Ektamatic grade A paper has a thinner paper base than even single-weight paper, and thus minimizes image diffusion in the paper-negative process. If you have the impression that paper-negative prints are only fuzzy, old-fashioned curiosities, then a real surprise awaits you when you first glimpse a paper-negative print made with this thin-base material.

Don't overlook the very practical application of making black-and-white prints via the stabilization and paper-negative technique from color transparencies for layout purposes.

Black-and-white prints of excellent quality can be made speedily from color negatives via stabilization processing. However, if you are using a variable-contrast paper for this purpose, use a contrast-controlling filter one grade higher than you might think would be required for normal results. The reason for this is that the orange tint of the negative masking layers has its own contrast-reducing effect, and you must compensate for it.

Sabattier, or "solarization," effects can be produced with stabilized prints. After the print has emerged from the machine, turn on the room lights and wash the print in running water for about 10 minutes. This will remove the stabilizing chemical so that the remainder of the exposed emulsion can be developed in ordinary paper developer. Place the print in one part of Kodak Dektol developer to two parts water. In bright room light, watch the formation of the negative counterpart of the original image and put the print into a stop bath as soon as you feel the desired effect has been achieved. The most interesting effect, we feel, is to let this secondary development go to completion. The resulting rather dark and low-contrast print should then be dried and subsequently copied onto a high-contrast film and reprinted for a very unusual derivation that resembles a steel engraving. This process works best if you start with a print that is somewhat lighter than normal. Admittedly, this weird effect is artistically suited for some subjects, such as line-lighted character studies, more than for others. But have fun and try it!

Chapter 6

Printing Color Negatives

COLOR THINKING

At this point we advise a short course in color theory—what makes color printing work, in other words. If you understand just a little bit, it will not only make color print-making more enjoyable, but it will give you the basis to reason your own way out of future color-printing problems. In fact, we can boil it down to these essentials:

1. White light (sunlight or your enlarger lamp) is composed of approximately equal portions of red light, green light, and blue light. Color film, consequently, has three light-sensitive layers, each sensitive to only one of these three primary colors.

2. However, color pictures (paintings or photographic prints) form all their colors by a combination of three other colors, cyan (blue-green), magenta (blue-red), and yellow.

3. In the photographic color-printing process, the three "light" colors get transformed into the three "printing" colors in this order:
——the red-sensitive layer becomes the cyan image;
——the green-sensitive layer becomes the magenta image; and
——the blue-sensitive layer becomes the yellow image.

4. Your job is to expose each of these print layers just the right amount to form the perfect picture.

TRICOLOR PRINTING

It will help to understand the procedure to think that each paper layer gets exposed separately and independently of the other two layers. In fact, this is what actually happens in the process known as tricolor printing—sometimes called the additive printing method. In practice, a relatively small percentage of prints are made by the tricolor method, but we want to discuss

77

it for the helpful background it will give you.

In making a print by this method, you would first expose the color negative to the color paper with a red filter (Kodak Wratten filter, No. 25). This would expose the red-sensitive paper layer, which, you will remember, will eventually produce a cyan image. Next you would substitute a green filter (Kodak Wratten filter, No. 99) for the previously used red filter and make another exposure. After processing, this would produce a magenta dye image. Lastly, a blue filter (Kodak Wratten filter, No. 98) exposure would be used to produce the yellow dye image. Incidentally, the order of exposure makes no real difference.

Keep the f/stop the same for each of the three exposures. However, the actual exposure times will not be alike. As a starter (based on a 4× magnification, an enlarger brightness of three foot-candles at the easel measured without a negative or a filter in the optical system, and an average-density Kodacolor II negative exposed to a sunlighted subject), try a 23-second red-light exposure, a 35-second green-light exposure, and a 6-second blue-light exposure.

We guarantee this first print to be a failure! Anyone else's guess would be better only if he were lucky. However, it will be readily apparent what was wrong, so try again. You should have a good print after about three attempts.

Here's the thinking you should use to modify the exposure ratios:

If the test print was too . . .	Reduce this exposure time.
Cyan	Red
Magenta	Green
Yellow	Blue
Red	Green and Blue
Green	Red and Blue
Blue	Red and Green

Note that there is *no* outstanding color-quality advantage to using this tricolor exposure method. The only practical advantage is that only three filters are required, as compared with the many used for the white-light single-exposure method, sometimes called subtractive printing.

78

The cyan-dye layer was produced by a red-light exposure.

The magenta-dye layer was produced by a green-light exposure.

The yellow-dye layer was produced by a blue-light exposure.

This print was made by the tricolor filter method. There is no print-quality advantage over the white-light exposure method. However, you should think through the tricolor technique to learn how color printing works.

If you move the easel between tricolor exposures, color fringing like that shown opposite will result. However, this effect can be deliberately introduced for unusual derivations.

Incidentally, when making tricolor prints, don't accidentally jar the easel between exposures or else you'll have a misregistered print. Since, in this case, the three images do not literally fall on top of each other, all subject outlines will have violent color fringing. Of course, you could cause this misregistering deliberately for unusual or abstract effects.

WHITE-LIGHT (SUBTRACTIVE) PRINTING

As mentioned previously, the "white" light from an enlarger lamp consists of a mixture of red, green, and blue light. Since this is true, why not use all of them simultaneously, to expose the red-, green-, and blue-sensitive layers of the color paper? This is exactly what is done in single-exposure, white-light printing. The only problem is that the *ratio* of these three colors of light is not automatically correct to produce a good print. In fact, there is usually too much blue and green light, so it becomes necessary to adjust the ratio by means of color-compensating filters.

There are two types of color-compensating filters: those made of gelatin (commonly called CC filters) for use underneath the lens, and those made of acetate (commonly called CP filters) for use above the enlarger condensers. Although there is no difference in what these filters do, for best print quality the two types should not be used interchangeably.

The function of these filters is to subtract some light of the complementary, or "opposite," color to the filter color. For example, the yellow filters subtract some, but not all, of the blue light. The proportion of blue light subtracted from the source is the function of the numerical value of the filter. Thus, a CC30 yellow will subtract one half of the blue light from the beam and allow the other half of the blue light to be transmitted. (These values are logarithmic; an additional CC30 would subtract half the remaining blue light, allowing one-fourth of the blue light to pass.)

Similarly, the magenta series of filters subtract green light and the cyan filters subtract red light.

So, let's give it a practice try: Since the color quality of your enlarger system is probably too blue and green to print a standard outdoor or blue-flash negative properly, make up a

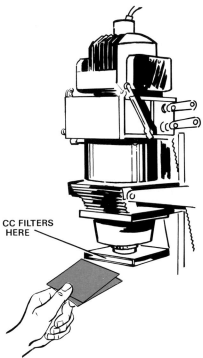

Color compensating filters, which are gelatin, go below the enlarger lens. Use as few filters as possible in the pack.

CC FILTERS HERE

Color printing filters, which are acetate, go above the negative in the enlarger. If they were used below the lens, they would impair image definition.

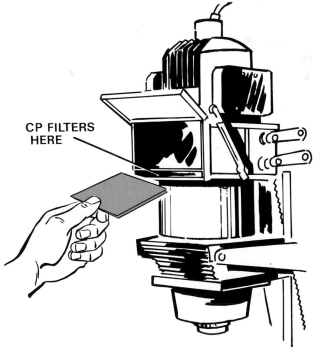

CP FILTERS HERE

filter pack of 60M plus 60Y. (The reason is that magenta and yellow equal red, which will absorb its complementary color, cyan—the blue-green mentioned above.) Add to this pack a Kodak Wratten filter, No. 2B. This filter prevents ultraviolet light from passing through to the paper and creating unwanted yellow tinges in the print. *You should have this filter in the enlarger for all color printing work.*

Incidentally, always try to use the least number of filters to comprise the pack. For instance, it would be better to make up a "60's worth" of magenta by combining a CC50M with a CC10M—only two filters—than to use six CC10M filters.

Will the above suggested pack result in a good color print? Maybe and maybe not—you'll just have to make a test print to find out. A given negative with a given enlarger may require a filter pack ranging from as low as 10 magenta plus 10 yellow up to 150 magenta plus 200 yellow. Neither of these packs is wrong if it produces a good print. The *degree* of filtration depends on several factors such as the color of the light that exposed the film, the balance of the particular paper emulsion you are using, the characteristics of the particular color negative, the age of your enlarger lamp, and the voltage used to operate your enlarger.

Exposing the Test Print

With the negative in the enlarger, the "first-try" filter pack in place, and the processing solutions ready, make a test print. Not a test strip, but a full print. (For one thing, it isn't practical to process a small test strip on the Kodak rapid color processor; for another, you'll be better able to evaluate a print than a small test strip.) It's better to make a series of exposures on a whole sheet of paper using the procedure described for black-and-white test printing. (The test consisted of a staggered series of total exposures of 4, 8, 16, 32, and 64 seconds.) The test paper (it's not a print yet!) is now ready for processing.

PROCESSING THE COLOR PRINT

There are, of course, several methods of processing color prints. Where do you fit into this scheme of things?

—*Tray processing.* For small-volume amateur printing with

minimum equipment expense.

—*Drum-type processing.* Advanced amateur printing or small professional studio with low-volume color-printing needs.

—*Tube-type processing.* Small-to-moderate volume in professional establishments.

—*Basket-line processing.* Professional volume or commercial photofinishing.

—*Continuous processing equipment.* Highest commercial volume such as large photofinishing establishment or central processing laboratory for custom and chain portrait studios.

We're concerned here with only the first three, which represent typical small-scale processing methods.

Tray Processing

Ideally, in your darkroom you should have a flat-bottom sink large enough to accommodate five trays arranged like this:

Developer	C-22 Stop Bath	Bleach-Fix	Stabilizer	Running Wash Water

Steps for Tray Processing

Processing Step	Remarks	Temp C	Temp F	Time in Minutes*	Time at End of Step
1. Developer	No. 10 safelight filter	31 ± 0.3	88 ± 1/2	3 1/2	(3 1/2)
2. C-22 Stop Bath	Agitate as described	31 ± 1.2	88 ± 2	1	(4 1/2)
3. Wash	Running water	31 ± 1.2	88 ± 2	1	(5 1/2)
4. Bleach-Fix		31 ± 1.2	88 ± 2	1 1/2	(7)
Remaining steps can be done in normal room light.					
5. Wash	Running water	31 ± 1.2	88 ± 2	2	(9)
6. Stabilizer	No rinse after this step	31 ± 1.2	88 ± 2	1	(10)
7. Dry	Air dry—don't ferrotype!	Not over 107	Not over 225	—	—

*Include a 20-second drain time in each process step.

Mix the chemicals and place one quart (946 milliliters) of the appropriate processing solution into each 8″ × 10″ tray. Adjust the temperature of the solutions to 88° F (31.5° C). This can easily be accomplished by using the sink as a water bath, tempering the water as needed with the cold and hot water faucets. Try to keep the developer temperature within 0.5° F of normal; keep the other solutions, *including* the wash water, within 2° F of normal.

We advise you to use rubber gloves for processing color prints: This will prevent possible skin irritation, particularly from the color developer. Use your darkroom timer and follow the manufacturer's processing instructions meticulously.

How many prints will you be processing at one time? Sometimes only a single test print; other times perhaps as many as six prints in a batch. For repeatable and consistent color printing results, it is very important to learn the proper agitation technique for each situation.

You can give a single sheet of color paper adequate agitation by lifting it from the solution once per minute. It is not difficult to process several sheets of color paper at one time, but the agitation technique becomes a trifle more involved. Here's the proper way to handle a batch of prints: introduce each exposed sheet of paper *face down* into the developer tray at equal intervals according to the following schedule:

Number of Prints	Insertion Interval
2	30 seconds
3	20 seconds
4	15 seconds
5	12 seconds
6	10 seconds

It's a good idea to identify the "lead" print in a batch by nipping off a bit of one corner. You'll agitate the prints properly by interleaving them. This means removing the bottom print in the stack and placing it on the top. This interleaving begins after the same number of seconds *following* the insertion of the *last* print. Thus in a 3-print batch, you'd wait 20 seconds after inserting the third print into the developer, and then put the bottom print on the top of the stack. Each successive bottom print is removed after the same 20-second interval of time and put on top. At the end of 3½ minutes, briefly drain the bottom print and place it in the stop bath.

86

Incidentally, we recommend that you use the Kodak stop bath, process C-22. Some instructions refer to it as an "optional" step. But, the definite "stopping action" of this solution is desirable, especially if you are processing a batch of prints. You can safely use this solution as a "holding bath" until all the prints in a batch have arrived at this station. Yes, it's possible to go directly from the developer into the bleach-fix when using the few-prints, rubber-gloves processing method, but we don't advise it because of the high probability of streaking the print. You'd have trouble agitating the prints in the bleach-fix while still trying to extract the remaining prints from the developer. Also, any "back contamination" of the developer with the bleach-fix will cause severe cyan staining of those prints that are still in the developer.

Following the stop bath step, drain the prints and place them in a running-water wash for one minute. This flushes away the stop bath chemicals so they will not weaken the bleach-fix.

Put the prints in the bleach-fix for 1½ minutes, agitate them, transfer them to the running-water rinse for two minutes, and then place them into the stabilizing bath for one minute. They are then ready to dry. Squeegee the tender surface carefully to prevent puddles of stabilizer from standing on the prints and to hasten the drying.

Drying, especially with the resin-coated papers, should take only a few minutes. Since the resin coating on both sides of the paper base has prevented the paper from absorbing appreciable moisture, it wasn't very wet to begin with.

Don't ferrotype resin-coated papers. First, the F surface is already smooth and glossy. Second, if you do, you'll be really sorry, because at elevated temperatures the resin coating literally glues itself to the ferrotyping plate. You'll never get the print off and you might as well throw the entire mess away, plate and all!

Drum Processing

Using an "external" drum processor, such as the Kodak rapid color processor, models 11 and 16-K, the total processing time is just five minutes. This time reduction (compared with about 10 minutes for the tray method) is due to three factors: use of the more vigorous Kodak Ektaprint 300 developer instead of the Ektaprint 3 developer, use of a 100° F (37.8° C) processing temperature (instead of 88° F for the tray method), and use of the

very efficient rotating-drum agitation technique that accelerates the chemical action. Complete instructions come with the machine and supplementary instructions are packaged with the developer—follow them!

Tube Processors

These popular processors are available in a variety of sizes and with a variety of convenience features; some types can accommodate more than one print at a time. They carry the print *within* a cylinder that rotates horizontally on its axis. The bottom of the tube contains the solution so that every portion of the print emulsion surface is immersed in the chemicals once every revolution. Each kind of tube processor has its own set of accompanying instructions.

EVALUATING THE TEST PRINT

After processing *and after the print is dry,* it will be obvious which of the five levels of exposure is nearest to the correct exposure time. Perhaps the very best time will be between the trial times, so next time you'll split the difference between the two steps. Density evaluation is exactly comparable to black-and-white print density evaluation.

But what about the trickier matter of color balance? Chances are you'll find that one layer of the color paper has been somewhat overexposed with respect to the other two. A change will have to be made in the filter pack for the next try.

The decisions you must now make are: (1) What color is in excess? (2) How much (a trifle; considerable; a large amount)? Let's consider these questions separately.

Learn to think of the color deviations in terms of cyan, magenta, and yellow. *This is very important:* You *must not* describe deviations with words such as purple, green, pink, orange, or the like because your corrective control colors are cyan, magenta, and yellow. In other words, if a print is too orange, don't think of it as being too orange; *think of it as having twice as much yellow as magenta.*

However, let's first deal with the simplest type of problem and suppose the test print is too yellow. You'll recall that in terms of tricolor printing this would mean you had overexposed

Add a CC30C filter. Add a CC30M filter.

Add a CC30Y filter. Add a CC30R filter.

89

the blue-sensitive paper layer. To reduce the amount of blue light, additional yellow filtration is needed, since a yellow filter absorbs blue light. And therein lies the basic color-print control thinking: *To correct any color anomaly, add more of the same color filters as the off-color of the print.* Thus, if a print is too yellow, add more yellow filters to correct it. If too magenta, add magenta filters; if too cyan, add cyan filters *or* subtract magenta and yellow filters, which is the same thing. Let's summarize these possibilities in a table for ready reference:

Add a CC30G filter. Add a CC30B filter.

If the print was too . . .	Add these filters	OR Subtract these filters
Cyan	Cyan	Red (*or* magenta & yellow)
Magenta	Magenta	Green (*or* cyan & yellow)
Yellow	Yellow	Blue (*or* cyan & magenta)
Red	Red	Cyan
Green	Green	Magenta
Blue	Blue	Yellow

90

Print with normal color balance. Each of the small print is off balance by a CC30. In other words, it would require a CC30M filter added to whatever filter pack was used to make the magenta print to correct it in the next exposure.

Now let's go back to the print that was too orange—having twice as much yellow as magenta. If it was a *heavy* orange, you could add a CC20Y filter plus a CC10M to the pack. Or, if it was a *light* orange, you could add only a CC10Y plus a CC05M.

Go for a full-size print on your second try, since it should be close to normal. Rarely should you need more than three attempts to produce an excellent print.

For judging a print and evaluating what filters to add for making the first print from the test print and making the final print, we can advise nothing better than the Kodak color print viewing filter kit. It contains a complete assortment of viewing filters to allow you to judge what filters you will need to make an improved print after you've made that test print. This color print viewing filter kit contains cyan, magenta, yellow, green, red, and blue filters. Using the same illumination you will use for the final print, you select filters to look through until the print looks good. On each filter card is an explanation of what to add to or remove from the pack to achieve the same visual effect.

One trap we want to warn you about at this point is not to lay the filters down on top of the print because you will get double the filtration effect. Instead, hold them about halfway between your eyes and the print; then shift the viewing cards back and forth between the three available densities in order to choose the desired degree of coloration. You can use a combination of two of the cards for precise balancing. Then the values are added according to the instructions for removing or adding filters to the pack.

What about those available filter colors, red, blue, and green, which we have ignored thus far? Well, as you undoubtedly realize, red filters are a *combination* of yellow and magenta filters; green filters are a *combination* of yellow and cyan filters; blue filters are a *combination* of cyan and magenta filters. Think of them as "convenience" filters. Remember, as the number of filters used in a filter pack increases, the danger of disturbing print sharpness increases. This becomes increasingly true as your filters become older and probably abraded and finger-printed with use.

As suggested earlier, it would be preferable to use a single CC50 red filter to conveniently replace five CC10 magenta filters plus five CC10 yellow filters; or, as another example, to use a CC50 red filter to replace a 40M + 10M + 40Y + 10Y.

92

Filter Arithmetic

Suddenly, at this point, we're into filter arithmetic so let's state the governing rules:

1. You simply add numerical values of the same color.
(Example) CC10Y + CC20Y = CC30Y

2. When combining any pair of cyan, magenta, or yellow filters, the values remain constant but the color changes.
(Example) CC10Y + CC10M = CC10R
(Example) CC20Y + CC10M = CC10R + CC10Y

There are many filters available! There are about forty different color compensating filters and, surely, it would be helpful to have several of each of the most useful ones. Which to buy? Let's help you by suggesting—complete with the reasons for the selection—several levels of filter versatility. Remember, buy only the CP filters (acetate) if you will use them over the condensers; and only the CC filters (gelatin) if you will use them in front of the enlarger lens.

Minimum Filter Set

05M (one each)	05Y (one each)
10M (one each)	10Y (one each)
20M (one each)	20Y (one each)
40M (two each)	40Y (two each)

Even with such a streamlined selection of filters, you can print most average negatives. Doubtless, it will frequently be necessary to combine several of these filters to achieve sufficient filtration. This presents no difficulty when the CP (acetate) type of filter is used in a filter drawer in the enlarger. However, if the CC (gelatin) type of filter is being used over the lens, a degradation in image sharpness and contrast can occur when you combine four or more filters to make the desired filter pack, if the filters have become scratched or dirty. The principle is, obviously, to use as few filters as possible. So you see, you should understand filter arithmetic not only for economy but for print quality.

The number of filters needed to make the right filter pack can often be reduced by adding CC red filters. Accordingly, we suggest adding to the minimum set as follows:

Convenience Filter Set

CC05R (one each)	CC30R (one each)
CC10R (one each)	CC40R (one each)
CC20R (one each)	CC50R (one each)

Of course, you can see it's more convenient to use *one* CC30R filter than the four *equivalent* filters, CC20M + CC10M + CC20Y + CC10Y.

What printing situations do not fall within the control capability of the convenience set? First, you cannot make very subtle changes in color balance. To do this, add the following filters to your growing collection:

Versatile Filter Set
CC025Y (one each)
CC025M (one each)
CC025R (one each)

When would these be useful? *Never for* sunsets, most landscapes, or subjects composed of strong, bright colors—you really wouldn't notice the difference in the prints. However, there are "color-sensitive" subjects such as low-contrast, high-key, full-face portraits where a 0.025 color shift makes a noticeable difference indeed. Also, there may be a commercial-type subject in which the subject color needs to be as closely adjusted to the color of the original object as possible.

Occasionally, an unusual negative may require small amounts of cyan, blue, or green filtration. However (if you understand your filter arithmetic), it is not necessary to own sets of these filters: *You can make these occasional prints merely by possessing a high-value CC cyan filter,* namely a CC40C.

Extra-Versatile Filter Set
CC40 cyan (one)

Here are the whys and hows: Suppose you had taken a closeup portrait with the subject in the shade and his face illuminated only by intense blue skylight. In printing such a negative, you'll probably find that even if you remove all the yellow filters from the filter pack—right down to zero—the resulting test print would still indicate the removal of *additional* yellow filters. What to do now? Of course, you can add CC blue filters, but you don't have any, and may not wish to acquire such a set.

Here is the simple solution: You can use a high-value CC cyan filter such as a CC40C, and rebalance the enlarger light using only CC yellow and CC magenta filters.

An example may help to illustrate the concept: Let's consider a print you have just made using a CC30M filter. It's

too blue and you estimate that a better print could be made next time by adding a CC10B filter. However, if you have been following our filter acquisition suggestions, you don't have a CC10B. Never mind, here is the way to solve this problem:

First, write down the values of the previously used filter pack:

CC30M

Now to this add the needed CC10B in terms of its *equivalent* magenta and cyan values (CC10M + CC10C):

CC40M + CC10C

This is the *desired* pack; but you have only the CC40C, which is 30 more cyan than you want. Put it in anyway and "neutralize" the extra 30 cyan by *also* adding an extra CC30M and a CC30Y.

The final pack of filters to be used in the enlarger thus becomes:

CC70M + CC40C + CC30Y

Since equal values of magenta, cyan, and yellow are neutral density, the effective filter pack is CC40M + CC10C with the "mathematically removed" CC30M, C, and Y. Now you can make the print. Just remember that there is indeed a "30's worth" of neutral density in the pack that will necessitate increasing the exposure by one full stop.

Chapter 7

Printing Color Transparencies

You undoubtedly have color slides from which you'd like top-quality enlarged prints. There are two basic methods to accomplish this.

THE INTERNEGATIVE METHOD

An internegative is a special color negative—usually enlarged to a convenient handling size—made from the original color transparency. Although it is possible for you to perform all the time-consuming steps necessary to make your own internegative, it is preferable, by far, to have this internegative prepared by a commercial laboratory specializing in this service. A commercial laboratory that produces internegatives will prepare internegatives to nearly any desired size. Standardized formats of internegatives can be made by placing an order through your Kodak dealer for $2^{1}/_{4}'' \times 3^{1}/_{4}''$ size internegatives from full- or half-frame 35mm transparencies. Internegatives $2^{1}/_{4}'' \times 2^{1}/_{4}''$ can be made from 126, 127 and $2^{1}/_{4}'' \times 2^{1}/_{4}''$ (120) square transparencies. The cost is far *less* than buying all the necessary materials and, in addition, the laboratory operates under the controlled conditions needed to produce an internegative that will print satisfactorily. If you've never tried to make an internegative before, you'll probably waste a lot of time and materials making your first ones.

Print this internegative just as you'd print any conventional camera negative with the same equipment, paper, solutions, and so on. However, you'll find that the color balance (the specific filter pack required) will probably be appreciably different. This is because the internegative material is manufactured differently

from conventional color-negative films used in the camera. Specifically, the masking layers and the sensitometric curve shapes are designed to operate efficiently as an intermediate film. Therefore, you'll have to make your own exposure and filter-balance trials to see what these differences are.

THE REVERSAL PAPER METHOD

The second method uses a reversal color paper, such as Kodak Ektachrome RC paper. You can print a color slide *directly* onto this paper without any intermediate step. It uses the same developing equipment, including the usual color-compensating filters, as employed for negative-positive printing.

There are several differences, however, in using a reversal color paper:

1. A Kodak Wratten filter, No. 2E, is substituted for the Kodak Wratten filter, No. 2B (which was required for negative-positive printing).

2. *Total* darkness should be used in handling and processing Kodak Ektachrome RC paper.

3. The enlarger should have an efficient infrared absorber in the system. Enlargers equipped with heat-absorbing glass or heat-absorbing condensers are adequate for most printing conditions. (When the infrared absorption is somewhat inadequate, you will notice a decided printing difference between different types of printing materials—say, between Kodachrome and Kodak Ektachrome film.) Most commercial laboratories using Kodak Ektachrome RC paper minimize these differences with an expensive infrared cutoff filter, such as the Kodak infrared cutoff filter, No. 304. Because these are available only in small size, they are customarily used below the lens.

You may want to consider the economic feasibility of segregating the transparency materials into like products and printing each type with a filter pack appropriate to that group.

4. The biggest difference is the readjustment of your color thinking from negative to positive! As compared with the negative-positive procedure described in the preceding chapter, things are reversed. For example, the *more* exposure Ektachrome paper receives, the *lighter* the image will be. Conversely, the *less* the exposure, the *darker* the print will be.

As for the filters, the color of the print changes in the same direction as the filter color. Thus you would *subtract* a filter of the color that was in excess in the print, or *add* a filter complementary to this same hue. Just so there will be no confusion, consult this table:

If the test print was too ...	Add	OR Subtract
Cyan	Red (or magenta & yellow)	Cyan
Magenta	Green (or yellow & cyan)	Magenta
Yellow	Blue (or magenta & cyan)	Yellow
Red	Cyan	Red (or magenta & yellow)
Green	Magenta	Green (or yellow & cyan)
Blue	Yellow	Blue (or magenta & cyan)

Before plunging headlong into print-making, you can have no better advice than to study the sheet packaged with the paper; it contains useful starting filter-pack information.

Once again, we can practically guarantee you will not get a good print the very first time. It will probably reduce the number of attempts to obtain a good print, however, if your first print incorporates a series of test exposures centered around the manufacturer's suggested starting point; one of the density levels in this series of exposures should be at or near the final desired density. It's important to use this level to facilitate evaluation of the color balance (Judging accurate color balance from an unusual light or dark area is very difficult).

Evaluation of color balance is exactly analogous to that for negative-positive printing. Remember, however, to reverse your filter thinking.

Process according to the manufacturer's instructions using either the Kodak Ektaprint R-5 chemicals (for trays and tanks) or the Kodak Ektaprint RD-5 chemicals (for drum processors). These chemicals are unavailable in kit form, but can be purchased individually.

98

Your Photometric Eye

Once a good print has been made from a given transparency material, such as Kodachrome 25 film, you'll find that in making other prints from other Kodachrome 25 transparencies your eye is the best photometer you can use. Why? Because you can directly compare a new slide alongside the one previously printed. If the new slide is just as good as the other one in terms of its density and color quality, you can print the second transparency identically with the first one, and you should achieve satisfactory results the first time. The reason your eye serves so satisfactorily as a photometer is that you can visually judge the colors and density from an aesthetic standpoint with a high degree of accuracy, and this is what is meaningful in a print.

On the other hand, the same visual judgment cannot be used for color negatives because the tones and colors are reversed and furthermore the visual evaluation is obscured by the needed masking color.

You can also prejudge the printing conditions for a transparency that is not the same as your first one. For example, you might have an excellent slide you want to enlarge, but you can easily see it's too blue. Compared to your "normal" first picture, it would need additional yellow filters in the filter pack. With practice, you can easily estimate the amount of yellow you must add. Until you have acquired this proficiency, however, we recommend using the judging filters contained in the Kodak color print viewing filter kit.

Don't forget: If a subsequent transparency is slightly lighter than the normal, give it somewhat *less* exposure in order to make it print *darker* than it otherwise would.

As mentioned previously, it is a good idea to segregate slides into brand types to achieve convenience in printing similarities. In other words, you'll want to compare an Ektachrome slide with another Ektachrome slide and not with a Kodachrome slide.

Incidentally, the usual enlarging mask that masks the edges of the paper will give black borders in the finished print. If you want white borders, it will be necessary to flash the border areas with white light while masking the center of the paper with opaque material. (Print flashing techniques are described in detail on pages 143-47.)

Chapter 8

Making a Better Print

VIEWING CONDITIONS

At last your print is finished. Or is it? Consider these points: First of all, is it too light or too dark? How dark or how light should you make a particular print, anyway? Why, an average, realistic lightness, of course. But although this answer seems simple enough, its attainment may not be easy. For instance, you might make a print that looks just right to you in the fairly bright "white light" illumination of your darkroom. You find out later, however, that the friend to whom you gave the print has hung it in a windowless hallway, and to everyone who sees it there it looks too dark. Well, it *is* too dark for the level of illumination in that hallway.

This is just one of the pitfalls of trying to make a print of exactly the right density. Let's imagine you're back once again in the darkroom—when the print is still wet—and you're first examining your picture. In the first place, a safelight, however bright it may be, is not a satisfactory light by which to judge print contrast, image tone, or density. A safelight has neither the proper intensity nor color quality to be used for this purpose. Yet many print-makers, wishing to make several identical prints from a negative, will examine the first test print by the darkroom safelight and, thinking that the print exposure is correct, will make the remaining prints on the basis of this erroneous judgment.

There is a particular danger when working with fairly warm-toned or cream-colored stock papers. The yellowish safelight may be reflected quite strongly from the warm image tone; but the finished print may be viewed under subdued daylight or by bluish fluorescent tubes, giving the impression that the exposure should have been decreased by 10 or 15 per cent for optimum quality.

Another danger to watch for is the "drying down" of normal

100

to low-key black-and-white prints made on a fairly dull-surfaced matte paper. While wet with the hypo bath or the wash water, the surface of matte papers acquires a temporary sheen due to water providing a more uniform reflecting surface than the usual texture of the paper surface itself. The shadows of the picture appear more luminous, and you can see darkish details more easily than when that same print is dry. Since low-key pictures generally depend more on shadow details than normal or high-key pictures, "drying down" is particularly evident with these subjects. Accordingly, if you want to appraise print density accurately, the print should be thoroughly dry; just blotting or wiping off surface water will help, but not enough, since even subsurface moisture can give this emulsion an unnatural sheen. As mentioned previously, for best appraisal conditions, you should view the thoroughly dry print in about the same quality and brightness of illumination as that in which you plan to display the final picture.

The viewing conditions for color prints are doubtless even more important than those for judging black-and-white prints. The color quality of the viewing light strongly influences the apparent color balance of the color print. Accordingly, the print should be illuminated by a light of the same color quality and intensity (at least 50 footcandles) as that under which you plan to view the final print. The color quality for judging color prints should be illumination with a color temperature of approximately 3800 to 4000 K. This is approximated by several types of fluorescent tubes, including Westinghouse Deluxe Cool White or General Electric Deluxe Cool White. You can also view the results satisfactorily by using a mixture of fluorescent and tungsten illumination. For each pair of 40-watt Deluxe Cool White fluorescent tubes, you can use a 75-watt frosted tungsten bulb.

You'll remember that for best evaluation, black-and-white prints should be completely dry. The same is perhaps even more true for color prints, since, while wet, even correctly exposed color prints appear bluish and slightly dark. Try this: hold up a wet color print in front of a strong tungsten-light source and view it as a transparency. This will greatly facilitate an accurate evaluation of the colors in the middle tones.

You can appraise both black-and-white and color prints according to their final use even further. Keep in mind that a

Color prints are opalescent and bluish when they are wet. To appraise the color balance more accurately, view a wet color print by transmitted light.

print placed in the center of a large expanse of white wall space will look darker than the same print placed in the center of a dark wall. Similarly, a print hung on a wall near a window must be printed somewhat lighter than normal for proper viewing. The window, in the same range of vision as the picture, causes your eyes to "stop down," leaving a reduced eye sensitivity to view a print that was probably intended for normal viewing conditions. This example of a print hung near a window may be somewhat unfair, since it is generally contrary to tasteful interior decoration. Nevertheless, the principles governing eye adaptability to viewing conditions in this instance are the same as those which successful salon exhibitors use to judge proper print density for salon acceptance.

As a final thought about print-viewing conditions, remember that at low levels of illumination you will find it difficult to compare the shadow details of a glossy print with the matte print from the same negative. In other words, the brighter the viewing light, the easier it is to judge print quality.

Thus far, we've been talking about that very first print that

you have made. Now you are going to reprint it, since no one has ever made a print that could not be improved. Obviously, *the secret of making better prints lies in knowing how to improve those you have made in the past.* With that in mind let's take a good look at your print. Hold it at arm's length and study it carefully. Ideally, to judge a print effectively, you should imagine that someone else made it. *Now* what do you think of it? Can you think of any way in which you could improve the print? If you are *completely* satisfied, then look again because nothing has ever been made that cannot be improved.

EVALUATION QUESTIONS

Is your print sharp? Or is it a bit *too* sharp and can you see every grain of the negative image faithfully in the print? *Usually,* you cannot make a print that is too sharp.

Grain? Don't worry about it. And that bit of advice should take care of the problem of excessive grain size in prints. But you know how photographers are—they still wonder if there isn't some magical means of reducing or eliminating the grainy appearance of large prints made from small negatives. In a word, there isn't. Many people have published schemes for reducing the grain size in grainy negatives such as (and here we're talking about black-and-white negatives only) bleaching and redeveloping with fine-grain developers or with dye-coupling developers. In general, however, these techniques are not satisfactory. If you obtain any reduction of grain size, you usually sacrifice contrast or, more seriously, image sharpness.

Make sure your negative process technique will give you the finest grain possible; avoid overdevelopment. If you are a miniature-negative enthusiast, you doubtless know of fine-grain film developers to help solve your grain problem. Or, if less sharpness will help, print your negatives on rough or textured papers or diffuse the projected image slightly. If you worry constantly about grain size in normal enlarging procedures, that is a danger signal; it may mean you are spending too much thought on the technique of photography and *not enough on trying to say something with your pictures.*

Are you *really* satisfied with your print? Step back about 15 feet from it. Do the details "carry"? If they don't, is it because

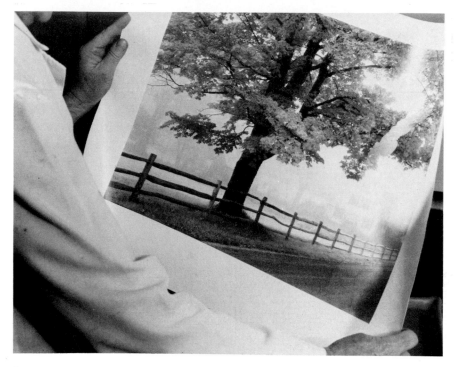

Only by careful study and analysis of every print you make can you improve your print-making technique.

Try this trick: View a new print *upside down,* and squint at it. This will help you decide about tonal relationships and compositional matters.

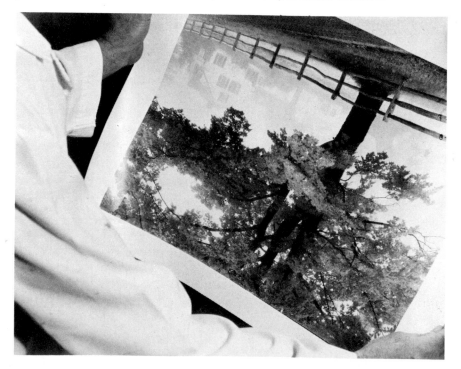

the print is too low in contrast? Check the cropping and composition in general. Now turn the print *upside down* and again check the composition for a balanced design. If you honestly cannot find anything wrong with the print, perhaps you have not asked yourself the right questions.

Maybe some friends can help. Sometimes it requires an artist's trained eye to see errors in composition, a technician to indicate how the print quality could be improved, or a printing expert to show you the best way to dodge a problem negative. Well-meaning but incompetent praise can only be misleading.

Often it will be helpful to take the print to a camera club for the members' constructive criticism. Professionals also have their print clinics. Incidentally, if you can't take a bit of "needling," better stay at home and take up the tuba, because this is often the "test under fire." You'll probably hear all types of suggestions, from a technical discourse on print reduction to "better crop about 20 inches off the top of that print!" Sift the wheat from the chaff and, after you come home or back to your studio, take a good look at your print and see if you agree with all the second guessers. Remember the salonists who put a picture in their homes where they can look at it every day for a week or so? Try it yourself. As you walk by the print with a sideways glance, it won't be long before someone standing nearby will probably hear you mutter, "Let's see; the left side should be cropped off a bit more, this cloud lightened—wonder how that corner would look a little darker. . . ." And before you realize it, you'll be heading back to the darkroom.

AVOIDING PRINTING PITFALLS

Latent Image Keeping

Let's say it's late in your afternoon or evening darkroom session. You've just made an excellent print—so good, in fact, you decide that you'll need another half-dozen exactly like it. While the exposing data is still fresh in your mind, you expose the other sheets of paper exactly the same way and put them away in a lighttight box for processing tomorrow.

In all likelihood, this batch of prints will probably be either lighter or darker than the first one. The culprit is the latent (undeveloped) image-keeping characteristic of the paper emul-

sion you happen to be using. This effect occurs with both black-and-white and color papers. It becomes more pronounced with time, but the actual rate and direction of change are really unpredictable. The only certain thing about it is that there will be a change.

Obviously, the practical way to avoid this printing pitfall is to keep the same time interval between the print exposure and processing.

Reciprocity Effect

This time you've made an excellent 8″ × 10″ print and it's so good that you decide you want a 16″ × 20″ version with exactly the same density. Of course, you realize that although this represents a two-times linear enlargement, the print needs *four* times the exposure because the new print will contain four times the *area.* If the exposure for the smaller print was 10 seconds, what will be the exposure for the larger print? It will be *more* than 40 seconds.

Here's the reason: The word "exposure" is actually a combination of two factors—it is a product of time and intensity. Since you can control exposure by either or both of these factors, you can obtain four times the intensity by opening the enlarger lens two stops. Or, you can multiply the time in seconds by four. Mathematically, either procedure is correct. However, from a photographic standpoint there is a difference. It is less efficient to expose four times as long, more efficient to increase the image brightness by four times. This behavior, which is found in most photographic emulsions, is known as the reciprocity effect.

To counteract this speed loss for most printing papers— black-and-white as well as color—you'll need to add 10 to 15 per cent when lengthening the exposure time. Watch out for the inverse effect: smaller prints become darker than a larger sample print. A convenient way to find the new exposure time when making an enlargement of a different size is to employ the "Color Printing Computer" dial in the *Kodak Color Dataguide (R-19).* This has been properly calibrated with a built-in compensating factor for the reciprocity effect.

You may find it interesting to know that modern, mass-production printing machines incorporate electronic controls, known as "slope controls," to automatically compensate for the reciprocity correction.

Paper Storage

Let's say that you're back from vacation or coming into your darkroom on a Monday morning to do some color printing. Properly, you had stored the color paper in the freezer. *A word of caution:* Allow the paper to warm up thoroughly to room temperature before opening it. Use the following table as a guide:

Warm-up Times from Refrigerated Storage

Paper Size	−18 to 21°C (0 to 70°F)	2 to 21°C (35 to 70°F)	10 to 21°C (50 to 70°F)
8″ × 10″ (25-sheet box)	2 hours	1½ hours	1 hour
8″ × 10″ (100-sheet box)	4 hours	3 hours	2 hours
16″ × 20″ (50-sheet box)	3 hours	2 hours	2 hours

The reason for this precaution is that moisture from the air can condense on the paper and be absorbed immediately by the gelatin of the emulsion. This could be an insidious condition. You wouldn't be able to see or feel actual droplets on the emulsion, but, nonetheless, the moisture would have been absorbed; and the characteristics of the paper would definitely have been affected. The absorbed moisture would produce unsharpness and noticeably different color balance, whereas thoroughly dry paper would not. Nonuniform densities might also result, depending on the local extent of the moisture absorption.

Photographic papers are a delicately balanced product and, like candy or cabbage, can present storage problems with which you should be familiar. Don't be concerned about the storage conditions of black-and-white papers. As long as they are not subjected to long-term keeping in summertime, attics, or damp basements, there should be no real problem. In other words, if stored at normal room conditions, black-and-white papers should keep well up to the expiration date stamped on the package.

Of course, black-and-white paper will undergo a normal, slow change of its sensitometric characteristics (speed, contrast, and so on) even under normal keeping conditions. The amount of change is so gradual and so small it is difficult to detect and of no practical consequence in day-to-day printing. On the other hand, if you don't plan to use a stock supply for a considerable time—weeks or longer—it would be a good idea to refrigerate or

even freeze it.

With color paper, however, things are different. Here's why: color paper has three different emulsion layers, each with its own keeping characteristics, all of which will not necessarily change at the same rate or direction simultaneously. When these small changes are translated into terms of color differences over a considerable period of time, they are readily apparent to the eye. For this reason we recommend that you keep color paper at low temperatures to decelerate the rate of change due to aging. Therefore, when you're not using your color paper for even a few days, keep it refrigerated or frozen. (Note: The color paper emulsion doesn't actually freeze—it's already a solid.) In fact, many commercial laboratories return their supply of color paper to the refrigerator each evening.

Newton's Rings

It's a humid summer day and some of your prints contain concentric ring patterns that are never twice the same. These print defects are the result of Newton's rings, which are patterns of light interference that can be projected down with the negative image onto the paper. They result in practically "un-retouchable blemishes." Newton's rings are formed between the negative and the negative carrier glass most frequently under atmospheric conditions of high humidity. If the printing can be postponed until a drier day, the trouble will probably disappear.

Here is how to combat the problem: Make a thin "soup" of talc or magnesium carbonate in Kodak film cleaner. The particles will be held in suspension by the liquid. Place the negative to be printed on a flat, clean surface with the emulsion side down. Dip a tuft of cotton in the suspension and rub it *lightly* over the back side of the negative. The liquid evaporates in a few seconds leaving a thin, even coating of the talc particles. Use a camel's-hair brush to even out any streaks or concentration of the particles. That's all there is to it; the particles provide just enough separation between the back of the negative and the glass of the negative carrier that the objectional rings will not form. Talc particles are small and will not appear in prints made with diffusion enlargers.

Condenser enlargers customarily employ glassless or "dust-less" negative carriers. Therefore, this treatment is not necessary for condenser enlargers.

108

Another way to prevent the formation of Newton's rings is with a "whiff" of the material known as anti-offset powder instead of the talc just discussed. This powder is used in print shops employing offset lithography. It's used in an atomizer to spray each sheet of paper as it emerges from the printing press to prevent the still-wet ink from transferring to the next sheet which will be stacked on top of it. Ask your friendly printer for a pinch of the powder; this much should be a lifetime supply.

There are other types of "mechanical" pitfalls including such obvious ones as spots, stains, streaks, fingerprints, and the like. To delve into an encyclopedic listing or myriad of mechanical black-and-white and color print faults is outside the scope of this book and fortunately these lists have been published elsewhere. However, the matter of artistic print faults does merit considerable attention.

ARTISTIC PRINT FAULTS

Artistic print faults might well be categorized as intangible faults. Many of these are concerned with composition, which means simply arranging all parts of the picture to form a harmonious whole. A creative print fault is somewhat more elusive than a mechanical error. A group of photographers will agree that fingerprints mar the appearance of prints, and they will agree that the best method of remedying the fault is spotting. But it is seldom that even two people will agree on the seriousness of an artistic fault and the appropriate treatment. They may, for example, agree that you should have printed one corner of your print darker. However, the exact amount of density you need to add to produce an "optimum aesthetic quality" is likely to remain a matter of personal opinion. In other words, heed the majority's vote to darken the corner, but try to decide for yourself *how much*. After all, it is your picture and it is here that print-making can give a wide interpretive range to your artistic ability. Photography has its rules, as does all art, but it is the individuality of the brush stroke that helps to make the master painter's work unique. Likewise, you should desire, pursue, and strive to attain photographic individuality. Could the prints be identified *without* your signature? Remember that photography has grown up. Contemporary photography is lean-

ing more and more toward creating an impression or an effect. For example, photographers have largely outgrown the idea that you must preserve full highlight and shadow detail, even "compressed detail." Therefore, they have learned to omit details, particularly shadow details, that do not contribute to the main effect and may distract or even lessen the total effectiveness of the message.

Here is why this is important to you: More often than not, a straight print does not utilize the full range or density scale of the paper; indeed, it is often physically impossible to do so. Do you think those shadows are *black* in the print you have just made? No, they are not; not usually. The prints may require some extra local exposure in the shadows to achieve an actual *maximum* black for the paper you are using. A maximum black is often very desirable from a print-quality standpoint, but printing in shadows means that some shadow details will be darkened and lost. Ah, the dilemma! In other words, you have two choices with regard to shadow details: (1) to preserve them if they are important in contributing to the total print effect, or (2) to print them down locally to a maximum black if they do not add to the print's effectiveness. Which to choose? This is a problem you will have to decide for yourself and *for every new enlargement you make.*

Probably the most important aspect of making excellent enlargements lies in realizing that the composition of a photograph is largely determined at the moment of exposure, *but not completely.* This is because both the method and the manner of print-making also influence its composition. Therefore, if you think you could improve your print, check the individual elements of composition over which you still have some measure of control. For example, should the print be horizontal or vertical?

To answer this, remember that a good recipe for picture-making is economy of subject material coupled with satisfactory spacing. In turn, the spacing is partially determined by the print size and shape. One of the great 16th-century masterpieces, Raphael's "Madonna of the Chair," is a circular picture. The composition was originally planned on a barrel-top, for want of other material, and the figures fill the space admirably. It is difficult to imagine this particular painting in any format other than circular without some loss of its effectiveness. Yet this

110

picture is exceptional; by far, the majority of paintings and photographs are rectangular, not oval, square, triangular, or other various shapes. From the ancients to the moderns, artists have found the rectangle most suitable for presenting their ideas. Photographers also take the rectangle for granted, and leave the matter largely to the manufacturers of photographic materials. Consequently, most print compositions are squeezed into conventional paper sizes of 8″ × 10″, 11″ × 14″, 14″ × 17″, and 16″ × 20″. Some of these popular rectangles are exactly proportional, the only difference between them being in size.

No one is likely to object to the composition if you use these rectangles for practically all of your print-making. Yet, you should not let convention dull your receptiveness to the novel ideas in picture shapes. Occasionally, an oval format is considerably more pleasing than the usual rectangle; sometimes a picture shape is square—any attempt to trim one side or another would introduce unwarranted restrictions or connotations on the subject. Rectangles themselves may be stretched out horizontally or heightened.

How does one know, you ask, when to alter conventional rectangular shape, or exactly how much to change it? The "when" is answered by the mood or atmosphere of the picture. The "how much" is answered by the type of subject and your individual treatment of that subject. If you are looking for something other than the tired old 8″ × 10″ proportion, you can use elementary geometry to find a pleasing picture shape. You may be interested to know that the ancient Greeks found one particular rectangle so pleasing in proportion that they named it the "Golden Section."

This is all part of *dynamic symmetry,* which you have probably heard about. Dynamic symmetry is, briefly, a system of pleasing proportions and interesting balances in design. It is based on a series of rectangles known as root rectangles because they are all derived from a square, which is "root one" rectangle. "Root two" rectangle is simply made by using the diagonal of a square as a side of a new rectangle whose end is equal to one of the sides of the original square. You've probably guessed by now that a "root three" rectangle is made by using the diagonal of the root two rectangle to form the side of a new and slightly longer rectangle. But school is out—it's really simple to construct these shapes as shown in following diagrams.

111

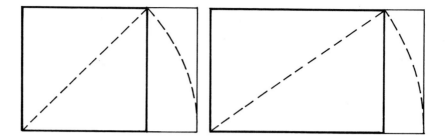

And after you are through, why not try to use one of these formats for an interesting new print size? Obviously, they will have horizontal and vertical applications.

Now look *inside* the picture frame. What can you alter to improve the print emphasis, unity, or balance? For example, is the principal subject—such as a sailboat in a marine picture—emphasized properly? Note the location of the sailboat in the print, its size, how it contrasts with the water or with other boats. You might improve the relative position of the sailboat by cropping one side of the print; you may alter its size by changing the degree of image magnification by lowering or raising the enlarger head. You may increase or decrease the boat's contrast with the surrounding objects by dodging, flashing, printing-in, or changing the print contrast—whatever you think is best. With this particular example you may achieve better balance if the foreground is darkened slightly. Or perhaps it will be more unified if that distant motor boat—the one at the left edge of the print vying for attention with the principal subject—is eliminated either by cropping or by one of the controlled techniques described in a following chapter.

You can analyze all photographs in a similar manner. Fortunately, no two prints are exactly alike; apply your artistic judgment to each new picture, and try to better each succeeding print.

If it will help, ask yourself candidly, "Does this print express what I saw when I exposed the negative?" Try to make a mental transition from the print to the original scene. See what may be missing, and then if possible, reprint accordingly. This may not be easy. Berenice Abbot says, "Prints which are made with lukewarm interest or a 'let the print take care of itself' attitude are never good prints. In most cases you have to sweat to get a superb print. The error comes from the attitude that

print-making is purely mechanical. Alas, too many prints look just that way; they look too photographic!"

How to "reprint accordingly" is difficult for a book to tell you. However, a knowledge of printing techniques may well provide the answer. For this reason, the following chapters are devoted to a selection of those essential print-making techniques: print flashing, combination printing, print reduction, and others. After you have read these chapters, think over all the possible ways of changing the appearance of your print regardless of whether it is black-and-white or color. Which of these will produce *the best possible picture?* Reprint accordingly.

Chapter 9

Light-Control Techniques

"Any photographer worth his salt has a set of cotton 'plumpers' to fill out sunken cheeks and some sealing wax to stick back prominent ears." So said Abraham Bogardus, one of the early photographers who made daguerreotypes, ambrotypes, and tintypes. With these processes, there was no negative and it was necessary to do any corrective "retouching" directly on the subject.

This rather droll advice points out the fact that the subject—whether a portrait or a landscape—is not always perfect, and it is up to the photographer to improve it if he can. There are several control techniques you can use. Some of these are concerned with the print, others with the projected image, but the beginning of control possibilities lies with the negative itself regardless of whether it is black-and-white or color. Since working on the negative is definitely related to the making of good enlargements, let's begin by discussing three of the most useful techniques that involve the negative. First, we'll discuss black-and-white negatives only; then, if there is something different about a color negative, we will identify this and explain it further. The techniques are pencil retouching, dye retouching—or "dye dodging," as it is sometimes called—and ground-glass printing. Each has a separate purpose, but often all three can be used to advantage in combination—something you might keep in mind.

"Any photographer worth his salt" should need a minimum of practice to start using these techniques proficiently to improve his results to new levels of success.

However, before you do ANY retouching or control work involving the negative—and this includes etching, pencil work, application of dye, chemical reducing, and so on—*read the following few paragraphs FIRST.*

Enlarging know how can often work wonders but there's really no good substitute for taking the picture correctly in the first place. This is the same subject, same pose, same place, same time, same electronic flash fill-in lighting . . . a different camera angle made the dramatic difference between these pictures.

PROFESSIONAL DIRECT DUPLICATING FILM

You should be aware of the remarkable product, Kodak professional direct duplicating film SO-015. This is a black-and-white film for making top-quality duplicate negatives either by contact-printing or by enlargement, in only *one,* single-exposure, direct-step operation. That is, it directly produces a negative from a negative without the need for an intermediate positive, and consequently, at a considerable saving of time and expense. The grain is extremely fine. In fact, if you duplicate a grainy negative, the grain of the *original* is all you'll see at ordinary print magnification! It is available in ordinary sheet-film sizes and can be tray, tank, or machine processed with the usual black-and-white film chemicals.

There are, of course, the obvious uses for which this film was designed, such as providing multiple negatives for production printing, "insurance" negatives of a valuable original, replacement negatives for glass plates or deteriorating historical negatives, and the like. However, let's consider just a few applications for someone like yourself interested in making quality enlargements.

1. If you had a 35mm portrait negative that required considerable pencil retouching, it would be so much easier to make an enlarged duplicate negative—say 4" × 5"—with this material and to retouch the duplicate.

2. Let's say you wanted to make a large print from only a small area of an original negative, and the degree of enlargement required was beyond the scope of your equipment. An enlarged duplicate negative would, of course, solve this problem.

3. Suppose you wanted a master printing negative of a specific size for a contact greeting-card production run. You can easily make an enlarged or reduced duplicate negative with your enlarger.

4. Of course, it would be better to do any extensive negative control work on an "extra" duplicate negative. If you want to practice dye dodging, for example, all would not be lost if you accidentally scrubbed away a piece of emulsion. Or suppose you wanted to use Farmer's reducer to bleach away the foreground of a cloud negative for a two-negative sandwich combination. You can do this on a convenient-size duplicate negative with no need to alter, and possibly damage, the original.

PENCIL RETOUCHING

Pencil retouching on the negative can be an invaluable method—one that often cannot be supplanted—of improving the final print results. For example, it is the best way of removing small facial blemishes from a portrait negative. However, despite the popularity of retouching in the professional studio, the joint limitations of reduced negative size and requisite skill make the technique difficult for use with most amateur film sizes. You could often save time and trouble, in fact, by taking a negative to a professional retoucher. Therefore, this section is not intended to be a complete treatise on the subject, but rather to point out that there are instances where a few adroitly placed pencil marks on a negative can help immeasurably to enhance print quality.

The smallest negative size that you can conveniently retouch is $3^{1}/4'' \times 4^{1}/4''$ or, at the least, $2^{1}/4'' \times 3^{1}/4''$, depending on the actual subject image size. You can accomplish wonders with miniature negatives, too, but only if you are sufficiently determined.

You can, for example, make an enlarged negative from all or part of your original miniature to facilitate retouching. The easiest way to do this, of course, is to print the original negative onto a sheet of Kodak professional direct duplicating film to make the enlarged negative. Otherwise you'll have to undergo the two-step procedure of making a film positive and then enlarging this positive onto another film.

One successful portrait photographer who uses miniature negatives retouches directly on the negative by using a magnifying glass more powerful than the final degree of enlargement. For instance, if he is going to make an $8'' \times 10''$ print from a 35mm negative (approximately an 8× linear enlargement), he uses a 10× magnifying glass as a guide for the extremely fine retouching required. Then he feels safe in assuming that, if the retouching appears satisfactory under a 10× glass, it should also be satisfactory in only an 8-diameter enlargement! But for most of us it is really more satisfactory to make an enlarged negative and use the normal procedure of retouching. In any event, a magnifying glass is a necessary accessory when retouching.

The retouching stand is your most important tool. While good stands can be purchased, any negative viewer can be

pressed into temporary service. It is also easy to construct a stand with a few pieces of board and a square of frosted or opal glass only slightly larger than the negative.

The most important feature of the retouching stand or desk is the brightness of the illumination. Actually, it makes little difference if the source is a tungsten lamp, a fluorescent tube, or reflected daylight, but too bright a light may cause eye strain and obscure fine details.

H and 4H pencils will meet most of your retouching needs. Be sure to sharpen them with No. 00 sandpaper to at least an inch-long point and keep them at needle sharpness for work on all negatives. Obviously, the finer the pencil point, the less noticeable the retouching will be on the print.

For a small amount of retouching, such as required by most panchromatic portrait negatives of babies and children, you will not need to use retouching fluid (a "dope" that provides an added tooth to the negative emulsion). For other negatives requiring a heavy graphite deposit, however, you will find retouching fluid helpful. In applying the medium, be sure you place the negative emulsion-side up on a smooth, flat surface. Use a minimum amount of the fluid (one or two drops should suffice for small to average-size negatives) and rub it immediately and briskly with a tightly wrapped cotton pad in a circular motion so that the retouching fluid will blend out to the edges of the negative and leave no line of demarcation that might show in the print.

Cut a hole slightly larger than the size of the area to be retouched in a black paper mask and place it over the negative on the inclined section of the stand. You are now ready to begin.

It is best to start first with a discarded practice negative or a duplicate negative and to work with an unretouched print from that negative as a guide. Then, as work progresses, you can, if you wish, make occasional proof prints for reference until you have completed the retouching. Just what to retouch and how much to retouch is up to you, since it will vary from one negative to another and with your personal preference. You may want to at least soften, or perhaps completely obliterate, miscellaneous blemishes in a person's face. Go easy on lines or markings that give the face its character and individuality of expression, since their removal would destroy the likeness or naturalness in a portrait. After all, your subject may feel like the old man who

118

said, in commenting on his thoroughly retouched portrait in which he scarcely recognized himself, "Why, it took me 80 years to get those lines in my face, and some fool took them out in 10 minutes!"

If your picture is a landscape, check carefully to see if you can improve the results by retouching (i.e., softening) unsightly wires, tree or shrub branches, sticks, stones, and the like. In all probability you may not be able to completely remove these objects with ordinary pencil retouching but you can soften or lighten them somewhat. It often helps if the highlights of clouds, or reflections on wet pavements and muddy roads are accentuated, particularly in backlighted scenes. Here the pencil work can be a great help.

Throughout your retouching, remember to use a light, extremely fine pencil stroke. The "stroke" is usually a series of minutely penciled lines resembling figure 8s, 6s, 9s, 0s, and the like. Consequently, no two people have exactly the same stroke, just as no two people write in the same way. Avoid using straight lines. Build up the retouching gradually; if the 4H pencil does not deposit sufficient graphite, try the softer H pencil. If this still isn't enough, apply a retouching "dope" to the *reverse* side of the negative and pencil there to add more density. Never bear down with the pencil, as excessive pressure may cut the emulsion; the risk is especially acute if you use a hard, sharp pencil.

Keep these three general rules in mind:
1. Match the density of the defect to the surrounding area.
2. Avoid the tendency to over-retouch a negative.
3. Create no abnormal retouching that will appear nonphotographic in the print.

Finally, if the retouching is not to your satisfaction when the job is completed, you can remove all pencil marks with another application of retouching "dope," and you have a second chance to begin all over again and correct your previous mistakes.

In one sense, a photographer may be compared to a magician: the fuller his bag of tricks, the more accomplished his performance. Fortunately for us all, straight retouching techniques are not difficult to understand and master and at the proper time they are good tricks to have up your photographic sleeve.

RETOUCHING COLOR NEGATIVES

Retouching color negatives with pencils is very similar to retouching black-and-white negatives. The same pencils, retouching fluid, and procedures apply but with a few minor differences. The first is that color negatives cannot be etched successfully because of the three different-colored emulsion layers. Secondly, subject-for-subject, color negatives need less retouching. The reason is somewhat psychological: normal facial lines in a black-and-white portrait seem more objectionable than do the same lines in a color print, where they are accepted as more natural.

It's a good idea to make an enlarged proof on Kodak Panalure paper to help assess the need for retouching. Don't make this proof on a non-panchromatic paper because reddish blemishes will be unduly darkened and overemphasized.

Use black graphite pencils for most color-negative retouching except for reddish facial blemishes. You can easily neutralize these areas, which appear cyan in the negative, with a brick-red-colored retouching pencil.

You're more apt to need retouching fluid for color roll-film negatives than for sheet films, since the larger sizes, often used for professional portraiture, are manufactured with a built-in "retouching tooth." If you need only slight retouching, apply it to the emulsion surface; if you need more retouching, then apply it to the reverse side. You can apply a maximum amount by using both sides in conjunction with retouching fluid. Cover pinholes—light spots caused by dust particles on the film during exposure—with a tiny bit of Kodak opaque, using a very fine-pointed brush. You can then cover up the resulting white spot on the print with dyes.

If you desire more detailed information on color-negative retouching, see the Kodak pamphlet, *Retouching Color Negatives (E71)*.

DYE RETOUCHING

Dye-dodging steps in where pencil retouching leaves off. While it isn't suited for fine detail work like facial blemishes in the portrait negative, it is excellent for the local dodging of

moderate-sized areas in the negative. For example, with this technique you could lighten hair by several tints, add needed detail to an underexposed tree trunk, or emphasize cloud highlights. If you wish to lighten the shadow side of a building in a strongly sunlighted outdoor scene, for example, an overall medium application of a weak dye solution will do the job much better than dodging manually when you expose the print. Or, if you wish to vignette a high-key portrait so that the image will fade out gradually at the edge of the print into clear white paper, make repeated applications of a fairly strong concentration of the dye at the edge of the negative until the dye acts like opaque and effectively blocks out the light.

There are two advantages of dye dodging: no matter how many prints are made from a negative treated in this way, the dodging will always be exactly the same in each print—a near-impossibility if you make a print through ordinary hand manipulations. Also, this dye is absolutely free of grain or texture of any kind, and if applied properly, is undetectable in the print.

These near miracles are all in the realm of a water soluble, red dye called Kodak crocein scarlet, intended only for use on black-and-white negatives. The dye is easy to control because it is readily absorbed into the gelatin and lets you add practically any degree of density to the negative.

Kodak crocein scarlet is available in a 30ml (1 oz.) bottle, but this quantity is deceiving because a little will last a long time. A suggested procedure is to mix 0.7 gram (10 grains) in 30ml (1 oz.) of water to make up a strong stock solution that you can use to make up dilute solutions. For general work, a mixture of about 20 drops of this stock solution to 30ml (1 oz.) of water will be satisfactory; the actual circumstances will determine the specific strength. Nevertheless, this mixture will serve as a guide, and you can alter it later as you see fit. Naturally, the working solution should be more concentrated if you intend to build up heavy density than if you only want to lighten slightly the shadow side of a baby's face in a delicate, high-key close-up.

The stock solution has sufficient strength to be used as an opaque to spot pinholes in negatives or to eliminate entire backgrounds, but use it with caution. You can add three drops of a wetting agent, if desired, to help apply the solution evenly.

Notice that the dilution amounts are given in drops. This

will not seem strange when you find out actually how little is required. Measure the stock solution and the water with an eye dropper, placing the required quantities of each in a small bottle or container. Use either a Q-Tip (a bit of cotton wrapped tightly around the end of a toothpick will do as well) or a spotting brush, and a retouching stand or a viewing box for the negative.

One of the first things to learn about using dye is not to apply it to the emulsion side of the negative. If you do, the gelatin emulsion may swell and soften with the moisture and become extremely susceptible to scratches. An exception is when you are working with miniature negatives, since the solution does not "take" very well on the reverse side. But treat these little fellows carefully! Dip the brush (or cotton swab) into the diluted dye and, using a twisting motion, wipe it across a scrap piece of blotting paper several times to remove the excess solution. Never use so much of the dye solution that it is possible to shake moisture out of the swab or brush. The retouching implement should be fairly dry for best results.

Using a circular motion, apply the dye to the desired area. At first you may see nothing but, after many turns of the brush, the negative will begin to take on a slight pinkish tinge. If you think the brush has deposited all the dye it can for the moment, recharge it but always be sure to keep it quite dry. A pool of the solution on the negative is *greatly overdoing it* and will spoil your results. Build up the dye gradually until the treated part has a definite reddish tinge. Remember that you can prevent unevenness of application only if you keep the dye-charged brush *moving* until all the dye on the brush is absorbed into the emulsion.

Now! Is that enough dye? There are two things you can do to learn your progress at this point: make a contact proof print (be sure the last application of the dye is dry), or examine the negative with either a blue or green filter. If you have no filter, use a piece of blue cellophane because blue is the near complement of red. You will obtain a fairly good idea of the negative's printing properties. As a matter of fact, you will be seeing the negative much as it will be "seen" by the blue-sensitive paper emulsion. If the retouching seems to be unfinished, return the negative to the retouching stand and add more dye, checking your progress periodically.

If you are dissatisfied with the dye dodging, remove all the

retouching by soaking the negative in plain water for several hours. A drop or two (no more!) of ammonia added to the water will help speed the removal. You can also remove the dye locally, if you wish, by using a clean cotton swab charged lightly with 28% ammonia. *Do not allow this ammonia solution to come in contact with the emulsion side of the negative because it may spoil it.* Remember, too, not to work with the uncovered ammonia bottle close to you since it is irritating to nasal membranes. Even a faint whiff of ammonia is harmful.

Some workers believe you can apply the dye solution more easily if you have previously soaked the negative and blotted away the excess moisture. However, it is best to practice this technique first with a discarded negative just to be sure you don't scratch the emulsion.

Perhaps the best way to practice retouching with a dye solution, until you get the "feel" of the process, is to fix out several pieces of film until they are clear, then wash and dry them, and attach one of the pieces to the edge of the negative with Scotch tape. Apply the dye solution to this blank sheet of film. Then, if you make any errors, simply discard this piece of cleared film and attach another.

For altering negative details, dye dodging is a valuable supplementary technique to pencil retouching, and a companion technique to the ground-glass work described in the following section.

By all means, purchase a bottle of the red dye at once, if you don't have one already. But don't just add it to the collection of bottles on your darkroom shelf—learn how to use it!

GROUND-GLASS PRINTING

With only the simple materials of a piece of finely ground glass and a soft pencil, any photographer with patience and a modicum of manual dexterity can transform a mediocre print into one with pleasing quality, and at little expense. The cardinal rule for this control technique, as for any retouching, is not to overdo it.

Primarily, this method consists of taping a negative—either black-and-white or color—in contact with a piece of ground glass on which you can draw additional negative details with a

pencil. This "sandwich" is then printed as a unit.

As you might expect, the work is somewhat easier with comparatively large-size negatives. Also, the penciling is less apparent because large negatives require less enlargement than do small ones to produce a print of any certain size. But, this does not mean that you can't use the ground-glass technique successfully with small negatives.

In this connection, a good magnifying glass will aid in smooth penciling. However, if you use miniature-size original negatives, you may find it expedient to make a large-size copy negative to which you can attach the ground glass.

A piece of *finely* ground glass about ¹/₁₆″ thick should be ideal. Inasmuch as you can obtain it inexpensively from a glass store, it is a good idea to purchase several pieces of the ground glass in the same size as your negatives. This will prevent extra trips to the glass store in case of breakage, or if you decide to make another print in this manner, the materials will be ready and waiting. *The finest ground glass is none too fine.* If you are unable to locate a very fine ground glass, it is possible to grind your own using emery of No. 1200 grade.

The appearance of the ground glass itself may at first lead you to suppose that it absorbs much of the printing light and may lead to trouble in printing. Fortunately, the loss of light is slight. This seems to be the case when the negative–ground-glass combination is assembled. Negative details are readily discernible, even when viewed from the back and through the glass. Although the appearance of the "sandwich" might indicate it would produce a badly diffused print, you'll notice very little difference in sharpness—even in enlargements of heroic proportions—between a single negative and the same negative after the glass has been added.

However, the addition of the ground glass does have a slight flattening effect on the print contrast. In black-and-white printing, you may want to use the next harder grade of paper than you ordinarily would use.

Bind the negative to the ground glass with transparent tape so that the smooth (base) side of the negative is against the smooth side of the ground glass. Apply the tape to only the edge and the borders of the negative and the glass, so that it will not interfere with those portions of the image you'll use to make the print. The matte, or ground, surface of the glass will then be

accessible for the pencil retouching, and the retouching will be separated by the thickness of the ground glass and the film base from the negative image on the emulsion side of the film. This is important because it is practically impossible to incorporate details in the pencil work on the ground glass with a definition as sharp as that of the negative image. So it is advisable to separate the retouching marks from the emulsion by a short distance so that the retouching will be suitably diffused in the print. Thus, in the final print, you can minimize the appearance of pencil work that would be rather obvious otherwise.

To add the desired negative shading or detail to the ground glass, place the glass–negative combination on a retouching stand so that the work is illuminated by transmitted light. If you don't have a retouching stand, you can use a contact-printer as a light table, or, as a last resort, you can work against the glass of an ordinary window by which daylight enters a darkened room. You can easily tape the combination temporarily to a clean pane of glass, with the negative positioned to "look outdoors" and the ground glass ready for the necessary pencil work.

You can do the actual retouching in several ways, depending on the amount of detail you wish to incorporate in the final scene. The softer the pencil lead, the more density you will create, so choose your pencils accordingly. You can do the sharpest work with a finely pointed, medium-hard lead pencil, which you use for adding missing details or strengthening sharp details that are already present but have insufficient printing density.

Soft-lead pencils are often used with an artist's tool known as a "stump." This is simply a tightly rolled piece of cardboard or stiff paper that is used to soften pencil lines by a slight smearing action. This is an ideal method for working clouds into a landscape or for adding a desirable amount of separation between a portrait subject in a dark-toned background if, indeed, the lighting in the original scene did not provide it. You can probably do your ground-glass work most effectively in this manner. You can obtain stumps in various sizes from artist supply stores, or make them as needed by rolling a small sheet of stiff paper to about the size and shape of a cigarette. Then whittle to a fine point with a knife just as you would sharpen a lead pencil, and roughen slightly with a piece of sandpaper.

The next method of retouching is reserved for compara-

Above: a straight print. Because of the gray subject, the gray background, and the hazy-day lighting, it lacks a satisfactory tonal range.

Opposite: the remedy was to tape the negative to a sheet of finely ground glass and then to reinforce the weak highlights with graphite. This enabled more print exposure to be given, darkening the shadow areas while retaining highlight details.

tively large areas of the negative. Scrape some graphite from a soft-lead pencil with a razor blade until you collect a little pile of the powdered graphite on a sheet of smooth paper. (You can also use a black pastel crayon satisfactorily.) Touch the finely divided graphite with a tuft of cotton so that a sufficient quantity adheres to the cotton. Using a circular motion, rub the cotton briskly onto a sheet of waste paper for practice and to smooth out the pigment. Then rub the cotton lightly on the areas of the ground glass which require treatment. Add the graphite density gradually, by building up the tones with a series of successive applications rather than by attempting one heavy application.

To see how the work is actually progressing, you may want to make one or more proof prints. These need be no larger than contact prints. By examining the results you are retouching, you can readily see, for example, that a pencil line may be a bit too prominent and needs subduing with a stump. Perhaps a cloud's highlight requires slightly more density, or a shadow detail needs improvement. Because the work progresses so easily, it is difficult to avoid undue enthusiasm and consequent lavish applications of pencil, all of which may lead to an undesirable, artificial appearance in the final print.

One other precaution to take is to avoid getting fingermarks on the ground glass. Oily fingerprints can cause areas of the ground glass to appear transparent. These areas then transmit light more readily than do the neighboring areas of the glass and the subsequent print may contain various dark spots caused by this carelessness in handling the ground glass. Use lightweight cotton gloves when you handle the ground glass.

On the other hand, you can use this same transparent effect as a method of dodging. Place a *small* amount of Vaseline on the ground glass, directly over a negative area that requires additional printing exposure, to produce a darker tone in the print at that place. We particularly recommend this method of increasing print density in a given area where you want to subdue brilliant print highlights.

It is possible to remove the pencil marks and oil spots from the glass if you wish to use the same piece of ground glass for other negatives. However, because of the low cost of the materials, and the fact that it is difficult to redraw the pencil work accurately after you have once removed it from the ground glass, you should leave the ground-glass negative sandwich

intact if there is a possible need for additional prints. Use a new piece of glass for each new negative.

In spite of these recommendations, if you have to clean the ground glass, you can do it easily by scrubbing the glass with soap and water and a stiff-bristled brush.

LOCAL PRINTING

Next to making good "straight" prints, local printing is the most important technique a print-maker can learn. Local printing sometimes is referred to as "spot printing" and it can make a world of difference in the aesthetic quality of either color or black-and-white prints. It can emphasize important details or subdue unpleasant ones, stress compositional lines, and regulate print contrast. It offers a simple means of improving mediocre pictures and of enhancing good ones. Yet local printing is more than a mere trick of the trade. It can be an extremely practical method of control; in deft hands it is an art in itself as a means of interpretation through painting with light.

Because of its nature, you must learn local printing in the darkroom. No musician ever mastered his instrument by reading in a book how to do it; it took practice. The same concept holds true for any craftsman, including the photographic print-maker.

DODGING

The first type of local printing in which you should become proficient is dodging or "holding back" light. The basic principles described in the following paragraphs apply to both black-and-white and color printing. There is a bit of additional information about dodging in color print-making that we will discuss at the end of this section.

Dodging is most commonly used to lighten objectionable dark shadows that, if printed normally, might be devoid of details. Dark shadows are seen in prints of excessive subject brightness range, such as an improperly lighted portrait, a landscape containing brilliant cloud highlights and dense areas of foliage, or a scene with a dark foreground and a sunlit distance. The range of tones may have been recorded satis-

factorily on the negative, but because of the limited density range of the paper, both ends of the scale have to be controlled individually—if you are to expose the print for the relatively more important middle tones. Very often you can improve such a print if the light coming from the shadow portions of the negative is partially retarded during the print exposure.

How do you know if you can improve a print by locally retarding the exposing light? The best answer is to try it and compare your results with a straight print. Exactly how much light should you hold back? Again, the only way to find out, unless past experience can help you, is to try several variations.

Dodging implements are perhaps best made as the occasion demands them, because probably no two negatives will present exactly the same requirements. In one instance, a tiny ball of cotton on the end of a broom straw will be a good dodger; an oblong piece of black paper stuck onto the end of wire will work in another situation; or perhaps you'll use a sheet of opaque cardboard to hold back an entire dark foreground area. You may wish to elaborate on any of the basic procedures, such as with multiple dodging, to secure a desired effect.

It is important in most types of dodging to *keep the dodging implement in gentle but constant motion* during the exposure. If you do this, you will have no definite lines of demarcation between affected and unaffected areas. The dodged area should blend in smoothly and artistically with the area around it. If the shadows appear light or unnatural, you probably over-dodged them. Study your faults carefully and try to correct them skillfully when making the next print. If you find you need a "third hand" when doing this work, a foot switch control on the enlarger may help considerably.

If you have a bit of tricky or involved dodging to do, be sure that your overall printing time for the print is not too short; with a 5-second print-exposure time, for example, you'll go slightly mad if you try to accomplish consistent, intricate dodging. In this case, it is better to stop down the enlarger lens two stops to have an exposure time of about 20 seconds in order to accomplish all the intricate dodging leisurely.

In dodging color prints you must control the *color* of the area to be treated as well as the density. Modify an undesirable color by mounting an old CC or CP filter on the end of a dodging wire. Tape a paper clip to the wire and simply insert the filter

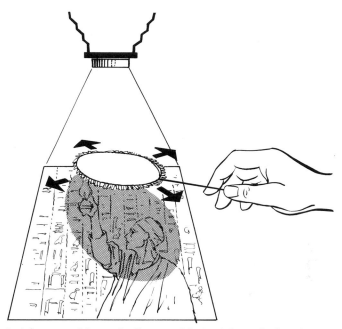

A round opaque dodging wand is an indispensable tool for printing. Use a *white* piece of cardboard for the dodger to keep better track of the portion of the image you are holding back. Your hand can be used as a variable-shape dodger. Keep moving the position of your wrist so as not to cause a light area where it holds back the image.

You'll need a good variety of dodging implements of varied shapes to fit all your printing needs. These tools can be used for either black-and-white or color printing.

into the paper clip. Just move this wand above the area to be treated during the print exposure. You'll need a high-value filter such as a CC40, since weaker ones won't have sufficient corrective effect. Select the filter color according to the same principles that apply to the usual filter corrective procedures. For example, a yellow dodger will reduce the yellowness of the treated print area. Save your old scratched filters for this purpose.

It may surprise you to know that you can form innumerable shadow outlines with your clenched fist. But the best dodging implements of all are those cut with a scissors from a proof print of the same subject. If this scrap print is the same size as the next one you are going to make, be sure to cut the dodging implement slightly smaller than the area to be treated, to allow for some image-beam spread.

Here's an example of this point, since it is well worth considering. Let's assume you are making a 14″ × 17″ print of a sailboat splashing along at a merry clip. The trouble is, you've

Of course the picture-taking illumination came from two portable electronic flash lamps and not from the kerosene lantern, as you can see from the shadows on the wall. This is a straight, normal-density print.

Planning the dodging attack via a small proof print. A soft pencil is used to indicate areas which will receive additional exposure.

134

decided, that the sky area in front of the boat is much too dark and needs to be lightened so the boat can "move into that space more easily." The problem is, then, to hold back a rather definite area of the sky in front of the boat. This is how to solve it: From an 8″ × 10″ proof print, which you can easily make for just this purpose, cut out that portion of the sky that you want to print lighter. Then use the cut-out piece of sky area as a dodger. You'll find that an 8″ × 10″ print is just about the right size to use for this purpose when making a 14″ × 17″ print from the same negative.

Hold your dodger up about ⅓ of the distance from the easel to the enlarging lens. The closer it is to the easel, the smaller the shadow on the paper, and the farther it is from the easel, the larger its shadow. While the size of the dodging implement itself may be constant, the area affected may be varied considerably by changing the distance between the implement and the paper. Note: Using the dodger close to the paper can easily create sharp outlines in the print, so be particularly careful to keep the dodger in motion.

PRINTING-IN

The second type of local printing is known as "printing-in," "burning-in," or "spot printing." The technique is identical for both black-and-white and color enlarging. It can darken a distracting portrait background or an excessively brilliant sky, or it can subdue unwanted reflections or highlights. In fact, the possibilities it offers you for exercising your artistic judgment are practically without end. It differs from dodging in that the density is intentionally *added* to a specific area instead of being subtracted. Also, printing-in takes place after giving the normal print exposure. Use it to subdue too-bright print areas: either add to the heavily exposed negative detail that did not record in an undodged print, or secure added emphasis for the main point of interest in the picture by further subduing subordinate areas.

Without any photographic paper in the easel, turn on the

The lantern was partially held back during the normal print exposure (opposite) and then the surrounding walls were dodged in. The telltale electronic flash shadows are still present, but the overall effect of the print is now far more dramatic, isn't it?

Above: the straight print—complete with bluish hair highlights. These were caused by blue skylight from a nearby window that was recorded in a rather long (slow) available-light exposure. Below: The remedy. It's a heavy blue filter (No. 80C), which was waved over the blue hair area during the entire print exposure. Even then, additional blue-light exposure had to be given to this area in order to print it down to a normal density. Opposite: the final effect. Generally, you'll need a high-density filter for local color dodging since weaker ones won't have a sufficient corrective effect.

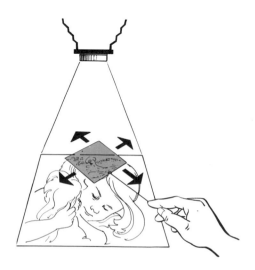

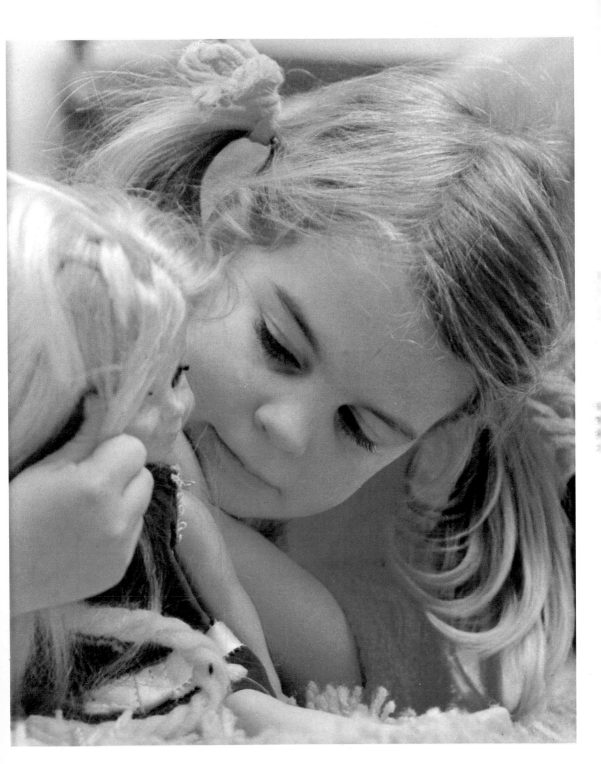

enlarging light and study the projected image of your negative. See how bright the side of that white house is where the afternoon sun hit it? Now cup your hands midway between the lens and the easel and practice blocking out all of the picture except just that brightly lighted area. Let only that particular portion of the light *and no more* pass through your fingers or palms. If you can't control the light with sufficient accuracy with your hands, cut a small hole approximately the shape of the too-light area in the center of a sheet of opaque cardboard and hold this over the easel. The cardboard should be large enough to cover the paper during the exposure. Now you are ready to try an initial print exposure with a subsequent printing-in exposure on the too-bright area.

Make a note of the normal printing time and also the duration of the additional exposure required to print-in the house until it is darkened sufficiently. Then, with this information filed with your negative, it will be a simple matter to reproduce the correct printing technique whenever necessary.

Just as you could hold back and change the color of local areas with a filter as the dodging tool, you can also print-in with a filter taped over the hole of the cardboard. Use a high-value filter (CC40) to achieve an appreciable color shift.

DODGING ON PAPER

There is an amazingly simple method of black-and-white print dodging that many photographers overlook. This is penciling or smudging directly on the paper before it is exposed. Suppose you wish to make a print of a landscape scene. There are several clouds in a row that could be lightened to advantage. Yet, because of the numbers of areas to be dodged, and because of the rather fixed outlines of the areas you want to dodge, it is practically impossible to do this with ordinary holding-back techniques. So this is how you proceed:

1. Get the dodging materials ready and put them next to the easel. The dodging material itself can be either crayon sauce (usually obtainable at art-supply stores) or finely powdered graphite. You could even take a soft (2B or softer) pencil and, with a razor blade, shave off some of the graphite into a small pile. Whatever your dodging medium, apply the graphite by

The straight print (above left)—complete with a dull, colorless background. Wouldn't these yellow flowers be more interesting if the background offered a contrasting color? It's easy to change it. After the normal print exposure had been made, a heavy yellow (No. 15) filter was placed over the enlarger lens, and the top portion of the paper was given additional yellow-light exposure to produce the interesting effect below. Of course the background could have been any color, depending on the color of the dodging filter used.

The photographer erred when taking this picture by allowing too much light to spill over onto the background. Note that the panel directly behind the wood-carver is distractingly bright, as is the frame of the scene on which he is working.

The overlighted areas are precisely outlined; therefore, they can be darkened properly by using a mask made on Kodak Pan Masking film to protect the remainder of the print while the overlighted areas are printed in. The final print is shown opposite. You definitely should master the technique of dodging with a mask if you are going to be a good color printer.

141

"smudging" with a ball of cotton, a tuft of cotton on a wooden match stick, or an artist's stump, as previously described.

2. Place the negative in the enlarger, focus it, make the usual adjustments, and determine time by means of a test strip. This much is routine procedure.

3. Place a red filter over the enlarger lens, position the unexposed printing paper in the easel, and turn on the enlarger.

4. Following the projected red image as a guide (during which time the print will not be exposed because the projection paper is not sensitive to red light), lightly smudge the areas that you want to print lighter than normal with the crayon sauce or graphite. For fairly large areas, such as clouds, a tuft of cotton is ideal for spreading the black powder. Dip the cotton into the powder, test it on a scrap piece of paper to see that a small amount will be deposited, and go over each cloud in turn. For more detailed work, such as the ruts in the road that you wish to emphasize, use the cardboard stump. And for extremely fine details, use a sharply pointed pencil—but use it gently.

Add the powder gradually, building up the density evenly with successive applications, if necessary. Be sure to use a circular motion so that the powder gets down into the "pores" of the paper texture and is not just deposited on the tops of the tiny surface bumps.

Use a sharply pointed pencil—with *very* light pressure, of course—as a limited "retouching" application in printing portraits with paper dodging. For example, you may wish to place or emphasize a line highlight down the length of a subject's nose, or you may want the eye catchlights to print bright and clear in spite of a diffusion disc placed over the enlarger lens. In cases such as these, it is very easy to mark the paper by using the projected image as a guide. It may be necessary to round out the catchlights by spotting after the processed print is dried.

5. Let's say that the sensitive paper has been smeared or penciled as desired, the red filter removed, and the normal print exposure given. Next, take a wad of clean cotton in one hand and insert the paper into the developer with the other. As soon as the paper is immersed, rub the emulsion with the cotton to remove the crayon sauce or graphite. Turn the cotton over and over while rubbing the print to pick up all of the dodging medium. It takes only a half a minute to remove the medium, as it should come off quite easily, and the job is done.

Obviously, this system of dodging, like other methods, has both its advantages and disadvantages. On the one hand, it is simple, convenient, and effective, but on the other hand it is not suited to volume print production, particularly where the dodging on several prints must match closely. Also, it works better with smooth-surface papers than with rough-surface ones, which are more difficult to "powder" without overemphasizing the surface texture. This is particularly true in even-toned areas that have no fine detail to help hide any dodging of this sort.

PRINT FLASHING

Print flashing is simply a technique of "burning-in" without the negative in the enlarger. It is an extremely useful method of controlling print tones and densities, of varying print contrast *locally,* and of subduing or eliminating completely any details or patterns that might otherwise be objectionable in a "straight" enlargement. We should point out that flashing is not a substitute for ordinary dodging or burning-in but is, in effect, a supplementary technique. Thus, any particular print may be both printed-in and flashed, depending on the effect desired. Keep in mind that flashing hides textures and darkens with a "grainless density," while printing-in brings out the detail and texture of the picture's highlights.

Area Flashing

You can use flashing in two ways. The first is for controlling the tones of comparatively large areas in the print. Let's take a hypothetical example and follow the technique, step by step:

The sun in the backlighted landscape scene glistens objectionably on the lake, which occupies the lower half of the print. Such reflections, if printed normally, may disturb the viewer since they might give him the feeling that he is looking directly at a brilliant light source. In other words, the reflections almost make him feel like squinting at the print, even though the highlights are not actual reflections of the sun but only small spots on white paper. As you realize, this myriad of minute reflections is represented in the negative by tiny areas of opaque silver, and it would be impossible in printing to darken each and every one of them down a tone or two by ordinary dodging

methods. Here is where flashing can save the print.

The procedure is to give the print its normal exposure time predetermined from test strips. Then, without moving the paper or the easel, remove the negative from the enlarger negative carrier. The empty negative carrier should be returned to the enlarger if it will help prevent any serious light leak from the lamphouse during the flashing exposure.

After replacing the negative carrier, stop down the enlarger lens at least 2 or 3 more stops (keep track of how many in case you want to reproduce your results) than you used to make the actual print exposure. It is desirable to reduce the intensity of the light in this manner, since it means that the flashing light will more nearly approximate the average brightness of the projected image and will be much more easily controlled then if it were to "blast through" brightly. Establish a level of light where the flashing exposures range from 10–20 seconds; any flashing time shorter than 10 seconds means that you will have to hurry the procedure, and you will find it hard to repeat the results.

Hold an opaque card at about ¹/₃ of the distance from the lens to the paper and, while keeping the card *constantly* in motion and shielding the upper portion of the print, expose the lake and sun reflection portion of the scene with the "imageless" light. The amount of flashing exposure depends on the effect desired, the height of the enlarger lamphouse, and the other related factors best determined by experiment.

The effect of this flashing is to subdue reflections considerably. Strange as it may seem, if you do the operation properly, you will not affect the middle tones and the shadow areas noticeably, because you usually notice a slight amount of fog density only in the highlight areas. Since the primary effect of flashing is the reduction of contrast and highlights, you can use this technique for local control over print contrast. For example, you can print the corners and borders of a portrait subject lower in contrast by flashing them and shielding the central area where the figure is located.

You may wonder how to control the placement of the flashing light without using the projected negative image as a guide. There are several ways in which you can do this. For instance, let us suppose that in the example of the backlighted water scene, you wanted to flash only the bottom portion of the

144

print as far up into the scene as the distant shore of the lake. Place a marker on each side of the easel at the shoreline while the negative image is being projected onto the easel. Then, with the negative removed, use an imaginary line between these two markers as a guide to the flashing.

Let's take a somewhat more complicated example: a portrait of a centrally located subject seated in front of an objectionably patterned background. The object is to subdue (or even darken considerably) the background without affecting the subject.

Here is how you should do this: After giving the normal print exposure, place a red filter over the enlarging lens so that you can use the projected image as a guide without affecting the exposure of the paper. Place a paper mask of the desired shape over the area you wish to protect. Then remove the negative and, taking care to keep the flashing approximately ¼″ *outside* or away from the edge of the mask, flash the paper on the easel. With this procedure, be *sure* that the light used for flashing does not strike the edge of the mask and cause a sharp line of demarcation in the print after development. True, this is a somewhat tricky operation, and you may not achieve the desired results on your very first attempt. However, a flashing procedure such as this does not require a particularly high degree of manual dexterity.

Flashing-in Details

The second method of flashing is used for subordinating objectionably bright print details. Although you can cut holes in an opaque paper or cardboard, and flash-in the print details in much the same manner as you would burn them in normally, you get much finer control with the use of a specially modified flashlight. You can easily convert an ordinary pen-type flash-light for this use by taping a cone of black paper around its tip so that you can project its light wherever desired onto the paper with an aperture as small as desired. To control the flashing more easily, it may be necessary, particularly with higher-speed projection papers, to reduce the light intensity of the penlight by taping one or more thicknesses of matte translucent tape over the flashlight lens.

Some expert print-makers prefer to construct a permanent, and somewhat more convenient, hand flasher that operates from an electric-light socket by means of an extension cord. A plastic

socket, such as that used for a miniature-base, Christmas-tree bulb, is a handy size, and a $7^{1}/_{2}$ or 10-watt frosted lamp will give about the right level of brightness. A cylinder of metal, an adjustable nozzle "snoot," and a simple off-on switch are all the other parts needed to do a good job of flashing-in details wherever necessary. This system has the advantage of not requiring batteries, thus assuring a constant brightness.

Let's just cite one hasty example of where such a technique would be extremely helpful: You are printing a portrait negative of a gentleman in a dark suit, but it shows an overly distracting white handkerchief projecting from his breast pocket. To try to darken in this handkerchief, which competes with the face for interest, would be a very difficult job since spilling the light accidentally past the handkerchief would also darken the suit and make a mess out of the whole affair. However, you could give this handkerchief a "squirt" of light with your local flasher in order to "knock it down" a few tones. Easy does it—better too little than too much flashing.

It is helpful, particularly with your first few attempts at flashing-in details, to flash small test strips and immediately develop them to check the results. Keep track of the flashing time as well as the general negative-exposure time, and alter your reprinting procedure accordingly. Do not try to flash the print while it is in the developer, even if you notice at that point that the original flashing exposure was insufficient. With some papers this subsequently-flashed area may have a warmer image tone due to its shorter development time. Such an area would be noticeable and objectionable if you toned the print later.

Flashing Print Frames

You can easily add interesting silhouette-type frames to a print by an adaptation of the flashing technique, and use these frames in many ways to produce unusual poster-type effects. Using various border masks, you can introduce silhouetted foreground objects, such as overhanging porch roofs or columns, in a landscape; or, you can put black oval frames around portrait subjects. Whatever mask outline you select, it should be simple and easily recognizable.

Suppose, for example, you want a waterfront scene or a group of sailboats to look as though you took them through a porthole. Only five simple steps are necessary:

1. Expose the print as usual.
2. Place on the print an opaque paper mask cut to the desired shape.
3. Remove the negative from the enlarger.
4. Flash long enough to blacken the borders.
5. Develop the paper as usual.

Controlled area or spot flashing can be accomplished with an ordinary pen flashlight. You'll probably want to tape a paper snoot over the flashlight lens to help direct the light beam. Be careful not to overdo this printing.

Let's elaborate on these few operations for the above example. After giving the correct print exposure, place a perfectly round object, such as a plate, of the desired size over the paper in the easel. While positioning the plate, keep the red safelight over the enlarger lens so you will not further expose the paper. Remember, this will allow sufficient illumination for you to see the projected image, yet the red light will not affect the blue-sensitive emulsion of the enlarging paper. After the plate is in position, remove the negative from the carrier, and give the printing paper a flash of light to blacken completely the remaining print area. When the print is developed, the central, unchanged portion of the marine scene will be framed by the artificial porthole. You can increase the illusion by partially blue-toning the picture. The deep blacks of the frame will give the appearance of being relatively unchanged, while the scene "beyond" will take on a pleasing aspect of reality.

Local printing is not always simple to execute properly, so do not be discouraged if you find it necessary to make several prints before achieving the desired results. Even the experts had to practice dodging or printing-in, and especially flashing, to become skillful. Remember, the next time you print a problem negative you *can* make a good print; local printing or flashing may help you do it.

DODGING WITH MATTE ACETATE

It is sometimes necessary to enlarge a miniature negative that requires a considerable amount of *precise* dodging. If you have followed us this far, you will recognize the problem immediately. Often you can't use ordinary dodging tools with complete success to dodge areas of odd shapes or contours. Also, if several print areas require simultaneous dodging treatment, how many photographers have the needed five hands to do the job? Use Kodak crocein scarlet on the negative, you suggest? Well, that may be helpful, but a dodging dye is difficult to apply to a small negative, particularly where sharp "edge treatment" of dark shadows is required.

The answer lies in using a sheet of matte acetate. The necessary shading is penciled onto the acetate sheet, which you place in contact with the enlarging paper. Then, when you give

148

the print exposure, the pencil markings and shadings are incorporated into the print. The process requires surprisingly little artistic ability for ordinary dodging results, and the materials are inexpensive.

Here are the steps for really precise and repeatable dodging of this type:

1. Compose the projected image and adjust the enlarger height as desired. Then turn the negative over so that the emulsion side is up and, with the negative in this position, make a *reversed-image* print.

2. Process and dry the print; tape it down onto a flat, well-illuminated surface. Now tape a sheet of clean matte acetate to the print so that the diffusing or matte side of the acetate is uppermost.

3. Using a medium-soft pencil and very light strokes, gradually shade in the areas which you want to print lighter. The fine tooth of the matte acetate provides an excellent retouching surface and permits you to use either a very light or heavy deposit of the graphite.

In many instances, the pencil lines alone will take care of the retouching or fine-line dodging that is required. In a portrait, for example, you can easily emphasize the highlight down the center of the nose or across the lower lip. Also, you can increase line-lighting effects and improve separation lines; or, perhaps you can lighten broad areas such as cloud "fluffiness" or a country lane. All of these areas require adding fine pencil lines to the acetate and then smudging or shading them with a tuft of cotton or a cardboard stump. The possibility of lightening broad areas means that you can practically add details where none exist in the negative; for example, a shaft of light from a church window (only if you can do this artistically!) or a lighter background for a portrait can be added.

4. After you think you've completed the retouching or dodging, turn the negative over in the enlarger to its normal emulsion-down position. Turn on the enlarger and, with the acetate sheet *matte-side down* in the enlarger easel, register the retouching with the projected image.

The registration is not difficult, but make sure it is accurate. This may require a *slight* adjustment of the height of the enlarger because the reversed-image print may have slightly changed its dimensions as a result of being processed.

After you line up the retouching with the projected image, tape down one edge of the matte acetate sheet so that the retouching can be swung away, like a page of a book, into or out of position.

5. Now you are ready to make the dodged print. Hold the acetate sheet up out of the way and insert a sheet of sensitive paper in the easel. Lower the acetate sheet onto the photographic paper and, to insure good contact between the two, place a clean sheet of glass over them. Make the exposure, process as usual, and the job is done.

Be sure, however, that the print is dodged exactly the way you want it to be, since it is easy to change the degree or placement of the dodging if you feel it could be improved. Perhaps you will want to regard this first print as a "progress proof." You may need to clean up some borders of the dodged area on the acetate sheet with an Artgum eraser or add more density to give just the desired effect. Once you've made these changes on the matte acetate, obviously you can make any number of prints with exactly the same dodging technique.

Because the matte surface of the acetate sheet is an effective light diffuser (and, in fact, makes an excellent diffusing material for use over flood-lamp reflectors), keep it in contact with the paper surface or else diffused images will result. It is for this reason that the glass plate is absolutely necessary and the matte side of the acetate must be immediately next to the printing paper. For this reason, also, the technique of dodging with matte acetate works best with smooth or fine-grained paper.

If the matte acetate sheet is in contact with the printing paper, it does not increase the print exposure appreciably. It does lower slightly the contrast of the resultant prints, but this is not serious and the amount is only equivalent to about half of a paper contrast grade. However, this is usually more than compensated for by the increased highlight brilliance this dodging technique provides. Also, be sure that the print receives full development; if the soft results still bother you a little, however, try using the next higher paper contrast grade.

Matte acetate sheets are available from your photographic dealer. He may have to order them for you, but they are available.

As mentioned previously, this technique can be used for either black-and-white or color print enlarging.

This is a good straight print. Yet it could be even more dramatic if highlights were emphasized and a backlighting effect were added.

Above: the apparently overdone retouching on a sheet of matte acetate. Below: The pencil markings now need smudging and softening until the retouched matte-acetate sheet looks like this. Use a cardboard stump, your fingers, or tissue paper to smooth out the prominent marks.

The retouched sheet of acetate is registered with the projected image, one edge is taped down on the easel, and the printing paper is placed underneath it for the exposure. Opposite: the retouched print.

Chapter 10

Special Printing Techniques

Tricks of the trade—that's what all craftsmen need. And the more tricks in enlarging you know, the better enlargements you'll make! So let's examine briefly the special printing techniques of diffusion, combination printing, texture screens, and vignettes, all of which are applicable to both black-and-white and color print-making.

DIFFUSION

Back in the early 1850s when exposures were long and enlargers but a dream of a mad photographer, one chap discovered diffusion. From the front of his camera to the floor he stretched a violin string. Then, while his subject sat immobilized in a posing chair during the lengthy camera exposure, the photographer sawed vigorously on the string with a violin bow. Diffusion indeed!

That was the 1850s. Today? Print diffusion is still with us and, from all appearances, always will be. But fortunately there are easier methods than our grandfathers first imagined for utilizing the diffusion principle.

Print diffusion is the effect created by an image that is not quite sharp. Why, you might ask, would anyone, after spending a considerable sum for precision-made, top-quality, coated camera and enlarging lenses, want to diffuse a print intentionally? Paradoxically, there are several good answers to this question. For example, diffusion can minimize the effects of minor negative defects, such as coarse grain and scratches, that may be particularly evident in greatly enlarged prints. You can hide coarse retouching marks on portrait negatives in the same way. From an aesthetic viewpoint, you may sometimes want to slightly diffuse your subjects, such as portraits of women or "atmospheric" landscapes, to create a more pictorial impression

rather than a literal one.

Diffusion may be divided into two general types, depending on the time at which it is introduced into the picture. Let's call the first "negative-type" diffusion, which you obtain by placing a diffusion disc in front of the camera lens when you expose the film.

The type of diffuser that is used, such as an adjustable portrait lens or an actual diffusion disc, depends on the degree of diffusion desired. Because the highlights of the subject reflect the most light toward the camera, the corresponding areas in the negatives will be affected (diffused) the most. Of course, this is not a printing technique, but you should at least be familiar with it as a commonly used method of altering the appearance of a scene.

In the second, or "positive-type" diffusion, the diffuser is placed in front of the enlarger lens. In printing, it is the shadow areas that receive the greatest exposure (from the clearer portion of the negative) and therefore they will have the greatest print diffusion. Unfortunately, diffusion is least visible in the shadow areas.

There are, nevertheless, advantages in each method. Although it is a matter of personal choice, negative diffusion is generally considered the most desirable. Backlighted wet-pavement bricks, backlighted blond hair, backlighted sparkling reflections in a winding stream—all of these are improved by a slight diffusion of the highlights from a pictorial standpoint. In fact, diffusion often imparts an ethereal quality to the photograph. As a general rule, all specular reflections (the most brilliant) are more pleasing when softened in this way. You will find less "strain" on the eyes in viewing a diffused photographic reproduction with specular reflections than you would with an undiffused one. Of course, the disadvantage of the negative-diffusion method is that you cannot make an absolutely sharp print from a diffused negative. You can easily overcome this by foresight, however, and make two film exposures, one normal exposure without the diffusion disc in place and a second, diffused version shot through the disc.

The advantages of introducing diffusion when you make the enlargement are readily apparent; the original negative still may be "as sharp as a tack," and you can easily control the degree of diffusion in a variety of ways.

Above: the straight print made as sharp as possible. Compare this effect with the two diffused versions. Opposite: slight diffusion introduced by a sheet of plastic held below the enlarger lens for half of the print exposure time. Below: heavy diffusion introduced by a sheet of plastic held below the enlarger lens for the entire print exposure time. (Photo by Don Maggio.)

Diffusers can vary from optical-glass diffusers made especially for this purpose to homemade diffusers such as plastic window screening. You can easily make a handy diffuser with a small piece of glass, clear lacquer, and an old toothbrush. Lay the glass on a large sheet of newspaper. Dip the toothbrush into the lacquer and hold it a few inches above the glass. Move the end of a spatula blade over the bristles in such a way as to splatter the surface of the glass with the lacquer. The tiny lens-shaped droplets on the glass act as diffusers. Make two while you're at it; a lightly spattered glass for slight diffusion effects and a heavily spattered glass for considerable diffusion effects.

The technique preferred by many print experts is to diffuse the image for only a portion of the total printing time and leave the remainder of the exposure completely undiffused. This technique results in a combination "sharp-plus-diffused" image that helps to keep the highlights clear and sparkling but, at the same time, hides the coarse grain, retouching marks, and the like. The proportion of diffused to undiffused exposure time will naturally depend both on the light-scattering properties of the diffuser and the final effect you desire. As a general guide, you might use a moderate diffuser for 25 percent of the exposing time and leave the remaining 75 percent undiffused. After diffusing a portrait print, sharpen the eye catchlights with a spotting brush.

As you have probably surmised, any type or degree of diffusion will lower the print contrast. Slight diffusion does not lower contrast appreciably, but with moderate to heavy diffusion it may be necessary to use a harder grade of paper in order to achieve normal print contrast.

Better too little diffusion than too much. Excessive diffusion quickly degrades print quality to grayish mush. Sadly, several years ago the degree of diffusion in both landscapes and portraits did border on mush. Fortunately, much of this fad has disappeared, and the modern tendency is to employ diffusion techniques only if they are necessary to enhance the photograph.

Speaking of artistic effects, try *local* print diffusion. With a dodger of wrinkled cellophane or, for a "diffused vignette" effect, with a hole cut in a sheet of cellophane, diffuse the print corners but not the center.

Above: the straight print. While an excellent pictorial shot, it could be improved by making the large boat as the center of interest even more dominant. Below: A diffuse-edge effect can be introduced by printing the image through a hole in a plastic file envelope. Keep the vignetter moving *vertically* during the print exposure.

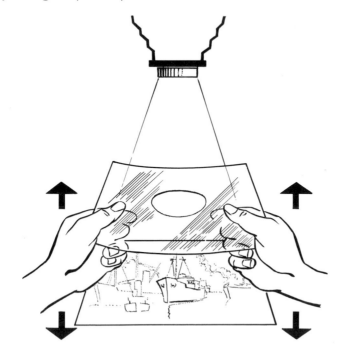

The final print really features differential sharpness. Notice how this treatment enhances the subject, heightening the foggy effect.

COMBINATION PRINTING

Of the many uses for combination printing, the most common is inserting clouds in a cloudless sky; and who among us, at some time or other, has not had a print that could be thus improved? There are several methods of adding clouds to a "bald-headed" scene, but the two most widely used are:

1. Printing two negatives simultaneously.
2. Printing two negatives separately.

If you are interested in improving your prints in this way, it would be farsighted to make a collection of negatives—black-and-white negatives will do for both black-and-white as well as color enlarging—that contain various types of cloud formations. Be sure to include some that are frontlighted as well as backlighted, since when you make a combination print the lighting on the clouds should be the same as on the landscape itself. Also, it would be handy if your cloud negatives were the same size as the landscape negatives. To make the job as easy as possible, the cloud negative should not contain any foreground whatsoever. How to do that, you ask? There are two ways: If you are using a 4" × 5" or larger view camera, it can be modified by attaching a black card to the inside *top* of the bellows about $1/3$ to $1/2$ the distance from the lens to the film plane. This card should be large enough to vignette about half of the ground-glass area. Thus, when you photograph a normal landscape, the sky will be exposed but the foreground portion will be obliterated by your vignetting card inside the camera. The other way to eliminate the landscape portion of a desirable cloud negative is to remove the silver image of the foreground with a chemical reducing solution (made by Kodak) known as Farmer's reducer; this solution is described for print-reduction techniques in a later chapter.

Photograph the cloud formation with a dark red filter over the lens. The red will hold back the blue of the sky, making the negative practically clear in this blue sky area but allowing the cloud to record normally for use in a cloud-negative sandwich.

From here on nothing could be easier from a printing standpoint: Simply position the two negatives as a sandwich in the enlarger negative carrier and print them simultaneously. Odd as it may seem, this technique of using a black-and-white cloud negative in combination with the color landscape negative

This full moon resulted from a short time exposure made on Kodachrome II film with a 300mm lens. An internegative was made from this transparency.

Obviously, this straight-print scene was exposed during the day, when there was enough light to use a high shutter speed to stop the action of the geese.

This dramatic combination print resulted from printing the moon negative and the geese negative as a sandwich. Note that the print density level is considerably lower than that of the straight print, creating the effect of dusk.

works just fine for color printing and the clouds will be white to bluish white in a normal fashion. Additional exposure will be necessary, especially in the sky area. Also, you may wish to print-in the clouds slightly to emphasize them, but you will find this out after your first test print from the combination "sandwich."

And now for the other method of printing two negatives separately. This is a type of double printing that you can use not only to insert clouds, but to make other types of combination prints as well—you are limited only by your imagination. Why even describe a second technique when the first one seems so simple? Well, just suppose that your desirable landscape picture had three birch trees in the foreground—surely you wouldn't want to print a cloud on top of them, would you? So, the key to this technique is extremely careful use of cut-out paper masks. This is how to print clouds into a blank sky, step-by-step:

1. Support a piece of clean plate glass about one-third the distance between the enlarger lens and the easel. Do this by laying it across two up-ended blotter rolls, wooden boxes, or anything else that is reasonably steady.

2. Insert the foreground or subject negative in the enlarger. Focus it on the easel, and stop down the enlarger lens diaphragm to where it will be during the print exposure.

3. Next, lay a large, discarded print or piece of white or light-tone paper face down on the plate glass so that it will intercept all of the light from the projected image. Fasten this paper lightly in place with Scotch tape.

4. With a sharp pencil, trace the horizon line or the edge of the area to be masked onto the paper. (Remember that the foreground trees should also be penciled into the mask.) Remove the paper.

5. With a *very* sharp knife, such as an etching knife or X-acto knife, cut just *inside* the trace line, into the foreground part of the mask, so that the projected edge of the foreground will extend slightly beyond the edge of the mask. This will prevent the formation of a white line at the juncture of the two images, as might be the case if you were to cut directly on the traced outline. The diffusion caused by the light passing the edge of the mask during the print exposure keeps this line from showing in the print.

Your mask should now be in two sections. Use the part corresponding to the foreground to shield the bottom part of the

164

If you are going to make beautiful landscape prints, you should have a good file of cloud negatives such as this one. You'll need backlighted clouds, frontlighted clouds, fat ones, long ones—all kinds—so that you can fit them to the foreground subject. Watch for these same clouds on the next pages.

165

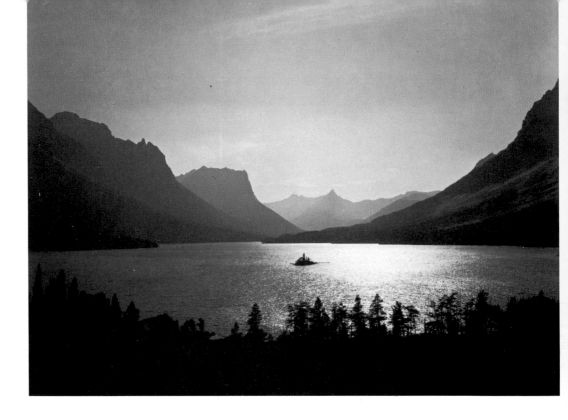

Would clouds enhance the scene above? Yes, but don't make the artistic mistake below—a naturally impossible backlighted foreground and front-lighted background clouds.

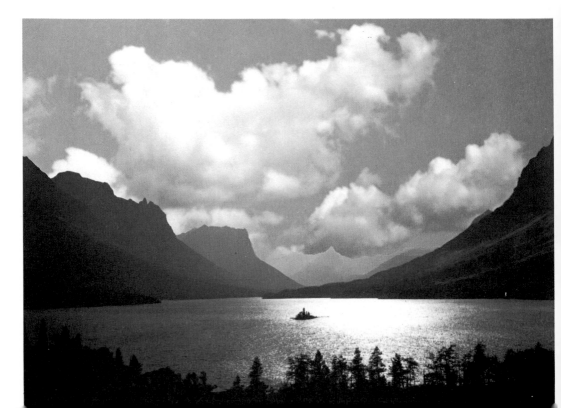

paper while the sky is being printed; then, use the top section while the foreground is being exposed. If the negative has a sky area so dense that it does not print, no masking of this area is necessary while printing-in the foreground; but this would be the exceptional case.

6. Trim the sky section of the mask along the cut edges so that just a little of the sky image will "spill" over it during projection. The amount to be trimmed away is very small—$^1/_{16}''$ or less if you are making an 8" × 10" print and up to $^1/_8''$ for a 16" × 20" print.

7. Project the image onto the easel; place on the glass the section of the mask corresponding to the sky, and tape it down. Get this mask into *exact* position; shift the glass slightly to do this after you tape the mask into place.

8. Determine and make the foreground exposure.

9. Mark the top and bottom lightly on the edge of the printing paper, and place the paper in a light-safe place.

10. Remove the sky mask. Do not move the foreground negative just yet. Then, using the projected image of the foreground negative as a guide, put the foreground mask in position on the glass. Be sure the mask is adjusted *accurately* and then tape it down.

11. Remove the foreground negative, insert the desired cloud negative, and readjust the enlarger if necessary. *Do not move either the mask or the easel.*

12. Replace the printing paper in the easel *precisely* as it was during the previous operation and print-in the clouds after determining the exact exposure time.

13. Remove the paper and process it according to the manufacturer's recommendation. If you've done all this correctly, your result should be a perfectly blended combination of the two negatives. If the two sections of the print do not match in some way, you can make a new print or perhaps conceal the error with careful spotting.

That's all there is to it. After one or two attempts, you'll agree it is a simple procedure. Just be sure, before you start, that the direction of the main light in both scenes is the same. It's rather disturbing if, for example, a cloud negative is printed with a landscape foreground and the sun position is different in each one. We mentioned this previously, but it's important enough to repeat.

Above: the straight, cloudless print. Opposite: improved scene with clouds. Below: the two Kodalith film masks that made possible the addition of the clouds—one for the foreground area and the other for the sky area.

Yes, clouds would help here.

The scene and the clouds are both frontlighted all right, but there is still something wrong, isn't there? (No clouds in the reflection!)

TEXTURE SCREENS

Suppose that, just before exposing a sheet of paper on the easel, you placed a sheet of tissue paper on top of the paper, and a sheet of clean plate glass on top of the tissue to hold it flat. Then you made the exposure, giving a little extra time to allow for the light to be absorbed, scattered, and reflected by the tissue paper. This is the simplest way of making a texture-screen print. The print image will be broken up somewhat, or "texturized," according to the textured pattern of the tissue paper. This effect is, of course, more suitable for some subjects than it is for others.

You can purchase texture screens commercially or make one from a translucent textured plastic sheet; use them in one or more thicknesses and for all or only a portion of the total print expsoure time.

You can also make texture screens from opaque subjects that have a textured surface, such as cloth or grained plywood sheets. To do this, shine a spotlight weakly across the surface of the opaque material and make an underexposed negative of it with your camera. Combine this texture-screen negative with the subject negative by either printing both together or enlarging the texture-screen negative separately onto a large sheet of film; in the latter case, handle the film as a true texture screen and print it in contact with the enlarging paper in the same manner as in the above example with the sheet of tissue paper.

A final word about using texture screens: Use them as often as you wish, but be sure they improve the final print or give the exact result you are seeking. The photographic process has enough merit to stand on its own two feet—to look good a photograph doesn't have to be disguised as an etching!

VIGNETTES

A vignette is a print in which the edges of the subject—usually a head-and-shoulders portrait—fade gradually into the surrounding area of the printing paper. There's no mystery about it: An image of the head and shoulders is simply projected through an oblong hole in an opaque cardboard held underneath the enlarger lens so that the print borders remain unexposed. Keep the cardboard in continuous motion during the exposure

A colorful design is the print goal of these bottles, and therefore, they make an ideal subject to print through a texture screen. Note also that there is no fine detail on which the print is dependent and which would suffer if obscured by a texture screen.

To create the patterned effect, a sheet of bubble plastic ordinarily used for packing was placed over the color paper and held flat by a sheet of heavy plate glass. (A life-sized contact print of the plastic appears below.) Which pattern do you prefer? Exercise your artistic judgment with caution—a spider-web texture may not be so appropriate on a baby's face.

the "fade-out" between the exposed and unexposed portions of the print will be gradual. You usually obtain the best vignetting effects with high-key portraits of women and children. Somehow, it's too delicate a treatment for a man.

However, if you have lost your enthusiasm for plain-vignetted prints, here's an idea: Try making a vignetted print that has a *gray* tone instead of a white tone surrounding the image. It's a little harder to make but, with the right subject, it may be more artistic.

The gray-toned background is produced exactly as though you were making an ordinary vignette, except that the edges of the paper are flashed after the vignetted subject is exposed. Here is a convenient way to do the flashing: Take out the enlarger lens after the subject exposure but leave the negative in place. Have ready a dodging wand of about the same size as the oval through which you projected the subject image. Take the exposed paper out of the easel and mark it lightly so you will be able to tell which side is the top and which is the bottom. Now place a test strip on the easel, and, with the usual test-strip exposure technique, find out how much exposure will produce the desired shade of gray on the print borders. Replace the paper with the portrait image oriented as it was previously. Turn on the

Here is how you'd do it: Simply project the central portion of the image through an opaque card with a hole of the appropriate size cut in it. Be sure to keep the vignetter moving during the print exposure.

enlarger, use the dodger to protect the subject area of the paper from the flashing light, and give the borders the amount of exposure indicated by the test strip.

It will probably take a few trial prints before you get the exact effect desired, but it will be worth your while when you do. Just don't start to make a vignette like this with your last sheet of paper!

Suppose you wanted to eliminate the overlighted bonnet from the straight print and concentrate the viewer's attention solely on the face. Vignetting is equally easy with color and black-and-white prints. A gray or colorful border area can be substituted for the white border if desired.

Chapter 11

Making Black-and-White Prints From Color Originals

USING COLOR NEGATIVES

Yes, you can easily make an excellent black-and-white print from a color negative with ordinary enlarging procedures. Such a print might be useful, for example, for reproduction purposes where color would be too expensive or impractical.

To make the best-quality print, you should use a panchromatic paper, such as Kodak Panalure or Panalure portrait paper. These papers employ a special form of panchromatic sensitizing that enables them to record equal amounts of the three color images—cyan, magenta, and yellow—comprising the total color-negative image. (Actually, the papers have the greatest sensitivity to blue light to compensate for the orange masking-layer color.) You might say that these special papers see to it that a "fair share" of each negative image is recorded so that the result is equivalent to a black-and-white print made from a black-and-white panchromatic negative.

If you use a conventional enlarging paper to print a color negative, you can indeed make a print that might seem satisfactory at first glance. But this print would be virtually identical to those made by photographers during the old era of "color-blind" films. Such films, which were sensitive only to blue light, reproduced colors erroneously in terms of their visual brightness. For example, a red fire engine would appear almost black, while a bright blue bathing suit would appear nearly white. Since blue and white are almost the same colors to these films, clouds simply disappear from landscape pictures.

Besides being able to achieve a normal panchromatic tonal rendition with color negatives and Kodak Panalure papers, you can also introduce special effects. You can, in fact, introduce all

The color print opposite shows how the colors of the original subject appeared. Using this as a reference, look back and forth between the color print and the different variations of the black-and-white prints. This shows the astounding degree of control you can have over the monochrome tonal relationships.

Above left: a straight print from a color negative made on Kodak Panalure paper. This paper is designed to produce a tonal rendering similar to that of prints made from negatives on panchromatic film. Above right: Black-and-white prints can be made from color negatives on ordinary Kodabromide enlarging paper. However, this is a non-color-sensitized paper, and the reds of the original become a very dark gray. Below left: Filters can be used with Panalure paper to subtly or drastically alter normal panchromatic rendering. In this case a very dark red filter (No. 29) made the sky black and the umbrella white. Below right: A complete reversal of tonal relationships was produced by using a dark blue filter (No. 47B), which rendered the sky white and the umbrella black.

the filter effects in the darkroom that you might employ when taking an original black-and-white picture on panchromatic film. For example, you could use a yellow filter on the enlarger lens to moderately emphasize the clouds, or a red filter to greatly exaggerate the cloud-sky tonal difference.

Don't forget: With these special papers that can "see all colors," use a Kodak safelight filter, No. 10 and keep the safelight exposure to an absolute minimum.

USING COLOR SLIDES

Occasionally you may want to make a good black-and-white enlargement from a color slide. Do this by making an intermediate film negative: Place the transparency emulsion-side up in the enlarger negative carrier and mask off the unused portion of the carrier image area so that no stray light will lessen the projected-image contrast. The film we suggest for the internegative is Kodak Super-XX pan film 4142 (Estar thick base) because of the long straight-line portion of its sensitometric curve; this will help you to preserve the tonal relationships of the color transparency. The exposure for this internegative will probably have to be determined by the usual test-strip method. As a starting point, try 15 seconds at $f/11$ for a three-diameter enlargement and bracket the test exposures on each side of this estimate.

The most important thing is to avoid risking contrast buildup during this procedure. Consequently, it is advisable to develop the internegative to a low-contrast range. We suggest Kodak HC-110 developer used at dilution B (see the label on the developer bottle) at a developing time of seven minutes. If this gives consistently too much contrast, use Kodak Polydol developer for five minutes.

As was the case with making black-and-white prints from a color negative, you may want to use a colored filter over the enlarger lens when exposing the film. A filter here has just about the same general effect as the same filter on the camera lens when the actual scene is photographed. Yellow, orange, and red filters will, progressively, give darker skies, a green filter will lighten foliage, and so on. No filter at all is needed to keep the tonal relationships about the same as you see them in the color

slide, so for general work no filter is required.

Obviously, some slides will make better black-and-white prints than others. The most important criterion is to select a slide that is flawlessly sharp and normally exposed. A *slightly* dark transparency will also reproduce well but a light transparency will never make a really good print because of lack of highlight detail.

Chapter 12

Toning

The basic purpose of toning is to heighten print realism. Compare this black-and-white scene with its brownish counterpart to see if you don't prefer the toned version.

An almost infinite variety of brown tones are at your disposal. The actual color
that will be produced depends on the paper toner combination selected, and
to a lesser extent on the processing conditions.

Toning is the chemical method of changing the image color of a black-and-white print to a colored image, usually sepia or blue. Skillful toning improves the appearance of most prints, excepting those intended for commercial reproduction. We're used to *cool* snow and water, *sun-bathed* landscapes, and the *warm* tone of flesh in portraits. The expert photographer recognizes the subconscious stamp of approval most people place on well-toned prints, and he uses toning *wherever it will contribute to the communicative or pictorial effect he wishes to portray.* Toning is easy. Many excellent toners are available from manufacturers in concentrated package form, ready for dilution or simple mixing. Most of them will keep for months or even years, take up little storage space, and can be used at room temperature, and work rapidly, usually as single solutions.

Although there are chemical procedures for adding nearly any color to your photographic image, the common ones are described in the following text.

BLUE TONES

Pictorialists, salon exhibitors, and camera-club enthusiasts regularly use blue tones for creating mood pictures of such subjects as night, fog, coldness, mystery, rain, and so on. A great variety of tones is not available with the usual gold chloride toner. Warm-image papers tone deep blue, while cold-image papers give a slate-blue color. The color can also be controlled to a small degree by the type of development given to the paper prior to toning. Slight overexposure and underdevelopment yield bluer results; underexposure and forced development produce less blue results.

The packaged Kodak blue toner contains thiourea and gold chloride as the principal reacting agents. The silver image is etched slightly by the thiourea and finely divided metallic gold is deposited on the silver grains.

Although both the visual contrast and density of the print are increased by this toner—something you should note—the effect is slight and the necessary exposure decrease in making the original print will vary from none to not more than 10 per cent for low-key subjects. Thorough washing before toning is very important: Traces of residual hypo may cause uneven

Snow, marine, and some night scenes are often improved by blue toning. The finer-grained, or warmer, the image, the bluer the toned color can be. Because printing inks cannot exactly reproduce toning colors, you should experiment by making your own blue-toned prints to evaluate different effects accurately. Note that an unlimited variety of toning-like colors can be produced by printing black-and-white negatives onto color paper with the appropriate filter.

toning. Consequently, we suggest you use hypo clearing agent for processing non-resin-coated papers that are to be toned subsequently.

Blue toning progresses slowly but uniformly at room temperature. The time may vary from 10 to 45 minutes. You can obtain any intermediate tone in high-key prints by simply removing the print when you reach the desired depth of tone, but *it is advisable to let low-key prints tone to completion.* The toned image, incidentally, is more stable than the silver image alone for long-term keeping.

RED TONES

Red tones are appropriate for sunsets, fires, and certain industrial operations such as interior scenes of blast furnace operations, and so on. You get pleasing reddish tones by using a gold chloride toner such as the Kodak blue toner on prints that have been previously sepia-toned in Kodak brown toner or Kodak sepia toner. Wash thoroughly for at least 30 minutes before placing the sepia-toned print in the blue toner; otherwise, stains might result.

BROWN TONES

Although you can produce almost any color by some type of toning process, brown tones are by far the most common. Virtually all toned portraits should be some shade of brown. Most portraits that are to be hand colored are first given a basic brown tone to save the colorist much time and effort. The pictorialist and exhibition photographer generally select brown tones for photographs of landscapes, architecture, and similar subjects.

Brown tones can be classified into three broad groups—the characteristic reddish-to-purplish brown tones produced by selenium toners, the colder-toned chocolate browns of the single-solution sulfur-reacting toners, and the warm brown (somewhat yellowish brown with warm-image papers) of the bleach-and-redevelopment sulfide toners. In addition to these pronounced toner differences, the papers themselves vary considerably in their image characteristics, and by selecting the

186

proper combination of toner and paper you can get tones ranging all the way from a decidedly cold brown to a very reddish or yellowish brown.

Kodak Poly-Toner

Of all the commercially available toning solutions, Kodak Poly-Toner is perhaps one of the most frequently selected for achieving sepia tones. Its interesting characteristic is that by diluting the stock solution with different quantities of water, you get a variety of brown tones ranging from reddish brown to yellowish brown. As you increase the dilution the tone becomes progressively warmer. Standard dilutions are 1:4, 1:24, and 1:50.

The 1:4 dilution increases density slightly and is best compensated for by a 20-30 second reduction in print developing time.

The 1:24 dilution requires no modification in processing; a normal print will tone without change in density or contrast. 1:24 is the primary recommendation for warm-tone papers.

The 1:50 dilution has a slight reducing effect on the shadow areas of a print but you can compensate for it by a slight increase in the print development time. However, note that increased development time often results in a colder-than-normal tone and thus the effect of using the weak toner dilution is partially cancelled out. Incidentally, professional oil colorists often prefer this type of print for eventual oil coloring, since the tone obtained is well suited for this purpose and the slight loss of shadow density is not important.

Hypo-Alum Toners (Kodak Hypo-Alum Sepia Toner TIA Formula)

One of the toners most highly regarded among professionals consists of a hypo and potassium alum solution with a silver salt added to reduce any tendency to bleach. Most papers will tone a rich pleasing brown in about 15 minutes when this solution is used at 120° F (49° C). The silver image reacts directly with the colloidal sulfur in the toner to form a very stable image of silver sulfide. Although no packaged form is on the market, the solution is fairly easy to prepare from bulk chemicals, is quite economical, and has a high capacity and good keeping characteristics. You do not need to wash prints thoroughly before toning and the highlights are free from stain.

187

Bleach and Sulfide Redevelopment (Kodak Sepia Toner—Packaged; Kodak Sulfide Sepia Toner T-72 Formula)*

You can tone any paper—even cold-image enlarging papers —in a bleach-and-sulfide-redevelopment type of toner. The warmer-image papers have a tendency to produce rather yellowish-brown images.

Prints to be treated in this type of sepia toner should receive 10 to 20 per cent more than normal exposure to compensate for the bleaching that takes place. If you wash prints well before toning, this bleaching is a repeatable effect that you can correct. If, however, your wash is insufficient, small traces of hypo left in the print will cause the bleach to act like Farmer's reducer, and excessive irregular bleaching may occur. It is therefore advisable to use Kodak hypo clearing agent as a prebath.

Do not use the bleaching solution in chipped enamel trays or let it come in contact with metal objects containing iron. Iron reacts with ferricyanide to form Prussian blue, and blue spots are quite likely to form on the prints. Even the water supply from old rusty pipes may be harmful.

Use the sulfide redeveloper near an exhaust fan or preferably under a vented exhaust hood. The hydrogen sulfide fumes given off are both disagreeable and poisonous. It is advisable to use print tongs or to wear rubber gloves, since this solution is strongly alkaline.

Partial or incomplete toning with sepia toner is not practical. The bleaching process does not proceed uniformly, and if the action is incomplete, spotty tones result.

Polysulfide (Kodak Brown Toner—Packaged; Kodak Polysulfide Toner T-8 Formula)*

Solutions containing mainly sodium carbonate and sodium polysulfide will react directly with silver images to form silver sulfide. Toning is complete in five minutes at 100° F or 20 minutes at 68° F. Inexpensive and simple to use, polysulfide toners are well suited for large-scale toning operations. Partial toning is not satisfactory. The toning action is not uniform, and if you remove the print before it is completely toned, irregular tones will result.

As a general rule, develop warm-image papers (such as Kodak Panalure paper) in a cold-toned developer (such as Kodak Dektol developer) if they are to be subsequently toned in Kodak

*For toner formula and usage instructions, see Reference Section.

188

brown toner. The reason is that sulfide toners produce a yellow-ish-brown result when the original image is comparatively fine-grained. Although this yellowish-brown color is preferred by many photographers who wish to oil-color their prints, it is a tone that is not usually pleasing by itself. In addition, these toners lessen both density and contrast, the effect being most pronounced on fine-grain images.

It is easy, however, to compensate for density and contrast losses and, at the same time, to produce a more pleasing (less yellow) image tone by changing the development time for papers that are inherently warm-toned. Do it this way: Determine the exposure to obtain a print of normal quality with a 2-minute development time. Do this with a small test strip if desired. Then, for the final print, give the same exposure time but extend the developing time to 3¹/₂ minutes. As a black-and-white print it will look a little dark, but the toning process will "bite it back" so that the end result will look good.

Highlight stains may result unless the print is washed thoroughly before toning. Kodak hypo clearing agent, as mentioned previously, will reduce this staining tendency. A fresh fixing bath and the two-bath fixing technique will also help to improve the thoroughness of the washing.

Again, use the sulfide-type toners near an exhaust fan or preferably under a vented exhaust hood because the fumes are harmful and have an unpleasant odor. Also, it is advisable to use print tongs or wear rubber gloves because of the strong alkalinity of the solution.

Selenium (Kodak Rapid Selenium Toner—Packaged)

Selenium toners contain sodium selenite as the principal toning agent. The silver image is oxidized by the selenite to reddish-brown silver selenide. The toning proceeds rapidly at room temperature on warm-tone papers; cold-tone papers hardly tone at all. Both the contrast and density are increased *slightly* by the toning process. If the original print is to be fully toned, it should receive normal exposure but about 10 per cent less development time.

A hypo-clearing prebath is recommended to neutralize any acid from the fixing bath; otherwise, traces of acid remaining in the print can cause decomposition of the toner, and finely divided selenium will then be deposited on the print and cause

an objectionable pink highlight stain.

The extent of dilution of the stock solution is not critical; at a 1:3 dilution, a print is completely toned in 3 minutes. Partial toning is usually satisfactory at a dilution of 1:10. The action progresses uniformly and the print may be removed at any time—one of the outstanding advantages of this particular type of toning operation.

A word of precaution about partial toning, especially if attempted with toner dilutions in the range of 1:10 to 1:20: With some warm-tone papers, the extremely dilute toner may affect the shadows more than the highlights. Thus, in toning a portrait print, the subject's face might be grayish and his suit brownish. The interesting reason this occurs is due to the small but definite grain size distribution from highlight to shadow. The shadow areas are comprised of a greater proportion of fine silver grains, which tone more readily than the coarser grains of the highlight areas.

This toning characteristic can be utilized for a real print-quality bonus. Make this test: Cut an old print in half, keeping one of the pieces as a comparison control check. Tone the other half completely in a solution of one part selenium toner and fifteen parts of hypo clearing agent. Dry the treated piece and compare the halves. You'll probably find—even with "untonable" Kodabromide—that the blacks are blacker, increasing the tonal range for noticeably improved print quality, *and that the image color will remain relatively unchanged.* This procedure works best with prints made on paper grades No. 1 and No. 2, and hardly at all for grades No. 3 and No. 4.

Nelson's Gold Toner (Kodak Gold toner T-21 Formula)*

Many professional photographers highly recommend Nelson's gold toner. There are apparently two reasons for this—the first being the beautiful variety of pleasing brown tones available, unlike those of any other toners, and the second being the fact that one can advertise a "gold-toned portrait" (the latter reason having obvious commercial appeal). No manufacturer has yet packaged this formula, but you may feel it is worth the trouble and join the ranks of many salon and professional portrait print-makers by making up your own batch. You can obtain gold chloride from chemical specialty companies if it is not available at your photographic-supply store.

*For toner formula and usage instructions, see Reference Section.

Kodak gold toner T-21 is for warm-tone papers and consists of a mixture of hypo, potassium persulfate, silver chloride, and a small quantity of gold chloride. The silver image is converted primarily into silver sulfide, with traces of gold probably present in the image.

Prepare the prints with normal density and contrast—another advantage of this toning procedure. Toning proceeds uniformly from 105 to 110° F (40 to 43° C) and is completed in about 20 minutes. Partial toning is satisfactory at shorter times—still another advantage of this toner.

Toning at temperatures below 100° F (38° C) is unsatisfactory; the required time increases rapidly until, at room temperature, there is scarcely any visible toning effect. You'll want to keep at hand an untoned print for comparison during toning.

It's a lot of fuss and bother to produce a gold-toned print, isn't it? But perhaps you would do well to reread the above advantages of this toner as well as to examine carefully well toned prints made by professional photographers who have employed this technique.

PREVENTION OF TONING STAINS

Selenium, sulfide-redeveloping, and polysulfide toners are quite likely to produce highlight stains if the prints are not properly prepared for toning. The intensity of the stain is usually proportional to the residual amount of silver and hypo in the black-and-white prints. Undesirable concentrations of these contaminants are present in prints treated in exhausted or nearly exhausted fixing baths or in prints that have not been washed properly.

Keep hypo and silver salts to a minimum by observing the following precautions:
1. Use a fresh or nearly fresh fixing bath. An even better suggestion is to use the two-bath fixing technique (not required for RC papers).
2. Use Kodak hypo clearing agent (not required for RC papers.)
3. Wash thoroughly.

We cannot overemphasize the importance of using a hypo clearing agent. It causes the hypo and silver salts to wash out

more easily, while under conditions of imperfect washing the residual alkali of the agent serves to retard the fading action of the residual hypo. The alkalinity also prevents the formation of pink highlight stains caused by the precipitation of metallic selenium when an acid-reacting print is treated with a selenium toner.

To avoid highlight stains, these precautions are particularly important when using the packaged Kodak rapid selenium, brown, and sepia toners and the formula toners Kodak polysulfide T-8 and sulfide sepia T-7a. Kodak hypo-alum sepia toner T-1a, gold toner T-21, and blue toner are generally free from any tendency to form highlight stains. However, irregular toning may result when blue toner is used, if hypo is still present.

THE EFFECT OF PROCESSING VARIATIONS

Image tone is primarily a matter of silver-grain size, so that the variations in development that influence particle size have a marked effect upon the tone. These differences are usually magnified by the toning process.

Using a warm-tone developer such as Kodak Selectol or Selectol-Soft in place of a colder-toned developer such as Kodak Dektol developer will give warmer black-and-white images. Most of the brown toners will give as warm or warmer tone images, some becoming quite yellow-brown; on the other hand, Kodak blue toner will tone with greater ease and produce bluer tones.

You get a somewhat similar warming effect if the original development time is decreased. This latter procedure is not recommended for making marked changes, however, since it usually degrades the image. Although quality in a print is difficult to define, it is largely dependent on the scale of values reproduced, and skimpy development results in a reduction in the number of distinguishable tones. For highest quality, develop fully all prints to be toned.

Incidentally, the surface of the paper has a slight effect on the brightness of the resulting image tone. Matte surfaces generally produce somewhat colder or less-bright image tones than the lustre surfaces.

As implied previously, you can trace many toning failures to

192

improper fixing. Traces of silver halide left in the emulsion from insufficient fixation will react with most toners to produce muddy tones. Complex silver salts left in the print from an exhausted fixing bath are difficult to wash out, and will form stains when the print is toned. Remember the recommendation for two-bath fixing.

If you are toning RC papers, leave a border that can be trimmed, since some edge penetration of the toning chemicals can occur.

Chapter 13

Control Processes

The term "control process" has a sort of aura about it, hasn't it? But there need be no mystery. By control process we mean a process for regulating or modifying strictly "mechanical" results, particularly with regard to local print areas. Thus, ordinary dodging is a simple control technique. When the average photographer speaks of a control process, however, he usually means something on the order of the bromoil, paper-negative, or gum printing processes. In spite of the awe or reverence they receive among pictorialists, very few of these processes seem to be surviving the test of time. The modern photographer neither tolerates the extra fuss and bother nor desires the somewhat "fuzzy" results usually obtained with the old processes. So we can skip most of these techniques. And yet a few controls are worth considering; for instance, let's take a look at chemical print reduction and the paper-negative process.

PRINT REDUCTION

Punch! That's what you'll learn about here. It's more than print quality; it's print punch, carrying power, brilliance. You've probably heard about making dark prints lighter with Kodak Farmer's reducer. However, it's not the mere ability to salvage an overexposed or overdeveloped print that makes this technique so famous; what counts is how the appearance of a reduced print differs from that of a normally made print.

First, before discussing print reduction, let's clarify its purpose. Reduction merely means bleaching or lightening the picture. However, it's not just a salvage technique for prints that were accidentally made too dark. Print reduction has a more noble purpose—that of making a good print better. You can do this by either of two means: by local area reduction or by total print reduction; or, you can combine the two.

Print reducers, such as Farmer's reducer, affect the print in two ways: The print is made lighter and more contrasty. With these results in mind, you probably already see several applications of print reducers useful to your own work. And, you're right. There are several ways in which a print reducer can help you. Here are some typical situations:

PROBLEM 1. You wish to print a low-contrast negative on Kodak Ektalure paper, which is available only in a normal printing grade, not the grade No. 3 or No. 4 that you need.
ANSWER: Intentionally overexpose the print, process it normally, and then reduce it back to normal density.

PROBLEM 2. You have printed for the highlight or middle-tone portion of a long-scale negative, and the print shadows have become somewhat dense and "blocked up."
ANSWER: Locally reduce just the print shadow areas, making them as much lighter as you desire.

PROBLEM 3. You have a portrait of a rugged old character that prints normally on grade No. 2 of Kodak Ektalure paper, for example, but it lacks extra carrying power and punch.
ANSWER: Intentionally overexpose the print, reduce the entire print slightly, and then work locally on the highlight areas that need special emphasis.

Farmer's Reducer

Probably the most widely used print reducer is Farmer's reducer. This reducer can be obtained in a convenient packaged form, Kodak Farmer's reducer, or you can make it yourself from only two inexpensive and easily obtainable chemicals, sodium thiosulfate, which is ordinary hypo crystals, and potassium ferricyanide. Mix up a stock solution of each chemical as follows:

Stock Solution A	
Potassium Ferricyanide	37.5 grams
Water	500.5 milliliters
Stock Solution B	
Sodium Thiosulfate (pentahydrate) (Hypo)	480.0 grams
Water to make	2.0 liters

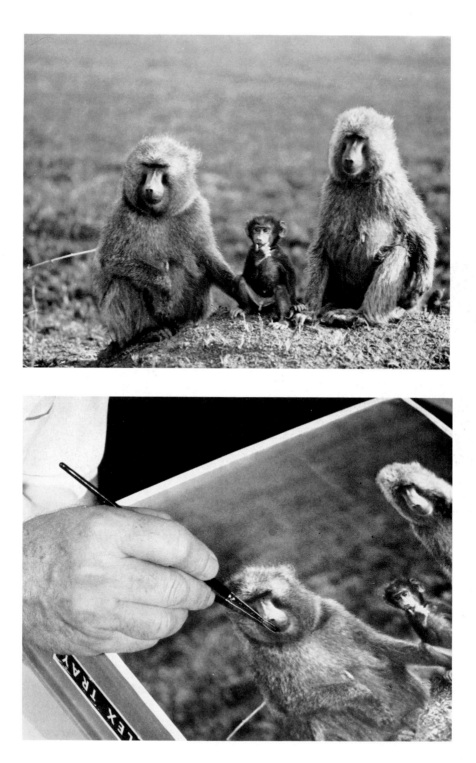

Opposite: a straight print. It not only lacks separation between the subjects and the background but also could benefit from a higher lighting contrast on the subjects themselves. The remedy here was to make an extra-dark print and then chemically lighten the baboons with Farmer's reducer. Use cotton swabs for treating large areas, a fine-pointed brush for details. Keep the treatment running water handy to flush off the chemicals or you'll overdo the treatment. Below: the finished reduced print. Print reduction is most often a salvage technique. Similar and more controllable results are usually better accomplished through matte-acetate dodging.

For normal print reduction, mix the following working solution:

Solution A	30 milliliters
Solution B	120 milliliters
Water to make	1 liter

Less rapid action can be obtained by using half the amount of Solution A.

Stock Solution B will keep indefinitely; Stock Solution A will keep about six months in a well sealed brown bottle. The working solution, however, will keep only about ten minutes before its activity deteriorates. Obviously, you will have to prepare the working solution immediately before use; furthermore, after you have reduced two or three prints, mix a fresh solution so you'll have a better idea of the speed with which the reducing action will take place.

Step-by-step, this is the print-reducing procedure:

1. Intentionally overexpose the prints by about 20 to 60 percent. Naturally, the amount of overexposure is an individual matter with each subject. It depends on such factors as the original subject contrast, the type of subject, the lighting contrast, and the contrast grade of paper that you are using. For example, low-key prints lend themselves to reduction better than do prints of average key, whereas high-key pictures in general are unsuited to this treatment. Also, you can reduce character studies of middle-aged-to-elderly people, as a subject group, with more pleasing results than you can prints of either babies or glamour girls.

2. If the print dries, resoak it in water for at least 15 minutes so that the reducing action can proceed evenly. Washing for only 15 minutes after normal fixing is sufficient before reducing the print.

3. Completely submerge the thoroughly soaked print in the working solution and agitate the print continuously.

4. After ten seconds, quickly remove the print from the tray and place it under a stream of running water. Do not wait for the reducer to react on the print before taking it out of the tray. The reason for this is that the reducer has a continuing action even after the print is placed in the running water. It naturally takes a short while before the water can displace the reducing chemicals from the print emulsion.

5. After a few moments of rinsing, inspect the print for changes in image density. Keep your eye on the print highlights, where you will first notice the reducing action. If the print has not been lightened sufficiently, return it to the tray of reducer for another brief "bite." You can repeat the cycle of reducing and then rinsing as many times as you desire. Just be careful not to overdo it; don't let the highlights be "eaten away right down to the bare paper." Remember, it's just like getting a haircut: it's easy to take it off, but putting it back on is another matter! Each print will, of course, require a different length of treatment. In general, prints having a warm image tone are reduced slightly faster than prints with a neutral or cold image tone.

6. The final step is to wash the reduced print for one hour in running water to assure complete removal of the chemicals.

Local-Area Reduction

Use this same general technique to reduce local print areas. Sometimes you may want to emphasize a highlight or middle-tone area.

Have you ever noticed how the inclusion of a bright object helps to "pep up" an otherwise dull scene? Well, local reduction often works the same way. Perhaps all that some of your overexposed prints need is a few lighter areas to save them from the wastebasket. But, often, you can improve even a well planned and carefully made print.

Take that old print of yours of the road winding through the countryside. Although you have always been fond of that shot, somehow it didn't seem to win the interest and praise you thought it deserved. The next time you are waiting for a batch of prints to wash, why not get out the reducing materials and try to make that road a shade or two lighter? Maybe that is just what it needs. After all, the "S" curve of the road is really the structural backbone of that print. If it were emphasized, the road would stand out from across the room, whereas now it merges confusingly with adjacent details in the scene.

A surprising thing about removing silver from the darkest print areas is that often you uncover hidden shadow details—details that you could not see when viewing the print by reflected light. What causes these shadow details, once given up for lost, to appear, seemingly from nowhere? It's because shadow details often extend "below" the visual level of a print's

darkest tone. Sometime, take one of your prints in which the shadow details are too dark to be seen clearly and hold the print up in front of a bright light source. Now, with the light transmitted through the back of the print, can you see those shadow details any better? You bet you can! If you want them to be more apparent when you view the print by reflected light, locally reduce those areas. When enough "top" silver has been removed from the dense areas and the local contrast has been stepped up a little, there will be your shadows, luminous and full of detail.

To reduce a print locally with Farmer's reducer, soak it well, place the print on an upturned tray bottom, and wipe the surface moisture from the print with a towel. Apply the reducer to the desired print areas with a piece of cotton or a brush, using a light, circular motion. At no time leave a pool of the reducing solution standing on the face of the print. This may cause uneven or splotchy reduction, with the outline of the pool showing plainly in the finished print. Lighten each area a little at a time, rinse, wipe dry, apply more reducer, rinse, and so on until you've achieved the desired effect. Time and patience will see you through and the result will be definitely worthwhile, if you don't overdo it.

Farmer's reducer, however, has one serious disadvantage. As a result of its action, it has a tendency to stain the picture image a pale-yellowish color. Don't misunderstand—it is still a very helpful and widely used print reducer. In the first place, the stain, which varies in intensity depending on the degree of reduction, is not very noticeable in many instances where the print is reduced only slightly. Secondly, with cream tint or old-ivory paper stocks, the color of the stain nearly matches the tint of the paper, and the stain thus passes unnoticed. The staining tendency can be lessened by not overworking an area without rinsing repeatedly and by adding fresh solution. There are, however, other reducer formulas that will not stain the print. Two of these are given here, one being recommended for total print reduction, and the other for reduction of local print areas and of fine details.

Non-Staining Reduction

An excellent print-reducing formula is the Kodak nonstaining reducer R-14. In fact, there is no reason, if thiourea is

200

available, why you can't use this reducer in all instances where you might otherwise use Farmer's reducer. The two solutions are made up as follows:

KODAK NONSTAINING REDUCER R-14
Stock Solution A

	Avoirdupois/ U.S. Liquid	Metric
Water (125-140° F, 50-60° C)	16 ounces	500 cc
Thiourea	½ ounce	15 grams
Sodium Thiosulfate (Hypo)	1½ pounds	700 grams
Water to make	1 quart	1 liter

Stock Solution B

Water (about 125° F, 50° C)	12 ounces	375 cc
Potassium Ferricyanide	5 ounces	150 grams
Water to make	16 ounces	500 cc

These stock solutions will keep indefinitely in separate bottles, particularly if Solution B is stored in a brown bottle away from continued exposure to a strong light source.

The two stock solutions are mixed immediately prior to use according to the following reduction purposes:

For chemically de-specking prints:

Stock Solution A	2 parts
Stock Solution B	1 part
Water	2 parts

Just a touch of a pointed brush charged with this solution will dissolve the silver gray to white paper in a matter of seconds.

For local print reduction:

Stock Solution A	10 cc
Stock Solution B	5 cc
Water	300-500 cc

This may seem to you like quite a weak solution, but remember that the stock solutions are extremely strong acting, and the weaker the working bath, the easier it will be for you to stop the reducing action with precisely the right amount of density removed. Furthermore, the slower acting a reducer is, the less tendency there is for any "continuing action" of the reducer to overdo or spoil the result. Agitate the print continuously while it is in the reducer to help insure even reduction. In fact, you can follow the same procedure outlined previously for Farmer's

reducer. As with Farmer's reducer, any print reduced with the Kodak reducer R-14 should first be soaked for about fifteen minutes in a tray of water. The prints should be completely immersed during this time and the water should be about room temperature. Mix the working bath at the end of the soaking time, not before, since the mixture is rather short-lived. When active, the reducing solution is a pale straw color; if it turns green to blue-green (depending on the dilution), it is no longer effective and you should replace it with a fresh bath. After reduction, wash the prints for one hour in running water, just as though they had come from a fixing bath.

What's so wonderful about this particular formula and why is it recommended? It's the excellent nonstaining properties of the thiourea. This chemical prevents the appearance of the yellowish residual stain image during reduction. If you have worked at all with Farmer's reducer, you will appreciate this advantage. Although thiourea is not a common chemical, it is not difficult to obtain. A drugstore or small photographic store will probably not have it on hand, but you can easily order it from your photographic dealer; stain-free reduction will make any wait well worthwhile. Incidentally, another name for the same chemical is thiocarbamide. Probably the reason photographers don't use the R-14 reducer more is that it is recommended primarily for graphic-arts purposes.

Caution: In all fairness, we should mention that thiourea is a strong fogging agent for sensitized photographic materials. As a result of the chemical being handled, some of the dry powder particles may remain suspended in air for some time; they will cause black spots if they come in contact with film or paper emulsions. Obviously, your work should be done away from rooms where photographic materials are usually handled. It is also difficult to remove traces of thiourea from the hands and some types of containers simply by washing in water; therefore, if you contaminate your hands, rinse them in a dilute sodium hypochlorite solution, and then wash thoroughly in warm water. Also clean containers, such as trays used for reducing prints, that will later be used to hold paper developers. Prepare the dilute hypochlorite solution by adding one ounce of any household hypochlorite bleach solution, such as Clorox, to one quart of water. These simple precautions, of course, apply to the following "dry" reducer, which also contains thiourea.

Small-Area Reduction

Let's spend just a bit more time in this department since it is here that you can improve even your best prints. Buy enough chemicals to make the following solutions, plus a small bottle of methyl alcohol, and you will be all set. There's no need to get any more because a little of these solutions will go a long way.

Stock Solution A

Iodine (crystal)	0.15 gram
Methyl Alcohol	30 milliliters

The iodine is a little stubborn about dissolving, but placing the components in a capped bottle and shaking it will hasten the solution.

Stock Solution B

Thiourea (Thiocarbamide)	0.30 gram
Water to make	30 milliliters

These are your stock reducing solutions, which will keep indefinitely. To use them, mix equal parts of A and B with an equal part of methyl alcohol. An assortment of small brushes, a bit of cotton wrapped around a stick, and an additional wad of cotton will complete this inexpensive equipment—a small price to pay to obtain sparkling results in your prints.

The advantage of this reducer is that it is known as a "dry" reducer, so-called because the print is worked on while it is in a bone-dry state. Then, too, the active reducer ingredients are dissolved in alcohol, which has a tendency to evaporate rapidly—so much so that the print quickly becomes dry after each application of the solution. Therein lies the success of this particular method: it allows you to do exceedingly fine work without staining the print. Furthermore, most other solutions for the same purpose are water-soluble. When used on a damp print, as they must be, it is more difficult to confine the action of the reducing solution to fine print details. This method eliminates that difficulty.

Let's suppose that you wish to improve the roundness of a cloud. Place the dry print on a flat, well-lighted surface with the prepared working solution in a small glass beside it. Also have ready a medium-size cotton pad and the bottle of alcohol. Dip one of the brushes into the reducing solution and carefully

apply it to the cloud area to be lightened. Since, at this dilution, the reducer works fairly rapidly, do not allow the tiny pool of solution to stand on the print for very long. Saturate the pad with the alcohol, and quickly wipe it over the area just reduced with the brush. As with Farmer's reducer, it is better to remove the silver a little at a time so that the reduction may be controlled more easily. Now repeat the process, applying the reducer to the print and then wiping it away with the cotton pad containing the alcohol.

When working up lighter print areas, such as a cloud highlight, be sure that you do not overreduce the whole cloud down to the white paper base. Of course, that's going too far. Keep in mind that areas of least density are acted upon sooner than are the shadows. If the density seems to go down a little too fast for accurate control, try either one or a combination of both of these alternatives: (1) Do not wait quite so long to remove the reducer from the print after each successive application; or (2) dilute the working reducer solution with twice as much alcohol.

In portraits, this method of controlled local reduction affords an excellent way of adding eye catchlights if they are missing. Just place a tiny drop of the solution in the desired place and let the reducer "eat" the silver completely away. If you make the catchlights a trifle large or irregular, you easily can round them later when you spot the print.

After the print has been reduced to your satisfaction, place it in a bath of plain hypo for a few minutes and then wash it in running water for the usual length of time. Immersion in the hypo bath is very necessary because the active ingredient in the reducer is the iodine, which becomes "neutralized" in the hypo. Thus, you remove the possibility of the treated print areas becoming lighter or slightly stained by small amounts of residual iodine. Rinse out the brushes you used, as well as the wad of cotton, so that they will be ready for some other purpose next time you need them.

Before actually starting to work on one of your good pictures, practice on a few old or discarded prints so that you may first attain some degree of proficiency. It would be unfortunate to overreduce a lovely 14″ × 17″ print and then accuse this method of spoiling it for you. So, by all means, practice a bit to guarantee fine results; the technique of reduction is not hard to learn.

204

PAPER-NEGATIVE PRINTS

"If it were not for the paper-negative process," said pictorialist Cecil B. Atwater, "many of my negatives would be worthless. The nature of my business is both an advantage and a disadvantage. I see a lot of country, but I have to be constantly on the move. I cannot come back tomorrow, when the light will be better, or when there may be clouds in the sky. I have to make my pictures now, and if there are flaws and defects due to factors beyond my control, I have to correct them in the paper negative."

Of all the known control processes, the paper-negative process is perhaps the best known, the easiest, and the one that permits the greatest control. Certainly it is the oldest; as long ago as 1835, Fox Talbot made successful photographs using light-sensitized sheets of "best quality" writing paper.

Is making paper negatives a lost art? Let's hope not! How else could you easily remove a shiny, incongruous car from a photograph of an otherwise picturesque country lane? In other words, the paper-negative technique is a wonderful way to rework a picture that you cannot retake under ideal circumstances. It doesn't take much skill by means of this process to move, add, or delete telephone poles, tin cans, clouds, or nearly any small details that, either by their presence or absence, detract from an otherwise pleasing composition.

Equipment

You will need only one item of equipment in addition to that found in almost any darkroom for making enlargements: a contact-printing frame the size of your final print. Since large paper negatives up to 16″ × 20″ in size are exhibited in salons, we recommend that you get a 16″ × 20″ frame if you are interested in this phase of print making; then you will be able to handle practically any size print the occasion may demand. It would be unfortunate, for example, to buy an 11″ × 14″ frame and then wish to make a 14″ × 17″ print.

Procedure

Starting with a normal negative, usually of a landscape or seascape, here, in brief, are the steps involved in making a paper-negative print:

1. Make an enlargement, cropped and dodged as you want the final print to be. Use a pencil or artist's stump to darken any detail or area which needs to be subdued.

2. From this enlargement, make a contact paper negative. Use the normal retouching tools and techniques to alter details on the negative. Remember that any pencil retouching on the negative means that the final print will be *lightened* in the corresponding places.

3. From the retouched paper negative, make the final print by contact. That's all there is to it—almost.

Let's take a look at some of the finer points in the process.

As in any artistic technique, there are some pitfalls to avoid—any artist knows it isn't difficult to paint a poor picture! In the first place, you want the contrast and the shadow and highlight details of the final paper-negative print to match those of a carefully made, top-quality "straight" enlargement from the same negative. There's no point in being evasive about it—this close match is not easy to achieve. If you have had any experience in making copies, you probably know it's advisable to make both of the intermediates low in contrast and fairly heavy in density. Since they actually are used as transparencies, by all means judge these intermediates by transmitted light, not by reflected light as you do an ordinary print.

Viewed by reflected light, each intermediate will seem far too dark, almost beyond redemption. But hold each dark positive or negative up to a fairly bright illuminator, and even the darkest shadow areas will appear luminous with full detail—or at least they should. Your aim should be a transparency that appears normal in density but has easily discernible detail in both highlights and shadows and is very low or flat in contrast. The lower the contrast, particularly in the positive, the easier it is to retain the details at both ends of the tonal scale. Consequently, you should generally use the softest grade of paper— usually grade No. 1. Don't be concerned at this point about the flat appearance of the picture; in going from step to step the process has a tendency to increase contrast, and unless you intentionally keep the intermediates at a low contrast, the final print will be so extremely contrasty you won't want to use it. Then, too, it's an easy matter to make any necessary adjustments in contrast in the final print by simply choosing an appropriate grade of printing paper.

206

The final print is made by contact with the paper negative in the contact-printing frame. Good contact is imperative during the exposure, as it is also when making the paper negative. If necessary, place sheets of blotting paper behind the paper in the printing frame to help secure good contact.

Grain in the Paper-Negative Print

In contact-printing both the paper negative and the final print, the exposing light has to penetrate the paper support. The diffuse outline of individual paper fibers in the stock are, therefore, recorded in the negative and final print as a textured pattern superimposed on the actual subject. In some instances this texture, or grain, as it is more commonly called, is fairly desirable. If it is not excessively heavy, it can give a pleasing aspect of "pictorial diffusion" that often enhances some types of subjects, such as atmospheric landscape scenes, crumbling buildings, and the like. It certainly hides any graininess of the negative.

However, one of the problems in the paper-negative process is not to let the paper grain become too pronounced. These are modern times, and sharp, clear pictures are more in vogue than the overdiffused, mushy prints of the mid '20s. For this reason, it is always advisable to use a smooth-surfaced, single-weight paper, such as Kodabromide N or A (and, of course, No. 1 contrast), for both the paper positive and the paper negative. To help hide excessive paper texture, we suggest a rough-surfaced paper such as Kodak Ektalure paper (R or X DW) for the final print. Rough surfaces also help to hide any rough retouching!

Another alternative for eliminating much of the grain is to use a film positive, which is described in the following pages. This is particularly feasible if not much retouching has to be done on the positive. Kodak fine grain positive film lends itself to this application.

Retouching the Intermediates

Any retouching in the paper-negative process should be applied only while the intermediates are viewed as transparencies, i.e., by transmitted light. For viewing the print as a transparency while this work is being done, a retouching stand is ideal and a negative viewing box is satisfactory; lacking either of these, tape the print by its borders to a windowpane so it faces

outdoors. Daylight will usually provide adequate illumination for the work. It is helpful, incidentally, to mask off with opaque paper any light from the illuminator not covered by the picture. Otherwise, this bright, stray light will "stop down your eyes" so that you cannot see the detail of the scene as readily.

Start by using a pointed pencil to clean all small white spots from the positive intermediate, such as those caused by dust on the film negative. Then, tone down any objectionably bright areas by gradual shading with the pencil. If the areas are large and of comparatively even tone, treat them with a tuft of cotton and a small quantity of powdered graphite or crayon sauce. Blend any unevenness with an artist's stump; a few stumps of different size will be helpful. Build up the density gradually, and blend it in smoothly with the neighboring print areas. Both an Artgum eraser and a kneaded rubber eraser are handy tools for correcting minor mistakes and for general "touching-up" purposes.

Retouch areas you want to be sharp, such as lines and other details, on the emulsion side of the positive or the negative, as the case may be. Retouch larger areas, such as those that require general smudging, on the reverse side of the intermediate.

The use of transmitted light, the retouching implements, and the general recommendations are the same for retouching both the positive and the negative. The key difference is this: Whereas every mark you make on the positive will be recorded as added density in the final print, the retouched negative areas will be lighter in the final print. The negative, then, is the place to lighten cloud or portrait highlights or catchlights in the eyes, and to brighten teeth or to emphasize reflections in water or backlighted scenes. Retouching either the positive or the paper negative is very similar, by the way, to the technique described in Chapter 9 for retouching and dodging prints with pencil work on matte acetate.

Be careful about overretouching. Better no retouching at all than too much. However, don't let this precaution keep you from making any necessary tone alterations; this is the reason for making a paper-negative print in the first place.

The paper-negative process works best for landscapes or other scenes where the print benefits by de-emphasis of details, or in prints where you want a misty-morning or old-world-charm effect.

An ideal paper-negative subject. The distracting horns, the bright fence post in the background, and other distracting highlights would be difficult to cope with in any other way. The first step is to make a low-contrast print on single-weight paper.

Above: With the positive placed face down on an illuminator, darken all distracting details with a soft pencil on the *reverse* side of the print. Be sure to blend the retouched areas into the background. Below: Anything that needs to be darkened is treated on the *reverse* side of the paper negative. View your retouching by transmitted light.

The finished paper-negative print. Compare this with the original straight print. Some print spotting may be necessary to conceal unskillful retouching of the intermediates.

DIAPOSITIVE-MASTER NEGATIVE CONTROL

Wouldn't you rather spend all evening making one good print than making one hasty mediocre print, and still have enough time left over to watch television for an hour or two? If you're after the super print, then these next few paragraphs are for you.

The following control process is similar to the paper-negative process except that both the intermediate positive and the duplicate negative are made on film. In brief, the steps are as follows:

1. From the original negative make a print by enlargement onto an 8″ × 10″ sheet of film.

2. After processing this film, which is a positive trans-parency called a diapositive, retouch it as desired.

3. Place the retouched positive on an illuminator and copy it onto the largest size sheet of film that your enlarger takes.

4. Process this film normally to make the master negative and retouch it as desired.

5. Use the master negative to make as many identical super enlargements as you need.

It sounds like a lot of work to go through these extra steps, so there must be some excellent reasons for doing it. And there are. For instance, you have absolute control over the contrast and density of the master negative, regardless of the contrast and density of the original negative. Also, you can retouch to your heart's content—by means of reducer, pencil, ground glass, or dye—on either or both of the film intermediates, and without any danger of spoiling a valuable original negative. It's this control in retouching, of course, that appeals to the master pictorialists. It's a nearly ideal method of lightening or darken-ing any area of a picture without producing the textured or fuzzy print that can result from the paper-negative process.

The two most important retouching tools are Kodak crocein scarlet for dye dodging and Kodak Farmer's reducer for chemi-cally reducing either or both the diapositive and the master negative. Just remember the principles that (1) dye on the diapositive or reducer on the master negative will make the final paper print correspondingly darker, and (2) dye on master negative and reducer on the positive will make the final print lighter. Look up the technique of using dye, in Chapter 9, and

the technique of using reducer, in Chapter 13. Farmer's reducer works the same way on film as it does on paper, except that film requires a somewhat stronger solution.

Copying the retouched diapositive presents no particular problem. Use an ordinary illuminator or printing box but be sure that the lighting is suitably diffused with opal glass so that the illumination is evenly distributed. Mask off any area of the illuminated surface not covered by the diapositive. Scan the entire transilluminated diapositive with an exposure meter to obtain an average reading and expose the master negative film as indicated. Obviously, a view camera with a ground-glass back is the most convenient type of equipment to use for making the master negative. Don't neglect to take the bellows-extension factor into account when calculating the exposure.

Kodak commercial film is suggested as a film material to be used for both the diapositive and the master negative. It has a comparatively low film speed (ASA 6 for tungsten light), which is a help in controlling the exposure. In addition, it is a blue-sensitive film, which means that you can carry out the development under a red safelight (Kodak safelight filter, No. 1).

To help preserve all possible tonal range and detail of the original, the diapositive should be exposed so that even the brightest highlights have a slight density and the development should be slightly less than normal. This will result in a transparency that is fairly dense and flat in contrast; it is not a transparency that has the same characteristics as one intended only for viewing. In addition, the master negative should be a trifle more dense than an original negative of normal density.

This should be sufficient information to get started with this technique of techniques. As a final word, plan all the steps before you start: Know exactly what part of the picture you are going to make lighter, what part darker, and exactly how and at what stage of the process you are going to do it. It's work to make a print this way but well worth it if you do a good job.

OTHER CONTROL PROCESSES

Many odd print effects can be achieved by combining positive or negative masks with the original negative when making an enlargement. The most interesting of these effects

The color negative was used to make a two-stage Kodalith Film "sandwich." These contrasty black-and-white images were then printed onto color paper through various colored filters. Techniques for making derivations such as these, and other interesting darkroom procedures, are fully explained in the

214

Kodak book *Creative Darkroom Techniques,* available from photo dealers. Buy it after you have mastered making good straight enlargements as described in this book.

are:

1. Posterizing, in which the final print is composed of only three or four different tone values.
2. Bas-relief, in which the subject is presented as a line image.
3. Highlight emphasis, in which a light, high-contrast negative is printed with the original negative.
4. The Person "tone-separation" process, in which the original negative is divided up into two "separation" negatives, one containing the highlights and the other the shadows.

In addition to these techniques, you can subject both black-and-white and color materials (negatives and slides as well) to several "tortures" such as reticulation, which forms weird patterns, or the Sabattier Effect (sometimes referred to as solarization), which results in a partial reversal of the image. These techniques and others, such as the gum-bichromate process and photo silk-screen printing, are described in the Kodak book *Creative Darkroom Techniques* (AG-18), available from AMPHOTO, bookstores, and photographic dealers.

For the person who has already mastered making good prints, these control processes may be of interest because of their ability to achieve an unusual pictorial effect; if you use one of these techniques, just be sure that it contributes to the *communicative* effect of your photograph.

Chapter 14

Color-Print Contrast Control

PRINTING COLOR NEGATIVES

Perhaps you haven't thought of it this way, but you exercise contrast control over all your black-and-white enlarging by selecting the proper contrast grade of paper each time you make a print. However, you exercise no such control when making a color enlargement because there is only one, normal-contrast grade of color paper available. The principal reason for this is that nearly all color negatives are processed uniformly in chemicals and procedures that help to maintain a constant contrast from one negative to another. Accordingly, one grade of color paper will fit the majority of color negatives, and normal-contrast color prints result.

On rare occasions, however, you may have a color negative that does require some contrast adjustment. This is usually due to abnormal lighting conditions and not to processing variations. What are these unusual lighting conditions? In general, too high a negative contrast is caused by abnormally high subject-lighting ratios. For example, the portrait-lighting ratio most commonly used by professional photographers is 2:1 to 4:1. A lighting ratio of 6:1 or more will produce a print that is too contrasty. This situation could result if the fill-light failed to flash and you didn't notice it at the time.

In order to alter color-print contrast, the most practical method is to prepare a photographic mask designed for this purpose. In this sense, a photographic mask is simply a black-and-white film image made in contact from the color negative and subsequently printed with it as a sandwich.

Lowering Contrast

First of all, you should note that masking will not solve all your contrast-reducing needs. A mask will work only if there was adequate exposure of the shadow detail. You cannot create

217

these details with a mask or by any other means if they never existed in the first place.

To lower contrast, a mask is prepared by a printing technique that yields an unsharp, positive image on an inherently low-contrast black-and-white film, such as Kodak pan masking film 4570. The technique of preparing an unsharp mask consists of exposing the film in a sandwich fashion as shown in the diagram below.

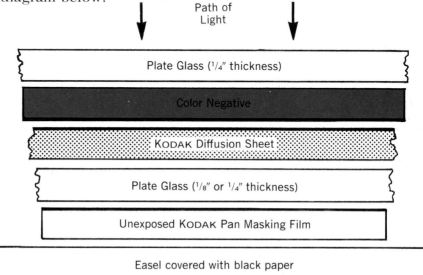

This is the recommended arrangement for making a diffuse contrast-reducing mask. A diffuse mask is much easier to register with the negative than a sharp mask.

The introduction of diffusion in making the mask greatly simplifies the register of the mask on the original. If the mask were perfectly sharp, the slightest error in register would cause an objectionable relief effect. Diffusion of the mask does not harm the sharpness of the reproduction; in fact *it actually makes the print appear sharper than it otherwise would.* The reason for this effect is that the edges of fine details in the original are covered by a more or less uniform silver deposit in the mask; thus, their contrast is preserved even though the contrast between larger areas is decreased by the positive mask.

To achieve a proportional exposure from each of the three image layers of the color-negative film, it is necessary to use four CC50B filters in the exposing beam. This compensates for the masking layers of the color negative.

218

Since the enlarger is used to expose the masking film, it is helpful to measure the amount of light in order to calculate the proper exposure time. Use a footcandle meter for this purpose. Adjust the enlarger height or lens aperture to provide three footcandles at the baseboard. Of course, the exposure depends on the density of the color negative. For an average negative, try an exposure time of 8–10 seconds as a test.

Tray-process the exposed film in either Kodak HC-110 developer using dilution F made up as described on the developer container, or in Kodak developer DK-50, in the ratio of one part developer to two parts water. The time of development for either of the two developers is 4 minutes at 68° F (20° C). Following development, give the film a 10-second stop and follow by fixing. We suggest Kodak rapid fixer, at the strength given on the container for film. Fixing will be complete in 2 to 4 minutes. Wash the film for 5 minutes in running water and dry it.

The image should appear as a very low-contrast positive. There should, however, be some detail over the full range of the picture with just perceptible image structure in the highlight areas. This will be rather difficult to judge since the image is both low in contrast and not sharp. A mask that has received too much exposure and consequently has *excessive* density in the shadow areas may yield a print with inadequate shadow density. Therefore, avoid excessive exposure of the mask.

The low-contrast positive mask is now carefully registered and taped to the base side of the color negative in preparation for printing. How can you predict the effect of the mask without going through the print-making step? A photometer or a densitometer can probably provide the answer. A normal color negative should have a density range of about .9 to 1.0. After you have made the mask and have combined it with the color negative, simply measure the density range of the combination. If your reading is considerably less than .9, you have overexposed the mask; if it is much more than 1.0, you have underexposed the mask.

For printing, position the masked negative in the negative carrier with the color negative oriented as usual (emulsion facing the enlarger lens). The exposure required when making the color print will be greater than that used when you printed the negative previously without the mask, due to the added

High print contrast caused by excessive lighting ratio in the original scene. This type of print can often be improved by superimposing a positive mask over the negative to compress the density range.

For contrast reduction, the mask exposure should be adjusted so that there is very little image detail in the highlight areas. The positive, contrast-reducing mask should be made with intentional diffusion. This simplifies registration of the mask with the color negative.

Normal contrast achieved by proper masking.

Here the contrast was reduced too much through the use of an overexposed mask. The image shadows show an undesirable smoky effect.

density of the mask. This exposure increase will be about 50 per cent.

Increasing Contrast

The easiest way to increase the printing contrast of a color negative is to mask the negative with a weak silver-image mask made with Kodak professional direct duplicating film. This is a simple, fast, one-step procedure. Expose a sheet of this film in contact with the color negative in a contact printing frame. Since this masking film is orthochromatic, a Kodak 1A safelight filter can be used during both mask exposure and development. It is a decided advantage to be able to watch the film develop because you can judge the degree of density buildup, which controls the resultant contrast. However, the primary density control is by exposure. Because this is a *reversal* film, keep in mind that the *more* the exposure, the less the density. Incidentally, it is interesting to know that because this film is orthochromatic, it exerts the most contrast-controlling influence on the magenta layer.

Use your enlarger as a convenient light source. With the illumination adjusted to yield three footcandles at the easel, the mask exposure time for an average density color negative will be about 150 seconds. Development is about 3 1/2 minutes in Kodak Dektol developer diluted 1:1.

After the mask is dry, register it with the negative, tape them together, and make the print exposure. Keep in mind it is always possible to chemically remove any local portion of the mask image with Farmer's reducer where you do not wish to alter the original contrast of the scene.

If you do not have direct duplicating film available, you must then employ a two-step procedure in which an unsharp negative mask is produced in an extra step from a sharp intermediate positive. Here are the required steps: Make the first mask—the positive—by contact-printing the color negative onto a low-contrast panchromatic film, such as Kodak separation negative film, type 2. Expose it in a printing frame with your enlarger as a light source. If you do not have a printing frame, use a sheet of glass to maintain contact between these two films, as shown in the diagram opposite.

Note that diffusion is not introduced at this point. As is the case when a contrast-reducing mask is made, four CC50B filters

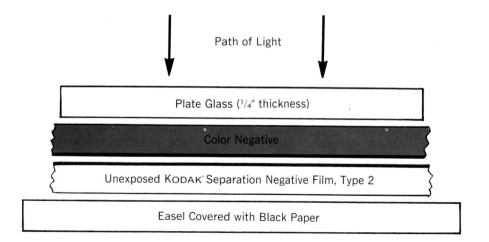

Path of Light

Plate Glass (¹/₄" thickness)

Color Negative

Unexposed KODAK Separation Negative Film, Type 2

Easel Covered with Black Paper

must be placed in the light beam. Adjust the illumination to provide three footcandles at the exposure time of about 8–10 seconds. Process this mask exactly as described previously for a contrast-reducing mask.

This resulting positive should contain the full tonal scale of the color negative (from important highlights to important shadows); it will, however, appear very low in contrast due to the fact that the original color negative itself was low in contrast and, also, that the masking film is inherently low in contrast.

Now use this low-contrast positive to prepare the contrast-controlling negative mask. It is at this point that you have control over the degree of contrast of the final print results. You'll use the positive to make a contact film negative on Kodak commercial film 6127 (acetate base) or 4127 (Estar thick base). The Estar base material has greater dimensional stability than the acetate base, but for this purpose the difference will be undetectable.

Use your enlarger lamp as a light source; the exposure time will be in the neighborhood of 20 seconds with the enlarger diaphragm adjusted to give three footcandles of illumination at the exposing plane. This exposure recommendation is only a guide since Kodak commerical film changes speed as you alter the developing time. In other words, developing a mask to yield highest contrast as opposed to developing a mask to yield lowest contrast reduces the film speed by a factor of nearly 10. For an average contrast increase, the development time would be 3¹/₂ minutes in Kodak developer DK-50, diluted one part developer

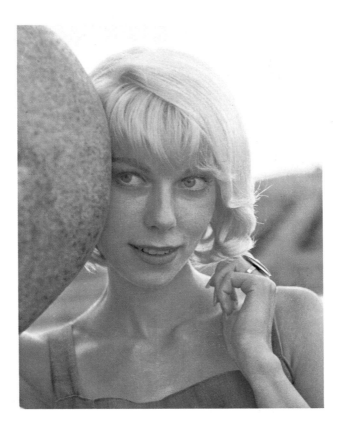

The extremely diffused illumination typical of an overcast day produced this low-contrast print. Low-contrast negatives are very rare. Most negatives print satisfactorily on a normal grade of printing paper.

To increase the contrast, the color negative was printed onto Kodak Pan Masking Film 4570 to form a positive image. This positive was printed onto a sheet of Kodak Commercial film to produce a negative image. This negative mask was then registered with the color negatives and the two were printed as a sandwich. Diffusion is not used to make either the interpositive exposure or the negative-mask exposure. A satisfactory negative mask should have no density in the deep shadows. Note that this contrast-increasing mask appears to be underexposed but that the highlights have adequate detail. This mask is registered to the base side of the color negative.

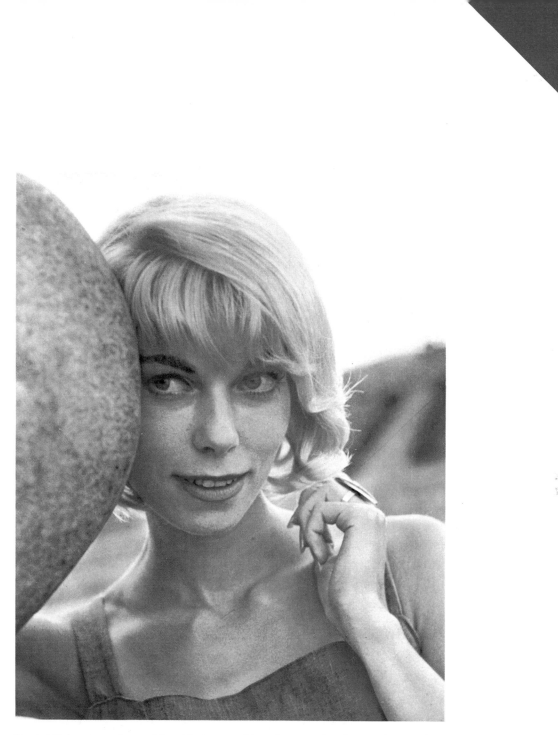

Contrast increased considerably by masking. Low-contrast negatives which can be improved in this way may be caused by a low lighting ratio, a low subject-reflectance ratio, camera flare, or slight underexposure.

with one part water.

By using a photometer or a densitometer, you can predict the needed increase of contrast in the same manner used for the contrast-decreasing mask. Thus, you should try to reach a density range for the combined mask and negative of about .9 to 1.0. Let's clarify this with an example: If your negative has a measured density range of only .6, you'll need a contrast-increasing negative mask that has a density range of .3 to .4 to make up this difference. Should the density range of this negative read more or less, make a new mask. This means that for *less* contrast, you need *less* developing time. Conversely, for more contrast, you need *more* developing time. Don't forget that when you alter the developing time you must also adjust the exposure time. Without a means for measuring the density range of the combination, unless you have had considerable experience judging such matters, you'll have to complete the print-making step to determine whether the mask was satisfactory.

PRINTING COLOR SLIDES

Exactly the same principles, procedures, and materials are employed for controlling the color-print contrast when printing color slides on Kodak Ektachrome paper. The only difference is that the first mask made will be a negative and will reduce the print contrast, and a second-stage mask made from the first one will be a positive and will increase the print contrast. The only other thing to remember is not to put the four CC50B filters in the exposing beam because you are not correcting for a color negative.

226

Chapter 15

Print-Finishing Techniques

SALVAGE PHILOSOPHY

Do you recall the story in Lucretia Hale's *Peterkin Papers* about the fellow who accidentally put salt in his cup of coffee? His entire family tried adding all sorts of things to make it taste like good coffee again, but without success. The problem was finally solved by a friend who suggested that they throw it away and pour a fresh cup!

Print-making has its counterparts. There's the fellow who spent hours spotting a print when he could have cleaned the negative and made a new, spotless print in a fraction of the time. Then, there's the person who used selective bleaches to lighten up a dark, off-color print, or the one who applied layer after layer of a dye wash to darken a too-light print area. Why not just make a new print?

We think it's an artistic, creative challenge to make a beautiful print, and we wouldn't like to see you waste your creative time by going overboard with print-salvaging procedures. However, nearly every processed and dried print needs a few finishing touches before it is ready for delivery or exhibition.

SPOTTING THE PRINT: BLACK SPOTS

No matter how careful you have been to avoid dust, scratches, fingerprints, and the like, a few unsightly spots often appear, even on the expert's prints. Before you can consider a print to be finished, you must remove two kinds of spots: black and white.

A black spot, which is caused by a "pinhole" in the negative, usually results from dust on the film at the time of exposure. The speck of dust, which may have settled on the film from the camera interior, prevents the light of the image from

affecting the sensitive emulsion in that particular small area. Thus, when the film is developed, this tiny spot will be transparent. Prints from this negative will record the tiny, transparent spot as a small, black spot. If the spot happens to occur in a deep shadow area of the subject, it may pass unnoticed in the final picture; if it should fall in any middle tone or highlight, you will want to remedy the defect.

Keep in mind it is much easier to correct a light spot than a dark spot. Accordingly, you should carefully inspect each negative *before* you print it—use a magnifying glass if necessary—for any transparent spots. Touch each one with Kodak opaque, using a very fine-pointed brush. Then treat the resulting white spot in the print with a brush and a bit of spotting color.

Suppose, however, that you discover an objectionable black spot on an otherwise excellent print and you don't wish to go to the trouble or expense of reprinting it. Choose one of the following remedies:

Chemical Etching
Black spots can be chemically reduced with Kodak non-staining reducer R-14 (see Chapter 13). The solution is applied to the print surface with a pointed toothpick or a small spotting brush. The spot should clear within a few seconds; then blot it with a piece of damp cotton. It is almost impossible to reduce the spot to match exactly the density of the surrounding area and make further work unnecessary, but this is not serious. As we said, it is much easier to take care of light spots than dark ones.

After you have bleached the objectionable dark spots, wash the print for a few minutes in running water to remove any bleach that may remain in the print emulsion.

Physical Etching
An etching knife, such as that used by professional negative retouchers, offers another means of eliminating black spots from prints. Physical etching is feasible only if a few tiny spots are involved; also, the technique is more successfully used on matte-surfaced prints than on glossy prints. You can't etch color prints because there are three color layers in the emulsion.

You can make a satisfactory substitute for an etching knife from a razor blade. Break a double-edged blade in two the long way, and then break these pieces in half, crosswise. The im-

portant thing about the etching tool is that it should be as sharp as possible; do not hesitate to use a new razor blade whenever you suspect that the old one is becoming dull.

Remove the objectionable dark spots in the print by carefully scraping or etching, with the blade held at right angles to the surface of the print. "Right angles" means just that, otherwise pieces of the emulsion will come up not unlike the action of a pickaxe pulling up asphalt pavement! The secret of successful etching is to remove the silver densities *gradually* with a very light stroke, trying to shave off tiny layers rather than to accomplish the job all at once or with only a few strokes. Practice this on a scrap print. Go back and forth lightly over the spot again and again, with the point barely touching the print. Continue this etching until the spot is no longer visible and blends with the surrounding tones of the picture.

If a particular print has required a considerable amount of etching with an etching knife, the print surface may assume a slightly "excavated" appearance when viewed obliquely. Remedy this by waxing matte-print surfaces with a clear (noncolored) wax. If the print is glossy, referrotyping may help solve the problem. Lacquering the print is really the best answer.

SPOTTING THE PRINT: WHITE SPOTS

White spots are perhaps the most common type of print defect. They are caused by dust or small dirt particles on the negative or negative carrier during the print exposure, or, less likely, by foreign matter that may have settled on the sensitive paper emulsion just before you made the print exposure.

As with black spots, the white variety is best prevented by keeping the darkroom and all items of equipment scrupulously clean. Especially important is brushing off the negative before printing. Once the white spots have appeared on a print, however, you can remove them with a small brush and a bit of spotting color.

Spotting media may be divided into three different types: pigments, pencils, and dyes. The choice is largely a matter of individual preference, but to some extent, it is governed by the type of work to be accomplished.

Pigments for spotting prints are available either in the form

of a stick of black India ink or as a pad of spotting colors containing daubs of black, brown, and white water-soluble pigment, such as the Kodak spotting colors. You can use either satisfactorily, and both are recommended for all-round spotting work. Incidentally, if you find the India-ink stick relatively insoluble, rub it lightly on a piece of ground glass. You can easily remove the granular ink particles from the glass surface, which serves as a miniature palette.

Take up the pigment on a water-moistened brush, and make a few trial strokes with the brush on a piece of scrap paper or on the white margin of the print (which you'll trim away later). With RC papers, the amount of moisture on the brush should be kept to a minimum. Deposit the black pigment (use brown for spotting sepia-toned prints) in a fine "stipple" of tone that is neither excessively moist nor dark.

Practice strokes should be a trifle lighter than the tone you wish to match on the print. If the marks are too light, remoisten the brush slightly, give the tip another light twirl in the spotting medium, and test the brush once more on the white paper. The primary purpose of the practice strokes is to remove excess moisture from the brush so as not to leave droplets on the print when you lift the brush from the print surface. If you want to match a dark tone, be sure the brush is well charged with the pigment; to duplicate a light tone, use a comparatively small amount of pigment. It is helpful to start with the dark print areas and proceed to the lighter areas, since the pigment deposited on the spots will become lighter as the brush becomes drier.

When all is ready, shape the end of the brush to a very fine point. Remember, a small brush does not necessarily mean a fine point. Large spotting brushes should have fine points also. A brush that is too small will not hold sufficient pigment and you'll have to spend excessive time recharging the bristles and wiping away the excess. Now bring the brush in contact lightly with the white spot. Touch the spot several times with just the very tip of the brush until you've deposited a sufficient amount of pigment to match the surrounding print area. It is far better to add to the density a little at a time, building it up gradually, instead of trying to hide the spot all at once. Should you add the pigment too heavily, you can easily remove some with a tuft of moist cotton. A Q-Tip is handy for this purpose. Then, after the print has dried a moment, try again.

230

Spotting prints with pencils is the easiest method of all to learn; it consists only of touching lightly the objectionable white spot with a sharply pointed pencil until the spot has disappeared. This method also has the advantage of speed; a brush requires occasional dampening and recharging with pigment.

When you use a pencil for spotting prints, stroke lightly so as not to dent the comparatively soft surface of the emulsion. Use the degree of pencil hardness best suited to a particular job.

We *don't* recommend a pencil to fill in a fairly large spot or a spot surrounded by a fairly heavy density. A heavy deposit of graphite on a print has a metallic sheen that possesses a different type of reflectivity from that of the rest of the print surface. It can, therefore, be easily detected. This is particularly true if you use a pencil that is too hard or a retouching stroke that is too heavy so that the pencil point flattens the natural texture of the paper. However, you can make these retouching marks practically disappear if you lacquer the print.

Glossy paper is the most difficult of all surfaces to spot. A ferrotyped, glossy surface presents no "tooth" to which minute particles of pencil lead can adhere. The best answer to this problem is to use spotting dyes, such as Spotone, manufactured by the Retouch Methods Company, Chatham, New Jersey. The advantage of using dyes is that they sink into the emulsion, increasing the density in the areas treated, without appreciably altering the appearance of the print surface.

Another advantage of using dyes is that you can match any image tone by mixing only a few drops of dyes of different colors. For example, you can produce a wide range of sepia tones by mixing warm brown with black and, if necessary, diluting this mixture with water. The blue Spotone dye is an excellent color for most blue-toned prints.

The application of the dye to the print is somewhat similar to that used in pigment spotting except that you should use a drier brush. Always test the charged brush on the margin of the print and then work up the spot gradually. Repeat this procedure until the spot has assumed the desired tone. Let's repeat for emphasis: *Do not use an excess of dye on the brush.* If you apply the color too liberally, reduce the spot by gently swabbing with a brush and warm water containing a few drops of dilute ammonia, and then blot with a tuft of dry cotton to remove the excess moisture. Dry the print before continuing.

231

CHALKING THE PRINT

So many straight enlargements have objectionably light, and consequently distracting, bright spots or small areas. Sometimes, if the highlight is small, it can be spotted down into unobtrusiveness with ordinary spotting techniques using dye or water color.

However, larger highlights that need toning down are more of a problem. Do not try to pencil them in and blend the graphite by smudging. On papers that have any sort of surface texture (and most of them do), the penciling emphasizes the paper texture by darkening the "hills" and not penetrating to the "valleys." On close inspection, a print so treated looks messy and smudged. Then, too, the graphite deposit seldom matches the image tone of the print. In fact, it is often more reflective than the rest of the print and forms a conspicuously glossy spot if you add much pencil density.

Here's the treatment we suggest for those excessively bright highlights: At an art-supply store, buy a small amount of the finest pumice they have and three or four sticks of artist's chalk, sometimes called pastel crayon. This chalk is inexpensive, will last indefinitely, and is available in many colors. To start, you'll need only black, blue, reddish-brown, and yellow. While you're there, buy a half-dozen assorted cardboard stumps if you don't already have some for use in matte-acetate dodging and ground-glass printing, discussed in Chapter 9.

Chalking a print is simple. With a razor blade or knife, scrape off a little pile of chalk dust from the piece of black chalk onto a piece of glass or any other suitable palette material. If the print is blue-toned, as it might well be for a night street scene, add a bit of blue chalk dust to the pile, and mix it in thoroughly with the black until the color approximately matches the image tone of the print. Use the other chalk colors with the black if you want to match the tone of sepia prints. To this pile, add just a pinch of the pumice and mix that in also. If you don't have the pumice handy, try a bit of household scouring powder as a substitute. The pumice helps to give the chalk a desirable "tooth," which in turn helps you to better work the chalk into the print surface.

Is it all mixed thoroughly? Good. Place your print on a flat, well lighted surface. Next, dip one of the cardboard stumps into

the pile of chalk dust and rub it around a bit to pick up a sufficient quantity. Don't worry about carrying too much chalk dust over to the print. Now, with the stump, begin to rub the chalk onto those highlights that need to be darkened. Start from the center of the highlight and work outward in ever-widening circles. Blow the excess off every now and then so you can inspect your work carefully. Add more chalk if necessary.

While this work is in progress, boil some water on the stove. After you have darkened the print highlights to your satisfaction, hold the print emulsion-side down and pass the print surface through the steam from the boiling water. A small electric hot-steam vaporizer is a convenient source of steam. Be careful to steam the treated areas thoroughly. Then, immediately plunge the print into a tray of cold water and hang it up to dry.

The steam-and-cold-water treatment is intended to soften the emulsion enough to allow the chalk to sink into the surface slightly and then set the gelatin firmly around the chalk particles. Thus, the chalk dust becomes a part of the emulsion and cannot be rubbed off. Further, it helps to reestablish the original surface gloss, hiding the retouching.

RETOUCHING COLOR PRINTS

There are remarkable degrees of control possible over both color and detail with color-print retouching techniques, far beyond the mere removal of dark spots and light spots. It is possible to lighten or darken areas, raise sagging chins and cheeks, slim necks, lighten wrinkles in skin or clothing, intensify highlights and even alter colors. In fact, most of the retouching required in professional portraiture is better done on the print than on a miniature negative.

There are two general methods of retouching color prints: with dyes and with colored pencils. Which to use when? Keep in mind that the dyes provide more color-correcting "see-through" type of retouching because of their translucent nature; on the other hand, pencils deposit more of a "cover-up" type of retouching because of their opaque nature. For example, if you wanted to eliminate a wisp of unruly dark hair on a portrait print, use pencil retouching. Furthermore, pencil technique is more practical if you are inexperienced.

The dead stalks of foreground grass are annoying highlights distracting from the primary interest centers. The easiest way to eliminate them is with a color pencil. First spray the print with a lacquer, such as Pro-Tecta-Cote Retouch lacquer to give it a surface which will accept pencil work. Simply blend the highlights down to match the tone and color of the surrounding area. Be sure to use a magnifying glass for all retouching.

Compare this effect with the unretouched version. Coat the treated print with a finishing lacquer so that the retouching will not smear.

Retouching with Color Pencils

Obtain a set of soft color pencils from an art-supply store. Eagle Prismacolor or Swan Carb Othello are excellent pencils made expressly for this purpose. To provide an adequate tooth that will accept the penciling, first coat the print with a lacquer such as Pro-Tecta-Cote Retouch Lacquer (manufactured by McDonald Photo Products, Inc., 2522 Butler Street, Dallas, Texas 75235). The lacquer is available in pressurized spray cans or in larger quantities for use in a spray gun. Regardless of which application device you use, shake the container thoroughly just before use to disperse the matting agent thoroughly; then, apply a wet coat to the print which should be in a horizontal position. Keep the spray nozzle 4 to 6 inches from the print surface. Use a back-and-forth sweeping motion, starting closest to you and working farther away. Let this coating dry for 15 to 20 minutes or until it is "hard dry."

Next, with a 5–10× magnifying glass, carefully examine the area to be retouched. Let's say it is a man's portrait and you want to subdue an unusually bright highlight area on his forehead. On close examination, you'll find that this place is not all one

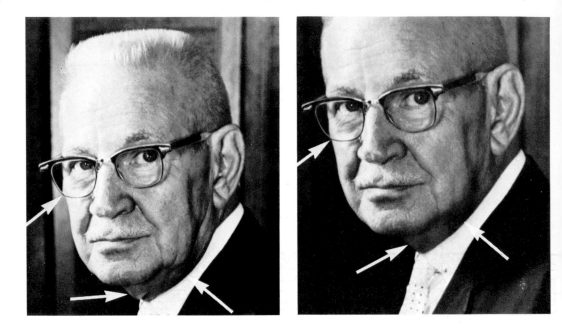

Above left: The retouching problems in the original print include the refraction of the glasses and the desired modification of the neck line in two areas. Below: after coating the print with a retouching lacquer to provide sufficient surface tooth, colored pencils are used to make the necessary corrections. Above right: the finished print.

color but a granular combination of, say, dark browns, a red, an orange and a "peach" skin tone color. These are the colors of the pencils you'll use, employing each successively with a very bright stippling stroke until you've built up sufficient total density. Incidentally, in this case, try to blend the highlight into the adjacent area by starting first at the edges and then working in toward the center. At this point, blend the colors by *lightly* smearing with a tuft of cotton.

Did you overdo it? Or make some unartistic mistake with the pencils? Don't worry—simply remove your unsatisfactory work with a bit of naphtha-saturated cotton, let the print dry, and try it again. Removing the retouching will not affect the retouch lacquer.

If you want to make considerable corrections in areas requiring a considerable density buildup, you should do the penciling in two stages, with a second medium coat of retouch lacquer applied between the applications to provide additional retouching tooth. Be sure to let this second coat dry thoroughly and then finish the corrections.

After you've completed all pencil retouching, protect it by applying first a *light* coat (no more) of a finishing lacquer (which we will describe subsequently) and, after it is dry, a second medium coat of the same finishing lacquer. We recommend the two-stage final lacquering technique to help prevent any running of the corrections, since a heavy, wet final coat would tend to cause the wax base of the Eagle Prismacolor pencils to run or the chalk of the Swan Carb Othello pencils to become translucent.

Retouching with Color Dyes

For retouching color prints with dyes, we suggest using Kodak retouching colors, which are supplied in cake form in small jars and available in nine colors plus reducer. Yes, liquid dyes are available, but they are absorbed too readily by the emulsion and are difficult to control easily. Besides, they are almost impossible to use to tint large areas. In fact, you may want to consider obtaining two sets of the cake dye colors; one each for the wet-brush technique and the dry-brush technique. What is the difference? Keep in mind the principle that "wet" dyes are absorbed rapidly but that "dry" dyes are absorbed slowly and, in fact, almost "sit" on the emulsion surface where

237

they can be smoothed out or even partially removed. So, keep two sets on hand. You wouldn't want to tint a large area only to find that your only cake of magenta dye had been saturated with moisture and would penetrate far too rapidly.

Wet-Brush Technique

Do all your wet-brush retouching first. This means correcting all dust spots and multiple eye catchlights in portraits. Speaking of portrait retouching, be sure to check for bald spots, crooked noses, hairline defects, skin blemishes, objectionable lines and wrinkles, and minor print scratches, all of which can be modified by wet-brush retouching.

Moisten the retouching brush by dipping into a small jar containing equal parts of Kodak Ektaprint 3 stabilizer and water. Swirl the wet brush around in the dye cake of the desired color and transfer a bit of it to a glass or plastic palette. You may want to add a touch of neutral dye, which helps to reduce the brilliance of the pure colors and makes them a little darker. Don't use the brush too wet; it's a good idea to discharge the excess by making a stroke or two onto a piece of paper, rotating the brush to help form a pointed tip. Carefully now, lightly touch only the point of the brush tip repeatedly in the spot to be treated and try to build up the dye density gradually rather than all at once.

Spots can be of any color: Magenta, cyan and yellow spots are neutralized by green, red and purple dyes, respectively. White spots should be made to match the surrounding print area.

Dry-Dye Technique

Here is the method for area color control. By smudging the dry dye around on the print with a piece of cotton (you'll have to breathe into the cake of retouching color before you'll be able to pick up any), you'll be able to alter hues to a remarkable degree. You could, thereby, warm up shadows, correct or intensify clothing colors, improve flesh tones, and subdue overly brilliant highlights and reflections. Buff the treated areas smoothly with a clean piece of cotton. Some excess color can be buffed off; all of it can be removed with reducer or anhydrous denatured alcohol. If, however, you are pleased with the dry-dye corrections, you can set them into the emulsion permanently by steaming the print for about 10 seconds or until the waxy appearance of the treated area has disappeared.

238

Dye Bleaches

You should at least know of the existence of selective and nonselective dye bleaches for retouching color prints. There are formulas published in the Kodak pamphlet, *Retouching Ekta-color Prints* (E-70) that will, for example, just reduce the cyan layer, making the print more red in the treated area. You can do this same thing to the other two image layers, either locally or totally and in controlled degrees of bleaching. More often than not, however, the procedures are more trouble than they are worth.

PRINT LACQUERING

You should consider the desirability of lacquering any carefully made and valuable black-and-white or color enlargement. Lacquering can help protect the print surface from abrasions, fingerprints, excessive humidity, atmospheric contaminants, and from sticking to the glass in a frame. Some lacquers contain an ultraviolet shield that helps to improve color-print stability. You can wash lacquered prints with detergent and a damp cloth to remove smoke haze or other soil.

In ascending order of sheen, we suggest you consider for a top coating the McDonald Photo Products lacquers, Pro-Tecta-Cote Matte, Matte Special, Lustre, and Clear.

Lacquering helps protect a print from abrasions and can also control the degree of surface gloss. For spray can application, direct the jet stream at about a 30-degree angle to the print

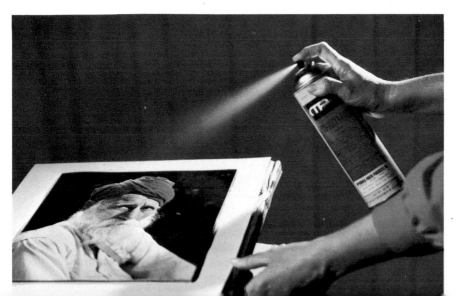

Lacquer Application

Most lacquers are volatile and combustible and, consequently, should be applied only with adequate ventilation and away from any sparks or flame. NO SMOKING while lacquering!

For spray-can application, hold the jet stream at about a 30° angle to the flat print. Start with the print edge nearest you and work toward the opposite edge with sweeping strokes. Try to lay down a homogeneous wet coat approximately 2½ inches wide with each sweep and overlap about ¼ of the sprayed area each time. If you do it right, you'll need only one uniform, wet coat.

For spray-gun application, hold the gun about four to five inches from the print at spray pressures of from 20 to 35 pounds. You may find it convenient to slope the print somewhat toward you; if you do, this angle should not exceed about 30° or else there may be a slight tendency for the lacquer to sag. As with a spray can, apply a complete, physically wet coat so that the lacquer droplets will run together and form a uniform surface.

If you want an extra high-gloss effect, use two coats of Pro-Tecta-Cote Clear with a 10-minute drying time between applications.

Matte Versus Glossy

Beyond merely providing protection or concealing evidence of retouching, lacquering can enhance a print in several astonishing ways. Let's see how.

When a beam of oblique, incident light strikes a print surface, most of the light bounces off at the same angle. But a small part of the beam is reflected up toward the observer's eye by the surface irregularities—that is, the "texture" of the print. These irregularities, while they may seem small, are nevertheless huge when compared with the wavelength of light. From this, you can easily see that the rougher the surface, the more the light beam will be deflected or scattered into the observer's eye. Light-tone print areas don't suffer very much by being diluted with this stray light, but shadow areas, which should be quite dark, are "grayed down" considerably by it. Thus, the surface sheen of a print has a direct influence on print quality.

The way to keep shadow areas dark is to provide them with a smooth surface from which the oblique, viewing-light beam can bounce off easily without interference from the paper

texture; and a smooth surface is exactly what waxes, lacquers, and plastic finishes supply. The smoother the print surface, the greater the range of densities in the print. And the greater maximum density available, the higher the quality of the print. In fact, to amaze yourself, mask off a diagonal half of a low-key print, and lacquer the other half with a high-gloss lacquer. Pull away the mask and compare the treated and the untreated portions. This, in brief, is what you'll find:

1. The blacks have become blacker, extending the tonal range (density scale) of the print.
2. Shadow details are more evident because the separation between them has been increased.
3. The color of a toned print has been considerably improved because of increased color saturation. Similarly, the colors of a color print are definitely more saturated— reds are redder, blues are bluer, and so on.

If you are going to lacquer a print, you won't need to compensate in exposure for the annoying tendency of a matte-surface black-and-white print to "dry down," because the surface reflectivity of a print coated with a high-gloss lacquer is about what it was when the print was wet during processing. In fact, you can use any favorite print surface, from "A to Z," and still make a "glossy" print.

Of course, it is no more advisable to put a high-gloss finish on every subject than it is to print all subjects on glossy paper. Portrait customers usually do not want glossy prints, and neither do a good many other people. But, aside from a consideration of personal likes and dislikes, there is no "photographic" advantage to adding a high-surface gloss to high-key prints or to those of atmospheric fog scenes, both of which have a relatively short tonal range. On the other hand, take a marine scene or an evening street scene shot in the rain, tone it a gold-chloride blue, apply the glossiest finish you know how, and you'll be very pleased with the appropriateness of the treatment and the extremely high print quality.

Special-Effects Lacquers
Texturizing Lacquer

By varying the type of lacquer, its dilution, and the method of application, you can achieve a variety of surfaces including stipple and brush effects. For example, McDonald Pro-Texture

is a high-viscosity lacquer that is used to create a brush-stroke texture when applied with a brush, or several interesting texture effects when applied with a spray gun (such as the DeVilbiss Model CGA-501 84 FF and similar pressure feed guns). The surface effect is controlled by three variables:

1. The *size* of the texture particles is determined by the spray gun's fluid adjustment. You'll want to produce a round spray stream, so use masking tape to close the side outlet holes in the "horns" of the spray-gun air cap.

2. The angle of application determines the *shape* of the texture pattern. A low angle (10°) produces an elongated weave-type pattern. A higher angle (60°) produces a leather-like finish. Apply the lacquer from two sides of the print to achieve good uniformity of the pattern. However, apply it sparingly enough to leave a small space between the lacquer particles, or else they will tend to run together and produce a smooth coat.

3. The particle *height* is determined by the distance the spray gun is held from the print. Applied close to the print, the lacquer is wetter and tends to "lie down." Used farther from the print, it arrives at the surface in a drier condition and tends to "stand up." For example, use a spraying distance of about 16 inches if you want a coarser, rougher texture. You can repeat any particular effect if you keep records of all the variables that produced it.

To produce brush marks, apply an even coat of Pro-Texture directly from the container. Wait for about four minutes until the lacquer has partially dried and it will retain brush strokes. Lay the print flat. Using one-half a scrub brush held at a 10° angle to the surface of the print, strike the print sharply with a twisting, stippling motion. This causes the individual tufts of bristles to create separate random brush strokes. Be sure not to leave an area until the bristle marks are retained. The brush should be stored in 3/4" of lacquer thinner kept in a sealable container. Before each use simply shake out the excess lacquer thinner and proceed.

As an alternate procedure, you may want to try an angle-cut stiff-bristle brush, such as in the Grumbacher 6361 series. You may want to acquire a 1/4", 1/2", and a 1" size. For, the larger the print, the larger the brush marks you can use artistically.

These brushes can be used to produce a really deep texture effect with the following procedure: Pour some Pro-Texture into

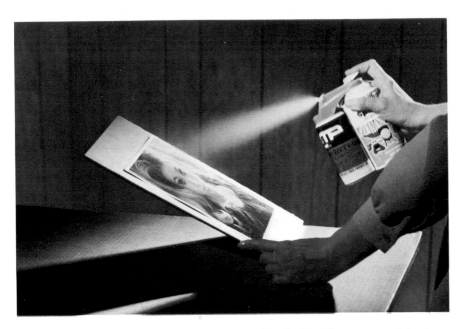

To create the effect of an old cracked oil painting, first spray with clear lacquer and then with McDonald Florentine which will check the previous coat.

The reticulated pattern can be controlled to yield either fine or coarse checking.

three wide-mouth, clean containers. Leave the top off the first for one day, the second for two days, and the third for three days. (Of course, this schedule can be modified for unusual temperature and humidity conditions.) This will give you three stock solutions of varying viscosity to be used as follows: Use the three-day material on backgrounds and obviously rough-textured subject areas. Use the two-day material on clothing, hair, and the like. Use the one-day material on flesh, smooth fabrics, and areas where minimum texture is desired. Apply the Pro-Texture of the desired viscosity to about one 5″ × 7″ area at a time and keep working it until it *retains* the individual brush strokes. The brush strokes should look crisp, not "gobby." Be sure to *follow* subject contours with your brush strokes—*don't cross them.*

Did you overdo it, or don't you like the effect? You can remove the coating with lacquer thinner without harming the print.

Reticulating Lacquer

McDonald Florentine is a reticulating lacquer that will "check" coats of Clear Lacquer, or Pro-Texture and Clear Lacquer, previously applied to a print. This creates the effect of a very old oil painting. You can control Florentine to create either large or small checks.

The most artistic effect is obtained by first applying Pro-Texture Lacquer to the print with a brush to produce a brush-stroke pattern, following the subject contours, and then applying a coat of Clear Lacquer. When these coats are thoroughly dry, apply the Florentine as an even wet coat from side to side and bottom to top. Interestingly, the *amount* of Florentine applied determines the size of the reticulated segments:
—A heavy, wet coat produces approximately 1/2″ segments,
—A medium, wet coat produces approximately 1/4″ segments,
—A light, wet coat produces approximately 1/8″ segments.

If you're intrigued with the pictorial possibilities of this "old masters" print surface, surely you'll want to further the effect by applying an antiquing coat to emphasize and darken the checked pattern. Make up this glaze as follows:

Parts	Material
2	burnt umber
1	lamp black
1	boiled linseed oil
2	turpentine

244

Brush the print evenly with this mixture, let it dry for five to ten minutes and then wipe it with a clean paper towel folded into a pad (to prevent cleaning up "valleys" of texture) to remove the excess. Wipe from the direction of the subject lighting, changing the towel when necessary, until you achieve the desired effect. Be sure the glaze is uniform over the entire print surface. If it isn't, drag a dry 2″ brush across the print, first horizontally and then vertically. With a cotton-tipped skewer remove all the glaze from the eyes; remove most of it from flesh tones and enough of it from important highlights so they will retain their sparkle.

Without waiting, when all the work is complete, add a finishing top coating of Pro-Tecta-Coat Clear Lacquer. If you've done everything artistically, you'll really have a remarkable print.

MOUNTING METHODS

A mounted print not only looks better than an unmounted print, it also lasts longer, because mounts act as stiffeners and help keep prints from being bent or torn. There are several choices of adhesives and mounting methods; the following are dependable and convenient to use. Incidentally, if you know you are going to lacquer the print, mount it first and then lacquer it. Most print lacquers are thermoplastics, and could be softened if subjected to excessive mounting heat; this could be messy.

Perma/Mount
Perma/Mount is a double-faced self-stick adhesive card that lets you mount prints onto nearly any type of mounting surface. No heat, presses, other glues, or any supplemental equipment is necessary. It can be used without staining or changing of the print color. It is available in sizes up to 11″ × 14″ from photo dealers or directly from the manufacturer, Falcon Safety Products, Inc., 1137 Route 22, Mountainside, New Jersey 07092.

Kodak Rapid Mounting Cement
This material is made especially for mounting small prints rapidly and permanently to any clean, dry surface. The cement is colorless, moisture-resistant, and nonstaining to prints, album pages, or mounts.

Suppose you want to mount some vacation pictures in an album. Arrange the prints on the album page in their desired order. Take the first print and lay it face down on a clean sheet of paper. Squeeze the tube of cement gently and touch the nozzle to the back of the print, drawing a line of cement around all four sides. Keep the line about ⅛" in from the edge of the print so that the cement will not squeeze out when you mount the print. Now, put a single drop in the center of the print and let it set for a few minutes. While you are waiting you can be applying cement to the next print.

After the cement has set slightly, mount the print in the desired place by positioning it and applying moderate pressure. Rub the print from the center outward to avoid wrinkles. If excess cement should ooze from the edge of the print, remove it by wiping with ordinary cleansing tissue.

It's good to know that, if necessary, you can remove prints mounted in this way without damaging them. To do this, place a sheet of clean, heavy paper or cardboard over the print and heat with a warm (not hot!) electric iron for 10 or 15 seconds. Then, remove the cardboard and the print as quickly as possible. If too hot, an iron might scorch the print; if too cool, it will not melt the cement.

Kodak Dry Mounting Tissue

At room temperature, this material looks like a piece of glossy tissue paper, but it contains a thermal adhesive that melts at a 200 to 230° F range to form a permanent bond between the print and the mount. You need a thermostatically controlled electric iron for mounting prints by this method. For occasional use, an ordinary household-type iron works fine if you set it between "Silk" and "Wool."

To mount a print with a hand iron, follow these simple steps:
1. Attach the tissue to the back of the print by touching the tissue quickly with the tip of the hot iron.
2. Trim the print and tissue to the required size.
3. Iron the mount to remove any moisture, which normally exists on porous material.
4. Iron the print onto the mount.

When tacking a sheet of dry mounting tissue to the reverse side of the print, start from the center and work out toward the

Dry mounting is easy. First tack the tissue to the reverse side of the print. Start at the center and pull the tacking iron toward the sides so as not to cause wrinkles in the tissue. Just two or three touches of the iron should be enough.

Next trim off the excess tissue together with the print border.

Position the print on the mount board. Hold it there, lift up one corner and tack the tissue to the mount. Repeat with each corner.

Use an overlay to protect the print surface when dry mounting. This overlay, whether paper or thin cardboard, should be dried by preheating in the press so it will not stick to the print during the mounting process.

corners. A tacking iron is the ideal implement. Then, trim the edges of the print so that the borders of the print will coincide exactly with the dimensions of the mounting tissue. Work on a flat surface, position the print as desired on the mount, and tack it in place; then, with a double overlay of wrapping paper or a thin sheet of cardboard to protect the print emulsion, mount the print. (The paper or cardboard should first be dried out in the press or else it will stick to the print.) If you use a dry-mounting press, apply the pressure to the mounted print for about 30 seconds and then release it. Allow enough time for the heat to penetrate the overlay, print, and tissue to effect a proper seal. If you use a thick cardboard for the cover sheet, heat for at least 45 seconds.

The temperature of the iron or press is important. If it is not hot enough, the adhesive will not melt; if the temperature is too high, the adhesion will be only temporary. Since excessive heat may also scorch the emulsion or melt the resin-coated papers, test a household iron for approximate temperature by touching it lightly and quickly with a wet finger before beginning the mounting operation. If the moisture just sizzles, the temperature is about right. The ideal temperature is 220° F.

When the mounted print is removed from the press, place it face down on a cool tabletop and allow it to cool in this position. This will minimize the usual tendency to curl.

Special Mounting Situations

Everyone has his favorite brand of glue for special situations—mounting photographic prints on unusual surfaces, for example. You'll want to be sure that such adhesives stick well, have no adverse effect on color-print dye stability, and won't wrinkle or blister the print. The authors prefer Lamin-All, which is manufactured by McDonald Photo Products, Inc., 2522 Butler Street, Dallas, Texas 75235, and which is readily available in most photographic-supply establishments.

Lamin-All is an adhesive that you can use to mount anything to almost anything else including resin-coated papers. Use it hot and dry on nonporous materials, or cold and wet on porous surfaces such as mounting board, construction chip board, wood, and so on. Briefly, these are the techniques involved:

For Mounting on Masonite: Spray the Lamin-All on the Masonite or back of the print, applying a smooth, even coat.

248

Allow to dry thoroughly, until the Lamin-All becomes clear. The Masonite boards may then be stacked and stored with only a sheet of silicone-coated paper (the pink interleaving sheets separating Kodak dry mounting tissues) between pieces. When you are ready to mount the print, remove the silicone paper, position the print, and place it in the dry-mounting press at 210° F for three minutes.

For Mounting on Plastic or Plexiglass: Spray the Lamin-All on the plastic in a smooth, even coat. Allow it to dry thoroughly, until the Lamin-All becomes clear. Position the print, roll it down to eliminate air bubbles, and place it in a dry mounting press at 210° F for 25–35 seconds.

For Mounting on Mount Board: Spray the Lamin-All on the back of the print or on a board. Allow to dry thoroughly, until clear. Position the print on the board, and place in the press. Mount at 210° F for 20–30 seconds. For cold mounting, apply the Lamin-All to the mount board or back of the print; apply a *light*, even coat, either by spraying or with a brush. Then, place the print in position; roll down with a rubber squeegee roller. Wipe any excess from the mount immediately.

For Mounting on Velvet or Other Fabric: Apply a light coat of the Lamin-All to the mount with either a brush or a spray gun. Allow to dry until the adhesive becomes slightly tacky. Apply the velvet and smooth it out as you position it onto the board.

For Mounting on Canvas: You can mount resin-coated prints—both color and black-and-white—onto canvas or even raised-grain pieces of planking. To do this successfully and so that the texture of the mount material is actually impressed into the print emulsion, a special procedure is necessary. The emulsion, the resin coating directly underneath the emulsion, and the paper base must be *stripped off* the bottom resin-coated layer.

It's easier to do this than it might sound: use a sharp knife or razor blade and split one corner of the print down about 1/4"—just enough so that you can get hold of the two portions with your fingers. Now, lay the print *emulsion-side down* on a clean table surface. Hold down the bottom split layer and carefully peel off the top layers. You must peel the uppermost part nearly 180° back on itself—*do not pull it straight upwards or you'll tear it.* You'll also tear the picture if you try to separate the layers with the emulsion-side uppermost. There should be no problem with this operation; just don't rush it. Call for another

249

Photographic prints can be given a canvas painting texture. The resin coated backing is removed, the print and canvas coated with Lamin-All, covered with a neoprene pad, and then mounted in a dry mounting press.

Stretch the canvas mounted print onto a frame with stretching pliers. After stapling in the center of all sides, work out the fullness toward the corners.

Painter-like brush strokes can be added to either black-and-white or color prints. Use thickened Pro-Texture lacquer.

It is important to follow subject contours with your brush strokes—don't cross them.

pair of helping hands if you think you'll need them for a large-size print. An especially good procedure for a large print is to pull the bottom layer of the print back about two inches. Tape top edge of the print face down on a table. Tape the resin film to a mailing tube and simply wind up the mailing tube rolling and peeling the film straight back.

The back of the stripped image is then coated with adhesive and mounted with a dry-mounting press. (Complete instructions on using Lamin-All to produce "instant ancestors" is available in the M-501 Lamin-All Canvas Kit available from photographic dealers.) The press should be fitted with a Teflon-coated neoprene pad to insure adequate mounting pressure over the irregular mount surface and to achieve the transfer of the mount texture to the face of the print.

Want to try a different print finishing technique? With resin coated papers it's possible to achieve an effect resembling decoupage. You can mount a print directly to a weathered board so that the texture of the board will show right through the image. (If finding a suitable board is a problem, you or your photo dealer can order a plastic "weathered board" called "Quebrada" from McDonald Photo Products, Dallas, Texas.) Here is how to do it:

1. The first step is to peel the entire resin coated backing off the print. Lay the print face down on a flat surface. Use a knife at one corner to start separating the backing from the image. Then grasp the backing and pull. This can be done with any size print.

2. Clip the flimsy image face down onto a stiff cardboard that is slightly smaller than the print. Apply Lamin-All to the plaque and allow it to dry completely. Apply Lamin-All to the back of the print and allow it to dry until tacky.

3. Put the two adhesive-coated surfaces together. Work out any air pockets with your hand. If you bring them into contact with sort of a rolling motion from one edge to the other, you shouldn't trap any air in the process.

4. Remove the cardboard and cover the print surface with a neoprene pad.

5. Place the plaque and padded print between two sheets of ¾″ plywood and clamp tightly from each corner. Allow it to dry for two hours.

6. Trim away the overhanging portion of the picture with a sharp knife.

7. Feather the edges with a wire brush. A rotating wire brush in an electric drill is an ideal tool for this job. Be SURE the direction of feathering is DOWN.

8. Darken the light edge of the print with oil pigments about the same color as the plaque.

9. We suggest you apply a top coat of lacquer, such as Pro-Tecta-Cote Lustre.

Reference Section

Notice we didn't call this section an appendix. Yes, it has tables and formulas you'll need to refer to now and then, but we hope you'll browse through it right now. Want to build a darkroom? Test a safelight? Choose an enlarger? Make tiny prints smaller than your negatives? These and other print-related topics are discussed here.

PACKAGED CHEMICALS AND SOLUTIONS

The modern trend is to use packaged chemical preparations that offer you many practical advantages. While a published formula, to be practical, must be restricted to fewer than a half-dozen readily available ingredients, chemicals prepared by the manufacturer may contain many other beneficial components.

For example, in addition to the usual developer ingredients of buffers, restrainers, accelerators, developing agents, and preservatives, a packaged, ready-to-use developer may also contain agents that prolong solution shelf life, increase capacity, and keep the solution clear during use. These ingredients may be present in minute quantities—in fact, quantities too small to be weighed accurately in a home darkroom—yet all are blended with professional skill and with uniformity from batch to batch.

As a result, packaged chemicals are easier to use, longer in life, and more effective in doing the job for which they were designed. Don't get snowed under with beakers, balances, or a pinch of this or that, just because you may have heard that some ingredient may be a beneficial additive; dispense with any unnecessary preparation time and get on with the business of making good enlargements.

Processing chemicals are packaged either as packets, as bottled solutions, or as canned or boxed powders. The packets—those handy, matchbook-size, metal-foil containers—are primarily for amateur use in making black-and-white contact prints. Their solution quantity is intentionally small to provide just the right amount for one evening's fun of contact printing;

then the "tired" solutions should be discarded. Whereas the canned and boxed chemicals are primarily for professional use, the bottled ones are well worth considering for both professional and advanced amateur work.

Bottled, concentrated, liquid developers, stop baths, and fixers are available in quantities to make more than enough solution for an evening of enlarging or a day's worth of commercial production, even with large-size papers. These liquids are easy to store, but best of all, they need only to be diluted with water for *immediate* use.

Mixing Solutions

Handy as packaged chemicals are, however, they do not relieve the photographer of *all* mixing responsibility. With developers, for example, there is little difference in the speed of mixing at temperatures of 90 to 125° F. But with some developers the manufacturer recommends that the water used be at 90° F so the final mixed solution will be nearer the recommended working temperature of 68° F. So, don't think all directions are alike. It's to your advantage to read and follow the directions each time you mix a solution from packaged chemicals.

If a developer is a two-component type (you'll find that one part is in a separate, inner container inside the package), you *must* remember to see that all the developing agent—the first chemical added—is *completely* in solution before adding the rest of the chemicals. An undissolved crystal here and there can "seed" the whole batch and cause crystallization, particularly if the solution is stored at comparatively low temperatures. Also, incorrectly mixed developers may contain complex crystals that are insoluble even at elevated temperatures.

Let's also take the example of a packaged fixer: The directions may say, "Pour the contents of this package, with continuous stirring, into one gallon of water, not over 80° F (20° C)." Now, it said *pour*, not dump; *continuous* stirring, not a lick and a promise; and *80° F,* not whatever temperature the tap water happens to be.

To avoid problems in the preparation of chemical solutions from liquid concentrates, you should pour the concentrate into the recommended quantity of water, at the recommended temperature, very slowly, and with continuous stirring.

Some photographers who mix *prismatic* hypo crystals at

125° F perhaps don't understand that the *anhydrous* (water-free) hypo and hardener in the modern fixer won't take such high temperatures. With prismatic hypo crystals (which in their apparently dry state contain water), a lot of water is absorbed in dissolution, but the temperature doesn't rise appreciably. With the anhydrous hypo, more water is absorbed faster, and the heat generated results in an unusable milky solution. It is, therefore, important to start at the recommended temperature of 80° F.

In cold weather some stock solutions may crystallize because, as pointed out above, undissolved particles of chemicals can serve as "crystallization centers" and thus hasten the crystallization of the chemicals that are in "excess" at that temperature. Some chemicals are sold in a concentrated-solution form. There is not much of a storage problem here because most of these solutions naturally have a low crystallization point and will withstand temperatures as low as 10–20° F without crystallization. Lower temperatures than this may cause a "needled" appearance in the solution, but when warmed up, the crystals will go back into solution without harm. An exception is glacial acetic acid, which "freezes" at about 60° F. On warming up, however, it liquifies readily and its subsequent use is not impaired in any way.

It is not true that glacial acetic acid expands as it solidifies and can break its glass container. Acetic acid, like so many other liquids (water is an exception), contracts as it turns to a solid that is difficult to reliquify rapidly.

Bottles for the developer stock solution should be the right size. If you mix a quart of solution it should be stored in a one-quart bottle, not a half-gallon or larger size. To further this end, a well-fitting screw cap or rubber stopper is preferred. Remember, a poorly kept chemical solution may deteriorate; a partially deteriorated developer has a short life and may produce stained prints. Incidentally, amber bottles have no practical advantage over clear ones. Plastic (polyethylene) bottles can be used for all solution storage except for developers. The reason for this exception is that the plastic has a tendency to "breathe"; this would cause the developer to oxidize. There are heavy-walled plastic bottles that are specifically made for developer storage. Just don't try to salvage empty bleach or cider bottles for this purpose.

After preparing the developer—or any photographic solu-

tion for that matter—be sure to label the bottle. Unidentified solutions can cause trouble in the darkroom, as you might well imagine. Also, be sure to add the date of mixing to the label, because some chemicals deteriorate after a period of time. If you wish, you can coat a gummed paper label with clear nail polish or cover it with transparent tape so that spilled solution won't blur the lettering.

Developers

You can do no better than to consult the data sheet that every photographic paper manufacturer publishes for his products. For example, let's say you're going to use Kodabromide paper; the primary recommendation for developer is Kodak Dektol developer, which is very well suited for this product and produces cold and neutral tones. It has long life and excellent keeping qualities. It shows little sludge or discoloration and is supplied in a variety of sizes.

On the other hand, suppose you were interested in exhibition work or wanted to make portraits and had selected Kodak Portralure paper. The data sheet for this product would give Kodak Selectol developer as the primary recommendation. This is a warm-toned paper developer eminently suited for bringing out the warm-tone characteristics of the paper itself. It has a greatly improved capacity and longer life than its predecessor, D-52 developer, and is compounded especially for warm-toned portrait and exhibition papers. It should be your choice in this instance.

These two developers provide you with every developer characteristic that you might normally encounter with one possible exception: when you find you are printing onto a single-contrast paper and the results are too contrasty, keep in mind that Kodak Selectol-Soft developer is also suggested for warm-toned papers. In other words, this is recommended for obtaining normal-contrast prints from contrasty negatives.

Stop Baths

You have two choices in formulating the stop bath: The first is to buy ready-mixed Kodak indicator stop bath. There is no need to guess whether or not this bath is active after considerable use. When exhausted, it turns purple and you can easily see the color shift even under darkroom safelight illumination. One

16-ounce bottle of this concentrated solution makes 8 gallons of working solution.

The other alternative is to mix your own from a stock solution of 28% acetic acid, using $1^1/_2$ ounces of this stock solution to 1 quart of water. If you need a larger quantity, add 6 fluid ounces of 28% acetic acid to 1 gallon of water. Since there is no point in paying money for water at a store, the economical procedure is to buy glacial acetic acid and make your own 28% stock solution. This is a simple matter of diluting three parts of the glacial acetic acid with eight parts of water. Do this carefully because glacial acetic acid may burn the skin.

There is a shortcut you should avoid. How often have you seen a fellow photographer mix up a stop bath by filling a tray half full of water and then pouring in a few "glugs" of glacial acetic acid directly from the bottle? Extra-strong stop baths may easily cause translucent water spots in the prints. These spots may disappear on drying and lead you to think there will be no problem, but in time and under unfavorable storage conditions these areas may accelerate the fading or staining of the print. Also, these translucent water spots may be the source of mottle if the prints are subsequently toned. Stop-bath ingredients are inexpensive, so do it right.

Fixing Baths

There are three convenient fixers that can be purchased in easy-to-use form: Kodak fixer is a single-powder preparation containing fixer and hardener, and can be used for films and for papers. It acts rapidly, is long lasting, and has a high capacity. It is packaged in a convenient assortment of darkroom sizes. Kodak rapid fixer and Kodafix solution are even more convenient than the powder. These liquid fixers need only to be diluted for use with paper.

Chemicals for Color Printing

Hurray for progress! When the current type of color paper first became available about two decades ago, it required six solutions (not counting the washes) and a 45-minute processing time. Today this has been simplified to only three solutions and five minutes. For the processing of Kodak Ektacolor 37 RC papers, the chemical steps are: developer, bleach-fix, and stabilizer. The chemicals may be purchased in a 1-gallon or $3^1/_2$-

258

gallon kit called the Kodak Ektaprint 3 processing kit. Or, the three chemicals may be purchased separately as Kodak Ektaprint 3 developer, Ektaprint 3 bleach-fix and replenisher, and Ektaprint 3 stabilizer and replenisher. For processing with the Kodak rapid color processor, Kodak Ektaprint 300 developer is substituted for the Ektaprint 3 developer.

TONING FORMULAS

KODAK SULFIDE SEPIA TONER T-7a
Stock Bleaching Solution A

Water	2.0 liters
Kodak Potassium Ferricyanide (Anhydrous)	75.0 grams
Kodak Potassium Bromide (Anhydrous)	75.0 grams
Potassium Oxalate	195.0 grams
*Kodak 28% Acetic Acid	40.0 milliliters

*To make approximately 28% acetic acid from glacial acetic acid, add 3 parts of glacial acetic acid to 8 parts of water.

Stock Toning Solution B

Sodium Sulfide (Anhydrous)	45.0 grams
Water	500 milliliters

Prepare Bleaching Bath as follows:

Stock Solution A	500 milliliters
Water	500 milliliters

Prepare Toner as follows:

Stock Solution B	125 milliliters
Water to make	1.0 liter

First be sure that the print has been thoroughly washed. Treat the print in the stock bleaching bath (Solution A). The image will bleach to a faint yellowish-brown image within about one minute. Rinse the print in running water at 18–21° C (65–70° F) for two minutes. Treat the print in the toner (Solution B). The original detail will return in about 30 seconds. Rinse the print thoroughly in running water. Treat the print in a hardening bath composed of 1 part of Kodak liquid hardener and 13 parts of water or, alternately, in 2 parts of Kodak hardener F-5 and 16 parts of water. Hardening should be from 2 to 5 minutes. Following hardening, wash the print for 30 minutes in running water at 18–21° C (65–70° F) and dry.

KODAK POLYSULFIDE TONER T-8

Water	750 milliliters
Sulfurated Potassium (liver of sulfur)	7.5 grams
Kodak Sodium Carbonate (Monohydrated)	2.5 grams
Water to make	1.0 liter

This single-solution toning bath produces slightly darker sepia tones than the redevelopment-sulfide toner, Kodak toner T-7a. It has the advantage, compared with hypo-alum toners, that it does not require heating, although raising the temperature to 38° C (100° F) reduces the time of toning to about one-fifth that necessary at 20° C (68° F).

To Use: Treat the well-washed black-and-white print for 15 to 20 minutes, with agitation, in the Kodak T-8 toner bath at 20° C (68° F) or for 3 or 4 minutes at 38° C (100° F).

After toning, rinse the print for a few seconds in running water and place it for about 1 minute in a Kodak hypo clearing agent bath, freshly mixed and kept for this purpose only, or in a solution containing 30 grams of sodium bisulfite per liter (1 ounce per quart) of water. Then treat the print for about 2–5 minutes in a hardening bath prepared by adding 1 part of Kodak liquid hardener to 13 parts of water, or 2 parts of Kodak hardener F-5a stock solution to 16 parts of water. If any sediment appears on the print, wipe the surface with a soft sponge. Wash the print for at least 30 minutes at 18–21° C (65–70° F) before drying.

For a packaged toner with similar characteristics, obtain Kodak brown toner.

KODAK GOLD TONER T-21
Stock Solution A

Warm water, about 50° C (125° F)	4.0 liters
Kodak Sodium Thiosulfate (Pentahydrated)	960.0 grams
Kodak Potassium Persulfate	120.0 grams

Dissolve the hypo completely before adding the potassium persulfate. Stir the solution vigorously while adding the potassium persulfate. If the solution does not turn milky, increase the temperature until it does. Cool the above solution to about 27° C (80° F) and then add the solution below, including the precipitate, slowly and with constant stirring. *The bath must be cool when these solutions are added together.*

260

Cold water	64.0 milliliters
Kodak Silver Nitrate, Crystals*	5.0 grams
Sodium Chloride	5.0 grams

*The silver nitrate should be dissolved completely before the sodium chloride is added.

Stock Solution B

| Water | 250.0 milliliters |
| Gold Chloride* | 1.0 gram |

*Gold chloride is a deliquescent chemical; it will liquefy rapidly in a normal room atmosphere. Store the chemical in a tightly stoppered bottle in a dry atmosphere.

The working solution is prepared by adding 125ml (4 fluid ounces) of stock solution B to the entire quantity of Solution A. This mixture is allowed to stand for eight hours. During this time a yellowish precipitate will form. The clear solution is poured off into another container. The precipitate is discarded.

Pour the clear solution into a tray supported in a water bath and heat to 110° F (43° C). During toning the temperature should be between 100 and 110° F (38–43° C).

Wash all prints to be toned for a few minutes after fixing before you place them in the toning solution. Soak dry prints thoroughly in water before toning.

Separate the prints at all times to insure even toning. When you reach the desired tone (5–20 minutes), remove and rinse the prints in cold water. After toning all prints, return them to the fixing bath for five minutes, then wash for one hour in running water. Consult the instruction sheets for RC papers, since the washing times will be less.

Revive the bath at intervals by the addition of Solution B. The quantity to be added will depend on the number of prints toned and the time of toning. For example, when toning to a warm brown, add one dram (4 cc) of gold solution after you've toned fifty 8″ × 10″ prints or their equivalent. Add fresh solution from time to time to keep the bath up to the proper volume.

Remember that after toning in Kodak gold toner T-21, you should refix prints in a fresh bath to insure the removal of excess silver salts. Then wash thoroughly. The toned image is quite stable, but it should be protected from excessive heat or intense light. If image-tone changes do occur from either of these causes, storage in a cool dark area will usually restore the original brown tone.

THE METRIC SYSTEM AND EQUIVALENTS

The metric system of weights and measures has been used extensively in the photographic world for the last two decades, hence it is seldom necessary to convert from the awkward English system of minums, drams, grams, scruples, and so on.

Since some old formulas are in English system only, the equivalents given should be helpful in making conversions when necessary.

WEIGHT
English to Metric

1 lb.	= 453.6	grams
1 oz.	= 28.35	grams
1 dram =	1.771	grams
1 grain =	.0648	grams

Metric to English

1000g (1 kilogram) = 2.2046 pounds

1g = .03527 ounce

VOLUME
English to Metric

1 gallon	=	3.785	liter
1 quart	=	946.3	milliliters
1 pint	=	473.2	milliliters
1 gill	=	118.29	milliliters
1 fluid ounce =		29.573	milliliters
1 fluid dram	=	3.696	milliliters
1 minim	=	.0616	milliliters

Metric to English

1 liter (1,000 milliliters) = 1.057 quarts

= 33.8 ounces

TEMPERATURE
Scale Converter

```
 F    C
125
       50
120
115
110
105
       40
100
 95
 90
 85    30
 80
 75
 70
       20
 65
 60
 55
 50    10
```

UTILIZING PAPER SPEED INFORMATION

The procedure for estimating approximate exposures when changing from one paper to another is quite simple. The numerical values for rating black-and-white paper speeds are arranged in the series 1......1000. The higher the number, the faster the paper. Each number in the sequence of values represents a speed difference of $1/3$ stop from the adjacent

number. Every third number in the ascending values is double in value. When you change from one paper to another, the relative speed difference between the papers is applied to make a test exposure. For example, if you have been using Kodak Ektalure paper with an ANSI paper speed of 125 and have made a satisfactory print at 20 seconds with a lens aperture of $f/8$ and you now wish to use Kodak Medalist paper No. 2 with an ANSI paper speed of 250, the exposure for a test can be made at $f/11$ at 20 seconds, or at $f/8$ at 10 seconds.

It is unreasonable to expect 100% precision results in the use of paper speeds. The values are relative and photographic paper, being a perishable product, can change with time. This means that though the initial test made will be close, it will not necessarily be precisely on the target.

Color papers do not have a conventional ANSI speed. For changing from one emulsion of paper to another, the manufacturer furnishes data for making test exposures. On packages of Kodak Ektacolor 37 RC paper will be found two sets of information; one is termed Tricolor Filter Factors and the other is termed White Light Data. This information may be presented as:

TRICOLOR FACTORS		WHITE LIGHT DATA
Red	80	CC −10M
Green	80	CC 00Y
Blue	70	Ex. Factor 70

If a good print had been made on this lot of paper using a lens aperture of $f/8$, and a time of 20 seconds with a filter pack of 70 Magenta and 60 Yellow, it is possible to calculate the conditions to be used for a test exposure on a second lot of paper with information presented as:

TRICOLOR FACTORS		WHITE LIGHT DATA
Red	80	CC +05M
Green	70	CC +15Y
Blue	70	Ex. Factor 110

For printing by the white light method, only the figures in the White Light Data section are used. The calculations for the new filter pack are obtained by first subtracting the two filter values listed for the first paper from the values of filters actually used in the filter pack when that paper was printed:

Subtract:*	70M	60Y
(−)−10M		00Y
80M		60Y

To this result is added the two filter values for the second lot of paper:

Add:	80M	60Y
	05M	15Y
	85M	75Y

This is the filter pack that should be tried with the second lot of paper for a test print. The new exposure to be tried can be calculated from the exposure factors given:

$$\frac{\text{Factor for new emulsion}}{\text{Factor for old emulsion}} \times \frac{\text{Exposure time for}}{\text{old emulsion}} = \text{New exposure time.}$$

For the examples given, the calculation becomes:

$$\frac{110}{70} \times 20 = 31.4 \text{ seconds}$$

*Remember that subtracting a minus value is equivalent to adding the value as a positive number.

DARKROOMS

The most important thing about a darkroom is to have one! Probably you do already. But, if you don't, and have been pleading "lack of space," take heart. You can make excellent prints with an enlarger set up in a kitchen, a bathroom, a corner of the basement, or even a large closet—all of them being better print-making rooms at night! You can establish a full-fledged photo lab in a space as compact as 6′ × 8′ or less, especially if this is for amateur or occasional work.

Although a "real" darkroom is not essential, it is convenient. Besides, enlarging is even more fun if you can work under ideal conditions. So, if you'd like an efficient, special place to make your super prints, here's a good basic darkroom plan for occasional printing.

264

Construction Notes

The basic plan illustrated is 6′ × 8′ (each square is 12″). This basic plan can be easily condensed to 5′ × 7′ and its shape can be varied; a dry basement is the best location (attics tend to be too warm in summer, too cold in winter). Walls can be of thin wallboard on light wooden frames, but don't try to use curtains: they catch dust.

Paint the floor or put asphalt tile down. Use the largest flat-rimmed sink you can afford; put a frame of 1″ slats in it as a base for tanks and trays. Linoleum makes an adequate counter-top and, of course, the hard-composition, kitchen-type tops are best. Buy trays at least one size larger than you think you will need. Incidentally, the high-impact plastic trays are excellent. Provide on-edge storage below the sink for extra trays and ferrotype plates. Plan at least one electric outlet on each wall. Forced-air ventilation is not imperative. Just leave the door open when you step out for a rest or a smoke, but don't forget first to cover up your light-sensitive photographic paper. If possible, provide a mixing faucet for hot and cold water and keep the outlet at least 15″ above the sink bottom. Counters need be no wider than 24″. Underneath, provide cheesecloth stretchers for drying prints or space for blotter rolls—remember that workability is more important than fancy finish.

By all means, keep everything in your darkroom clean—not only equipment but the walls, the workbench, and your hands as well. Change the darkroom towels frequently. Occasionally dust the table tops, shelves, and cupboards with a damp cloth. Any chemical solutions accidentally spilled on the floor should be removed immediately with a damp cloth. The reason for all this cleanliness is, of course, to combat dust, the perennial enemy of all photographers and print-makers. For example, fixer dust has been known to contaminate color developer, causing high stain levels in prints. Dried chemicals become dust in the air and can settle on the surface of photographic emulsions, causing spots. If you are making big enlargements from small negatives, this is a particularly annoying problem since it will require a great deal of spotting later.

If you are planning to build a darkroom, get a copy of Kodak pamphlet AK-3, *Darkroom Design for Amateur Photographers.* Single copies can be had free of charge from Dept. 841, Eastman Kodak Company, Rochester, N. Y. 14650.

A. Print washing tray. This should be as large as you have room for to accommodate batches of prints. A Kodak Duraflex 6-inch deep tray is ideal.

B. A Kodak Automatic Tray Siphon converts any ordinary tray into an efficient print washer. Water flowing into the tray at the top keeps the prints in motion and separated. There are no moving parts to wear out.

C. You may or may not think slats in your darkroom sink are a good idea: It's good if they keep a tray up off the drain so your sink won't overflow.

D. Be sure your sink has a mixing faucet for the hot and cold water.

E. Keep you thermometer handy here. It should measure both Celsiues and Fahrenheit. Calibrate your thermometer against one known to be accurate. If yours is accurate within 2 degrees, it will be satisfactory if you always use the SAME one.

F., G., H. These are print processing trays, usually arranged in the left-to-right order of developer, stop bath, and fixer. Ideal would be Kodak Duraflex trays which are made from a tough, durable, high-impact plastic, permanently inert against chemical corrosion.

I. Location for wall timer. A timer with an illuminous dial and sweep second hand is very useful for timing processing steps.

J. Enlarger. Be sure to consult the Reference Section pages dealing with enlarger and enlarger lens selection.

K. We suggest you add a foot switch to your enlarger to keep your hands completely free for dodging.

L. Suggested location for safelight. The Kodak Adjustable Safelight Lamp, with its double-swiveled shank and bracket, can be attached to a wall, shelf, or bench, and swung or tipped as needed. We suggest you buy a 5$\frac{1}{2}$-inch circular OC (light amber) safelight filter. This is recommended for Kodak Polycontrast Polylure, Polycontrast Rapid, and high-speed enlarging papers.

M. For general darkroom illumination, suspend a Kodak Utility Safelight Lamp, Model C from the center of the ceiling. This holds a 10 x 12-inch safelight filter and uses a 25-watt bulb.

N. Put your paper trimmer and other darkroom accessories here under this bench. Also build vertical racks for tray storage here. Paper should be stored across the room under the enlarger bench.

A Word About Professional Darkrooms

Obviously, to produce prints in professional quantities hour after hour, a well-planned and comfortable darkroom is essential. This room should be not less than 8' × 10' for one person to work in comfort and to hold the required professional equipment. The planning of such a room should include specifications for floors, walls and ceiling, ventilation and air conditioning. We can do no better than to refer you to the appropriate discussion in the Kodak publication No. K-13, *Photolab Design.*

SAFELIGHTS

We must emphasize the importance of safelights for your working comfort and print quality. For top quality, it is a good idea first of all to learn the "do's" and "don'ts" of safelights. You should remember that the purpose of a safelight is to provide you with just enough light to see what you're doing, yet not so much light that the photographic paper is ruined.

You should use two safelights, even in the minimal-size amateur darkroom. One, the Kodak utility safelight lamp, model C, provides low-level general illumination and is used so that the lamp is in the hanging position with the light directed toward the ceiling. For larger darkrooms allow one such lamp for each 60 square feet of ceiling. For working illumination over the benches and sink, use the Kodak darkroom lamp, model B; it should be installed so that it hangs no closer than 4' from the unexposed photographic paper. This should be equipped with a 15-watt bulb and the appropriate safelight filter. Be sure to consult the data sheet of the manufacturer for the particular enlarging paper you are using to find out which safelight filter is appropriate. For example, the Kodak safelight filter OC (light amber) should work for the majority of enlarging papers. However, the data sheet for Kodak Panalure paper recommends the Kodak safelight filter No. 10 (dark amber) in order to keep safelight exposure to a minimum since this particular paper has panchromatic sensitivity. Also, with some high-speed papers, such as Kodak Resisto rapid paper, you may wish to use only a 7¹/₂-watt bulb.

The Kodak safelight filter, No. 13, with a 7¹/₂-watt bulb, is used when handling Kodak Ektacolor 37 RC papers when making color prints. The formerly used Kodak safelight filter,

No. 10, does not give as much illumination as does the No. 13. In addition, you are less likely to cause light fogging even though the light transmitted by the filter is brighter.

A safelight is often taken for granted but, actually, how safe is a safelight—the one in *your* darkroom, for instance? It may come as a shock to you, but there is no such thing as an absolutely *safe* safelight. Ideally, a safelight should emit the maximum illumination of a color to which the eye is sensitive but to which the photographic paper you use is least sensitive. Since there is no sharp cutoff in paper sensitivity, the safeness of any darkroom illumination is a relative matter.

It is extremely important to follow the safelight recommendations of the manufacturer of the photographic paper you are using. It is not enough to assume a certain safelight gives "better, safer illumination," as one manufacturer advertises. A safelight that is ideal for papers of one kind may not be suitable for use with another. Be careful not to exceed the suggested wattage for the safelight lamp, don't use the safelight too close to the working area and don't leave photographic paper exposed too long to safelight illumination. The obvious danger, of course, is fog. Fogged black-and-white prints have gray instead of white borders and are characterized by "veiled," degraded highlights. In extreme cases print contrast is noticeably decreased and the prints have an objectionable muddy appearance. This is true with both black-and-white and color printing materials. The insidiousness of unsafe darkroom illumination, however, lies in the fact that *print quality can suffer even though the borders of the print are visibly free from fog.* It happens this way: Small amounts of safelight exposure that in themselves are not sufficient to produce fog may expose silver halide in the image portion of the print and cause it to develop to a higher density than if it had not been exposed to the safelight. Thus, there is sort of a double exposure—first, the exposure caused by the safelight and, second, the exposure caused by projecting the negative image onto the paper.

Almost without your realizing it, this combination can be enough to cause a faint highlight veiling—just enough to detract from the clean, sparkling quality that distinguishes a fine print. In high-contrast papers used for line copy work, safelight fogging may produce degradation of quality without producing visible highlight fog.

In color papers, unwanted tints of color may be evident. As a clue to this problem, let's say you used a Kodak safelight filter OA for color printing (this is NOT recommended!). The print highlights could have a pronounced bluish coloration (blue being the near-complement of the amber safelight color).

Although it may seem obvious, be sure your safelight filter isn't obsolete. Safelight filter designations have changed through the years and the one that you found in the trunk in the attic may have become faded with time. As with almost everything else, time may take its toll of some safelight filters. Check them at least twice a year to be sure they haven't become faded or cracked with age.

Checking Safelight Illumination

When you suspect that safelights are causing trouble, you can make a simple test as follows:

1. With the paper and the printing method you commonly use, make an exposure with your enlarger from a typical negative. Mask the borders of the paper to produce an unexposed area around the picture. *Do not have the darkroom safelight turned on for this portion of the test or in any other way expose the paper to safelight illumination before the exposure.*

2. Position the exposed paper about as far from the safelight as you generally work (just lay it underneath the safelight on the workbench without the easel masking the borders) and expose it to the safelight illumination by covering successive areas of the paper for different lengths of time. Keep one area covered all the time. Suggested safelight exposures for the print sections would be 1, 2, and 4 minutes.

3. Process the exposed paper normally and notice in the print the amount of safelight exposure that can be given without any appreciable change in print quality.

Remember, some papers are more susceptible than others to safelight fog because they are more sensitive, either in speed or to a particular color of light. Accordingly, a separate test should be made for each type of paper used. If you find that your prints are degraded in quality or fogged, the cure is simple: Use a *safe* light.

Ektacolor papers also can be checked in the manner just described. Remember, safelight fog will show up as unwanted tints of highlight color.

270

ENLARGERS

Selection

If you are thinking about buying an enlarger, no one can tell you which one is best or which one to choose. There are enlargers to fit different purposes and different size pocketbooks. However, for both black-and-white and color work there are basic features that every good enlarger should have—things you should check carefully before acquiring one.

For example, the enlarger construction should be sturdy; the head should not have a tendency to vibrate unduly long if the enlarger is jarred accidentally. In fact, you can test this feature for yourself by giving the enlarger head a slight tap and seeing if it is rigid, or if the vibrations are rapidly damped.

Although it is difficult to ascertain, the plane of the lens board should be exactly parallel to the plane of the negative. Also, interior reflections should be at a minimum. It may help here to remove the lens or lens board and turn on the enlarger and peer critically up into the bellows and negative carrier area. No bright metal should be apparent since any good reflecting surfaces at this location will increase the flare in the optical system and decrease the print contrast.

Let's consider a few more salient points.

Enlarger Lens Selection

You can probably solve this problem in a few seconds by taking the advice of your friendly expert photo dealer and be sure you are paying enough for a top-quality enlarger lens. However, if you want a little more background information, here are the relevant basics:

The covering power of the enlarger lens should be adequate. This means that the lens should be able to project a critically sharp image of the entire negative, including the corners as well as the center. To do this, the enlarger lens usually has to have a focal length equal to or greater than the diagonal of the negative. For a 35mm negative the enlarger focal length would be approximately 2".

If you have a camera with interchangeable lenses, you may have wondered if you could save money by using a camera lens also as an enlarger lens. Here's the answer: a camera lens may *not* necessarily perform equally well on an enlarger, particularly

at low degrees of magnification. For the most part, this is because the camera lens was designed and corrected for normal camera-to-subject distances, which means from infinity down to three or four feet, depending on how close the camera will focus. Enlarging lenses, on the other hand, are designed and corrected for working distances from three or four feet down to about twice the focal length of the lens. So you see, the enlarger lens design sort of "takes over" for producing images of optimum quality where the camera lens design "leaves off." For example, it would be unreasonable to expect that a lens from an aerial camera designed to photograph objects at a great distance from the lens (infinity) would satisfactorily serve double duty as an enlarger lens also. In other words, a great bargain at a war-surplus store might not be such a bargain after all. In addition, "fast" camera lenses of high aperture suffer from curvature of field at magnifications below 10:1 and, thus, are not suited for use on enlargers.

This is particularly true if lenses such as those mentioned above are used at or near their maximum apertures. But stop them down to $f/11$ or smaller and you will find that many of these lenses can be used for noncritical enlarging, especially if you don't mind annoyingly long print-exposure times. However, even this may not be feasible with extra-large enlargements, especially if you're using slower-speed papers. On the other hand, many top-quality unit-focusing lenses that are normally used for taking still photographs can also be used for enlarging with a high degree of satisfaction in many instances.

Let's repeat—for best results with any camera lens on the enlarger, be sure to stop it down before making the actual print exposure. Although we're getting ahead of ourselves somewhat, it is a good habit to focus with the enlarger lens wide open and then to stop it down two stops for the print exposure. There are several reasons for this:

1. A small amount of "falloff" is reduced at the edge of the circle of illumination.
2. A sharper image results because the edges of the lens are not used.
3. A more convenient print time will probably result. (However, for extreme enlargements, you may find you have to compromise somewhat in the amount of stopping down to avoid unduly long printing times.)

272

Again, we don't advise using older "bargain" lenses, since most modern enlarger lenses today are coated with a thin layer of magnesium fluoride to reduce intersurface reflections. As compared with an older noncoated variety, coated lenses have less tendency to project flare light onto the easel and tend to give improved highlight separation, especially from dense, high-contrast negatives. However, if you have one of these old lenses, don't throw it away; reserve it for printing contrasty negatives!

Another thing about old lenses: You will often hear that to make a good color print it is essential that one must have a "fully color-corrected lens." You will find that virtually all lenses made specifically for enlarging in the past three to four decades are remarkably well corrected for color. A lens that is not adequately color-corrected will show soft color fringes around images. Such fringes are particularly noticeable when a black object appears against a light background. A lens that is supposed to be fully color-corrected but which shows severe color fringes indicates the possibility that the lens element or spacing has become misaligned due to mishandling.

Provided that the lens barrel does not show damage, it is usually possible for the factory or the authorized service organization for the factory to realign the optics of the lens.

Did you say you *liked* the pictorial effect of the color fringing? For a moderate amount of fringing use a plano-convex lens as your enlarger lens; for an even heavier effect, use a double-convex lens. (These can be purchased inexpensively from an optical specialty company, such as the Edmund Scientific Company, Edscorp Building, Barrington, New Jersey 08007, but you will have to devise a diaphragm control.)

Enlarger Illumination Systems

Enlarger illumination systems can be grouped into two categories: diffusion and condenser.

Diffuse Illumination

Diffusion enlargers could be further classified into "diffusion only" and "diffusion by light integration." Which is better? Neither is truly better or worse—they are merely different. Diffusion illumination systems avoid the weight and cost of optical condensers. Diffuse illumination helps to eliminate the appearance of small scratches, grain, and the obvious effects of negative retouching.

273

Some enlargers employ fluorescent tubes, whose light is sometimes referred to as "cold light." Thse enlargers are of the integrated diffuse-type. They can be used for black-and-white portrait work in particular since the soft nature of this "cold-light" illumination tends to subdue blemishes, retouching, and grain. However, fluorescent light is not generally suitable for variable contrast paper or color printing.

Of course, diffuse means scattered. Since diffuse enlarger illumination is scattered thoroughly, its rays strike the negative at all angles. The scattering is usually accomplished by a sheet of ground or opal glass inserted between the light source and the negative in the diffusion-only enlarger. The integration system bounces the light from an internal, white, reflecting sphere or surface. When illumination is scattered in this way, as well as by the negative, the lens sees and projects an image of lower contrast than if condenser illumination had been used. As a general rule of thumb, black-and-white prints made with a diffuse enlarger require paper one grade of contrast higher than if the same negative had been printed with a condenser enlarger.

Condenser Illumination

The experts will tell you that a "pure" condenser enlarger would be one with a point light source, or at least a very small light source, such as would be provided by the filament of a projection lamp. Few such enlargers have been commercially available, unless you accept some types of fixed-enlargement printers used only in photofinishing plants, but even these usually introduce a degree of diffusion into the optical system to minimize scratches and dust. The important thing is that a true condenser enlarger for ordinary enlarging purposes would not be desirable anyway; prints would be extremely contrasty, and negative defects, such as scratches, would be accentuated.

The modern "condenser enlarger" has come to mean an enlarger that uses a light source covering a relatively large area such as a white glass, G. E. photo enlarger lamp No. 212, and a pair of plano-convex condensers, which are usually arranged in a "bucket" or a collar for support. This type of arrangement is intermediate between specular or "directed-ray" illumination and diffuse illumination, in fact, in about a 50–50 ratio.

Using condenser illumination is especially advantageous when small negatives up to $2^{1}/_{4}'' \times 3^{1}/_{4}''$ are to be blown up to large-size prints without excessively long exposures. There is

274

not the same optical need for condensers to print large-size negatives. This is fortunate, since large-size condensing lenses are expensive.

The advantages of using condensers are threefold. They direct through the negative and lens most of the illumination they collect, with the result that a relatively short printing time is usually required for the enlargement. The two glass condensers act as fairly good heat absorbers, and they, plus the short exposure time, keep negatives from becoming overheated during enlargement. This is all to the good since an overheated negative often buckles, rendering the image detail unsharp. Thirdly, the type of print quality afforded by this illumination deserves some special mention.

Generally, a black-and-white print made with a condenser enlarger is more contrasty than one made from the same negative with the diffusion-type enlarger. Depending on the specific enlargers being compared, this difference in contrast varies by approximately one grade of paper contrast. This means, for example, that a negative that prints well on No. 2 paper with a condenser enlarger would probably be printed on No. 3 paper with a diffusion enlarger.

However, the difference in contrast of color prints between the two types of enlargers is virtually indistinguishable. The reason for this is that the dye particles comprising the image in a color negative are *transparent,* whereas in the black-and-white negative, the discrete particles forming the image are opaque grains of silver, which scatter the light. (The technical explanation is that the silver grains have a much higher diffusing power than the dyes used in the color negative. This diffusing power becomes directly related to the effective difference in contrast obtained between a condenser enlarger and a diffusion enlarger.)

Another aspect of print quality is influenced by the system of negative illumination. Minor negative defects, such as scratches, small abrasions, even dust and coarse grain, are considerably less apparent in prints made with the diffusion enlarger. This is desirable since it minimizes defects and eliminates much of the need for spotting prints. Consider, for example, how this saves time for the unfortunate photographer enlarging a scratched or grainy negative, or how this would be appreciated by the professional portrait photographer who must

print negatives containing minute retouching marks.

For *best* results—and, after all, that's what you're most interested in—you should make the negatives to fit the enlarger you have. For black-and-white work this means that normally exposed and developed negatives will be fine for diffusion-type enlargers. But normal exposure and somewhat less development (about 30% less—and remember we're talking only about black-and-white processing, which can be varied) will yield a negative that will give excellent results in condenser-type enlargers. The reason is that less-than-normal development produces both smaller grain and lower negative contrast. These characteristics, teamed with the grain-emphasizing, specular illumination of the condenser enlarger, approximately cancel each other. So you see, a graininess or quality comparison between two prints made from the same negative and enlarged in the two different types of enlargers is not a fair comparison. As far as scratches are concerned, anyone who exercises reasonable care in processing films, and filing and handling negatives, should have no appreciable trouble with either enlarger. After all, anyone interested in top-quality enlargements does not shuffle negatives like a pack of playing cards!

Enlargers for Color Printing

Several enlargers made in the last few years have been designed with color printing as the primary function. The simplest type has a filter drawer in the lamphouse that accepts color printing filters. Other enlargers employ mechanical methods of altering the color of the light by means of filter controls. Some alter the color in discrete steps; others are continuously variable over a wide range, utilizing ingenious systems including (a) three lamps, one with a red, one with a green, and one with a blue filter, each lamp having an adjustable voltage control, (b) three rotating stepped-wedge subtractive filters, and (c) three dichroic subtractive filters. All of these designs are intended to make the necessary filter adjustments more convenient than handling and inserting individual filters repeatedly.

Let's state it clearly: It is not imperative that you use an enlarger designed primarily for color printing to make color prints; you can easily make good quality color prints using an older enlarger.

276

ENLARGER ACCESSORIES

The Enlarger Easel

If you own an enlarger, you probably have an easel or paper holder to use with it. The easel is a very handy accessory for holding the paper flat in the plane of sharp focus, for providing white print margins of the desired width, and for masking the paper in the desired print format. Besides, it provides a convenient method of shifting the paper around on the enlarger baseboard to secure the desired composition without cluttering up the image with your fingerprints!

Most easels accommodate paper sizes up to 11″ × 14″; larger than that, the easels are fairly expensive. However, you can easily make salon prints, or other large prints, even if you do not have a commercial-type easel. In fact, some photographers prefer not to use one since most easels "steal" a little bit from the picture area in the borders, which usually have to be trimmed away when the print is mounted. Although keeping the paper flat is very important, you can do this easily by placing a sheet of clean glass on top of the paper before making the exposure. The glass, of course, should be slightly larger than the paper that you are using; otherwise, the edges of the glass will make an undesirable optical mark on the print.

Plate glass, however, has the disadvantages of being brittle, expensive, and susceptible to dust, scratches, and fingerprints. So, if for these reasons you've joined the ranks of those who object to most easels and to plate glass, you can easily make a large easel from a drawing board. Along two adjacent edges tack down strips of the metal molding material commonly used for edging linoleum on kitchen counter tops. This molding has a slot that will readily accept the paper and hold it flat. This takes care of two edges. To hold down the opposite corner of the paper do this: On the corner of the drawing board opposite the molding, install a spring clip, such as used on clip boards for taking field notes. This easel won't give white margins all around, but it does provide a comparatively inexpensive method of holding flat large sheets of photographic paper.

Photometers and Densitometers

You should know that there are available several exposure-determination devices known as densitometers and photome-

ters. The visual models are low in cost but only moderately useful; the elaborate electronic units used in commercial color work have a Rolls-Royce price tag. However, when used properly, they can make measurements that will lead to more accurate print exposures than is possible by visual estimation only. Easel photometers, especially, are becoming more popular, and you'll want to investigate this enlarging accessory at your photo dealer's. These devices are more fully explained in Chapter 4. Also, be sure to note the use of these instruments in producing contrast-controlling masks in color printing.

Miscellaneous Enlarger Accessories

You will want to check over the other accessories available for various enlargers since they may also influence you in selecting a particular mode.

For example, some enlargers have accessory copying lights, exposure-meter brackets, filter holders, and so on, which make them more suitable for use as cameras. A few models incorporate an automatic focusing feature. This convenience is scarcely necessary for home use, and, as a matter of fact, is not always desired. In situations where the enlarger may be in constant use to produce a great volume of prints, usually professional, the automatic focusing arrangement can be a time-saver. A word of warning at this point—on some auto-focus enlargers you cannot interchange lenses. However, some models are available with two or even three lenses of different focal lengths that can be changed at will. (The reason for having more than one focal length of lens available for an enlarger is, of course, to print different-size negatives with the same equipment.)

You will be interested to learn that some "delux" enlargers may incorporate the so-called "distortion controls"—a tilting negative carrier or a swinging lens board. These adjustments are helpful in straightening out converging lines caused by taking pictures while the camera back is tilted out of vertical position. Also, you can maintain sharp focus over the entire print area when tilting the easel.

Some enlarger manufacturers provide a choice of negative carriers. Consider what size negatives you are going to be working with. It is a good idea to have a carrier that will provide a complete mask for your particular size. Is it a glass carrier or the glassless type? Many photographers using miniature nega-

tives prefer the glassless carrier because it eliminates four (count them!) glass surfaces on which dust can collect. Dust can be a problem, especially when making large prints from small negatives.

Another disadvantage in using the glass-type negative carriers is that Newton's rings, those annoying patterns of light interference, sometimes form between the back of the negative and the glass top of the carrier. The prevention of this phenomenon is discussed in the section dealing with avoiding printing pitfalls (Chapter 9).

EXTENDING THE MAGNIFICATION RANGE OF ENLARGERS

High Magnification

Occasionally, it may be necessary to "blow up" a negative beyond the maximum range of the lens-to-baseboard distance. For example, you may wnat to make a giant enlargement from an entire negative or to enlarge greatly a small area of a negative. Some enlargers have a lamphouse assembly that can be tipped to project horizontally. Others can rotate around the post so that, with the enlarger baseboard clamped or weighted securely in position, the image can be projected onto the floor.

Using an accessory positive lens over the enlarger lens is still another method of obtaining increased magnification. Although this is somewhat of an emergency procedure, it is particularly helpful for relatively inexpensive enlargers that cannot be adapted in either of the other two ways, provided you can move the lens closer than normal to the negative.

The accessory lenses formerly recommended were the Kodak Portra lenses (no longer manufactured), which were used to give a close-up effect. They could be adapted to many enlarger lenses with the appropriate adapter ring, depending on the diameter of the enlarger lens mount. They are mentioned because many are still in use. It is possible, however, to accomplish the same purpose with meniscus lenses available from Edmund Scientific Co., 300 Edscorp Building, Barrington, New Jersey 08007. There were three powers of Portra lenses manufactured, numbered 1+, 2+, and 3+. The equivalent focal lengths of the three powers in millimeters is:

$$1+ = 1000\text{mm}$$
$$2+ = 500\text{mm}$$
$$3+ = 333\text{mm}$$

Also note that greater magnification for a given lens-to-easel distance can be obtained with a relatively shorter-than-normal focal-length lens, which would cover a correspondingly smaller area of the negative. Therefore, you can use it to enlarge a small part of a larger negative. For example, the standard lens for a 4″ × 5″ enlarger is approximately six inches. However, auxiliary lenses of 4″ or 3″ focal lengths would greatly extend the magnification range of this enlarger. Don't forget, you cannot interchange lenses on some auto-focus enlargers.

Reductions

What about making unusually small projection prints? It doesn't seem right to call them enlargements. These prints might be used as miniatures for lockets or novelty gifts. Many enlargers can project an image about as small as the actual size of the negative itself. It is usually necessary, however, to find some way of propping the easel so that it is nearer to the lens than normal. A pile of magazines or a small wooden box can be used conveniently. Reductions can be made by projection if the enlarger has a sufficient bellows extension to extend the lens more than twice its focal length from the negative.

You can make extremely small projection prints most conveniently by using a lens with a shorter-than-normal focal length. However, you can use an ordinary enlarger for making reductions by merely adding supplemental lenses of the proper power. The supplemental lens shortens the effective focal length of the enlarger lens so that the projected image is at approximately a one-to-one ratio to the negative. For reductions smaller than a one-to-one ratio, turn the front of the lens toward the *negative*, if possible. In all probability this will help to produce a sharper image.

The heads of some enlargers will not approach the paper board closely enough for making reductions; in such a case, as mentioned above, raise the easel. Incidentally, you must always do this with an auto-focus enlarger.

Note that when the enlarger is operating near a one-to-one magnification, focusing is complicated by the fact that moving the lens alone changes both the object and the image distance at

about the same relative rate. The result is that it is impossible to focus by moving the enlarger lens alone. Therefore, the proper focusing technique is to set the lens distance at an approximate position and then move the whole enlarger head, or, if necessary, to raise or lower the easel. Should the image focused in this way be incorrect in size, further adjustment must be made in the lens-to-negative distance and the focusing done again, moving the whole enlarger head.

At the comparatively small apertures generally used in enlarging, a Portra lens, or an equivalent meniscus lens, does not appear to have any objectionable effect on definition at low magnification even when the strongest lens, the 3+, is used. In some cases, it is even possible to combine lenses 2+ and 3+ if a small aperture is used. Do you have a magnifying glass handy? One of those large diameter ones with a handle, the kind often used to examine retouching? Since the retouching glass is a positive lens, much stronger than Portra lenses, it *may* be satisfactory for making an emergency reduction if it is centered

EXTENSION OF LOWEST MAGNIFICATION (APPROXIMATE)

Kodak Portra Lens	Minimum magnification											
	1			1.5			2			3		
	1 +	3 +	2 + and 3 +	1 +	3 +	2 + and 3 +	1 +	3 +	2 + and 3 +	1 +	3 +	2 + and 3 +
Enlarger Lens												
50mm (2 in.)	0.9	0.75	0.65	1.35	1.1	0.9	1.75	1.4	1.15	2.5	1.9	1.5
75mm (3 in.)	.85	.7	.55	1.25	0.95	.75	1.65	1.2	0.95	2.3	1.6	1.2
100mm (4 in.)	.85	.65	.50	1.2	.85	.65	1.55	1.05	.8	2.15	1.35	1.0
128mm (5 in.)	.8	.55	.45	1.15	.75	.6	1.45	0.95	.7	2.0	1.2	0.85
135mm (5³/₈ in.)	.8	.55	.45	1.1	.75	.55	1.4	.9	.65	1.95	1.15	.8
161mm (6³/₈ in.)	.75	.5	.4	1.05	.7	.5	1.35	.8	.6	1.8	1.0	.7
190mm (7¹/₂ in.)	.7	.45	.35	1.0	.6	.45	1.25	.75	.5	1.7	0.9	.6

as well as possible over the enlarger lens and *if a small aperture is used in the enlarger lens.* Try it and see. The table on page 281 indicates approximately the extension of lowest magnification possible with various enlarger lenses by the addition of Portra lenses. Only those figures of less than 1.00 represent a reduced image. For example, suppose you were printing a 4″ × 5″ negative with a 6³/₈″ enlarger lens and the enlarger would normally focus down only to a one-to-one ratio. The addition of a 2+ and 3+ Kodak Portra lens makes a 1¹/₂″ × 2″ print.

F/STOP USAGE AND DERIVATION

Serious picture-takers and print-makers should have at least a cursory knowledge of *f*/stops. For example, suppose you wanted to double the exposure of the next test print: To achieve this effect accurately, you should open up the enlarger diaphragm by one *f*/stop, and not double the exposure time, which would lead to reciprocity trouble.

Additionally, in color printing, when changing the filter pack, exposure changes occur to layers of emulsion in the following amounts:

CC10 = ¹/₃ *f*/stop	CC40 = 1¹/₃ *f*/stops
CC20 = ²/₃ *f*/stop	CC50 = 1²/₃ *f*/stops
CC30 = 1 *f*/stop	CC60 = 2 *f*/stops

However, note that any particular filter color affects *only* the light color it controls by the above amounts. Thus a CC30Y has the equivalent effect of stopping the lens down by one full *f*/stop for only the blue portion of the light. (In other words, for this example, the red and green light are *not* "stopped down.")

Many color print-makers tend to think of required changes in color and density in terms of filter numbers, and you probably will too after you've had some color printing experience. You'll find yourself expressing a required change of exposure, for example, as a "30's worth." This is, of course, a one *f*/stop change for the one color.

The *f*/stop system is a universally used method of designating the relative light transmission of photographic lenses. The expression is derived to indicate the relative aperture by the fraction f/d where f is the focal length of the lens and d is the diameter of the lens aperture. A lens with 100mm focal length

and an aperture of 25mm would therefore have an f/value of $^{100}/_{25}$ or f/4. Since lens apertures are circular and the areas of circles are directly proportional to the squares of their diameters, the light transmission of lens apertures are inversely proportional to the squares of the f/numbers. For example, a lens at f/4 is four times faster than a lens set at f/8.

The following table illustrates the commonly used series of f/stops. The squared value shows that each stop is a factor of two difference in light transmission from the next stop.

F/number in 1-stop changes	Square of *f*/number
1	1
1.4	2
2	4
2.8	8
4	16
5.6	32
8	64
11	128
16	256

Note that the square values are exact, whereas some of the f/values are rounded off to the nearest convenient value. Interestingly enough, if you wish to memorize the series of f/stop numbers, you simply remember the 1 and 1.4 and alternately double each to eventually reproduce the series.

FILTERS USED IN MAKING COLOR PRINTS

Kodak Color Compensating Filters
These filters are made of optical quality gelatin and are intended for use in front of the lens.

The list shows all filters available, in the nomenclature which indicates the color and filter density.

Yellows	Magentas	Cyans	Reds	Greens*	Blues*
CC025Y	CC025M	CC025C	CC025R		
CC05Y	CC05M	CC05C	CC05R	CC05G	CC05B
CC10Y	CC10M	CC10C	CC10R	CC10G	CC10B
CC20Y	CC20M	CC20C	CC20R	CC20G	CC20B
CC30Y	CC30M	CC30C	CC30R	CC30G	CC30B
CC40Y	CC40M	CC40C	CC40R	CC40G	CC40B
CC50Y	CC50M	CC50C	CC50R	CC50G	CC50B

*no CC025 values made

283

CC025C-2
CC05C-2
CC10C-2
CC20C-2
CC30C-2
CC40C-2
CC50C-2

*These filters are preferred when cyan filters are needed.

Kodak Color Printing Filters

These filters are made of plastic, cellulose acetate. Their optical quality is such that they should not be used in the image-producing portion of an enlarger. They are, however, ideal for use in light source color correction.

The list shows the filters available, in the nomenclature that indicates the color and filter density.

Yellows	Magentas	Cyans	Reds
CP05Y	CP05M	CP05C	CP05R
CP10Y	CP10M	CP10C	CP10R
CP20Y	CP20M	CP20C	CP20R
CP40Y	CP40M	CP40C	CP40R

Special Cyan Series*
(increased absorption in infrared region designated by -2 in nomenclature)

CP025C-2
CP05C-2
CP10C-2
CP20C-2
CP40C-2

*The cyan-2 filters are preferred when cyan filters are needed. No Blue and Green CP filters are made.

Ultraviolet Absorbing Filters

The following ultraviolet-absorbing filters are available:

Wratten 2B	(gelatin)
CP2B	(acetate)

Index